WISCONSIN
AND THE
CIVIL WAR

RONALD PAUL LARSON

THE
History
PRESS

Published by The History Press
Charleston, SC
www.historypress.net

First published 2017

Manufactured in the United States

ISBN 9781467137195

Library of Congress Control Number: 2017948491

Notice: The information in this book is true and complete to the best of our knowledge. It is offered without guarantee on the part of the author or The History Press. The author and The History Press disclaim all liability in connection with the use of this book.

To the memory of my uncle Robert Weber, a Civil War buff who fostered my love of history, and my parents, Harold and Bernadine Larson, who always encouraged me to follow my interests.

CONTENTS

FOREWORD

It's hard to believe now, but the State of Wisconsin was only twelve years from territorial status when the Civil War began in 1861, not even a teenager when the war rolled around. Among its fellow upper midwestern counterparts, only Minnesota was younger, having just become a state in 1858. Yet for all its newness, Wisconsin was an exciting place to be between statehood and the start of the war.

A diverse population inhabited the borders of Wisconsin in 1861, and a daily influx of new arrivals certainly added to the rich tapestry of cultures. The opening of the Erie Canal made it easier for settlers from New York and New England to use the Great Lakes to transport themselves to the new Wisconsin territory, and they came by the thousands. They were joined by immigrants from Germany, Ireland, England and Norway seeking land and a better future. Once in the state, these recent American and foreign immigrants encountered representatives of the Ojibwa, Oneida, Potawatomi and other tribes, as well as free blacks and runaway slaves.

Historians like Lance Herdegen have argued that these settlers and immigrants combined "to form a new and different kind of American." They were an optimistic and opinionated lot, shaped by education, ideas and the technologies of the Industrial Revolution such as the railroad, telegraph and printing press. The open land was full of opportunity for those with ambition and the capacity for hard work and adaptability.

The importance of midwestern states like Wisconsin to the ultimate Federal victory cannot be overstated. In terms of manpower, Wisconsin

had over 91,000 enlistments in the Union army from a total population of 775,881. These men proved to be effective soldiers, often adapting themselves successfully to whatever the military situation before them demanded.

Beyond providing manpower for the army, Wisconsin played a key role in feeding the nation and its soldiers. Wisconsin was the second-largest wheat producer in the country at the time of the war. That wheat was sent to mills where it was turned into bread for the marching columns of Union blue. Local corn-fed hogs were shipped via the railroad to stockyards that converted these animals into bacon, ham and salt pork.

The natural resources of the state also armed and equipped the Union army. Wisconsin trees were felled and floated down Wisconsin waterways to be converted into musket stocks, wagons, boxes, barrels, buildings and many other wooden products. The southwest portion of the state contained galena, a soft lead mined and molded into bullets and shot. Iron deposits from the north were sent to factories that turned out products that left the state via the railroad or aboard ships that left Lake Michigan ports like the one in Milwaukee.

Over the past twenty years, an increased availability and access to sources has helped historians and students gain a better understanding of the importance of Wisconsin during this period. Advances in technology and communication have made the letters, diaries, memoirs and newspapers that historians rely on more available and accessible. No longer is it necessary to have to physically travel to libraries, museums or universities to view the evidence of the past in person to shape an argument. New sources and the connective power of the Internet help us to add additional pieces to the historical puzzle and expand on the arguments of past historians. Key word searches, access to newspaper collections online and extensive image databases have all linked historians to repositories of information all over the world via a computer or mobile device. For all of these reasons, it is important to revisit topics such as Wisconsin's role before and during the Civil War to renew and refresh present and future generations as to the rich history of the state.

DOUG DAMMANN
Civil War Museum Curator

Preface

Why another book about Wisconsin during the Civil War? Well, the last one was published in 1997. Two things have happened since then: a fair amount of scholarship and the Internet. The new scholarship alone would justify a new history. There is new information about every aspect of Wisconsin and Wisconsinites during that crucial time in American history. The experiences and voices of people not known or heard twenty years ago are now better known and can be heard. That is especially true for women, African Americans and Native Americans. Much original research has been done, and is being done, on these Wisconsinites during the war period, and some of it is in this book. There is also more emphasis in this book on Wisconsin's economy during the war and on politics, such as resistance to the draft in Wisconsin.

The Internet makes finding and using all of this new material infinitely easier than it used to be, as Doug so eloquently describes in his foreword. We are able to know more about the people who were living during that time than we used to. So, it is time for a retelling of the story. Of course, a book of this size can only present a fraction of that knowledge, new or old. Choices must be made and some topics emphasized while others are not. I have chosen to emphasize those that have not had as much emphasis before. This is my telling of the story. Others would emphasize other topics. That is the way of things and leaves room for others to tell their story of Wisconsin during the Civil War. There will always be room

for people to tell their stories. The irony for historians is that the success or failure of our storytelling is determined by the degree to which we successfully tell other people's stories.

RONALD PAUL LARSON

1

WISCONSIN BEFORE 1860

In the late afternoon of March 11, 1854, a mob of about four thousand men gathered outside the Milwaukee county jail. They were angry and on the verge of violence. Inside the jail, Joshua Glover, an African American man, born into slavery, was held alone in a cell and injured, dry blood encrusting his scalp. He had been captured the night before and suffered a severe head wound when U.S. Marshal Charles C. Cotton hit him in the head with handcuffs.[1]

Around 5:00 p.m., some in the crowd rushed the jail. One man kicked in the outer door. Others used pickaxes to make a hole in the wall next to the jail door. Men yelled for keys. James Angove, a mason, heard the call for keys and noticed lumber "all over the street" at nearby St. John's Cathedral, which was under construction. He picked up a beam about six inches in diameter and twenty feet long and shouted to the crowd, "Here's a good enough key." About twenty men grabbed hold of the beam and battered in the jail door. On the ground floor, Glover undoubtedly heard everything. He knew the men were trying to get to him. The undersheriff, S.S Conover, tried to prevent the mob from taking Glover, but men pulled him away. Glover was taken from his jail cell. As he emerged from the building, he waved his hat at the crowd. He was a free man.[2]

Escorted by one thousand men, Glover was put in a waiting wagon and driven from Wisconsin Street to East Water Street and then to Walkers Point Bridge where John A. Messenger, a Democrat, put Glover into his buggy and drove as fast as he could out of the city, heading west.[3]

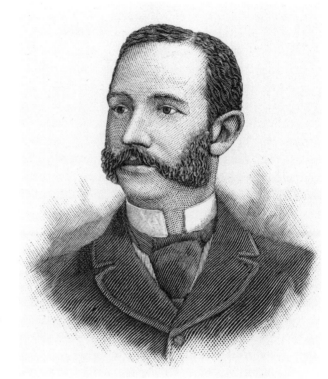

Right: A postwar engraving of Joshua Glover. *Wisconsin Historical Society*.

Below: A contemporary artist's rendering of the rescue of Joshua Glover. *Milwaukee Country Historical Society*.

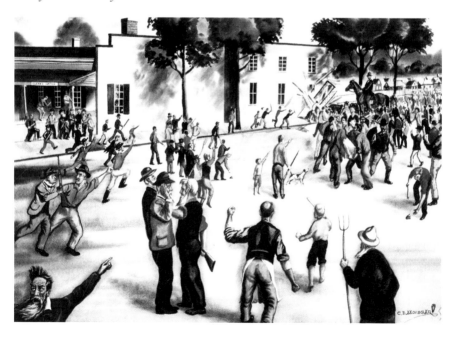

In the end, Glover, a slave who had escaped two years earlier from St. Louis and was working at a sawmill outside Racine, Wisconsin, when he was captured, gained his freedom. Sometime in the first two weeks of April 1854, with the help of abolitionists, Joshua boarded a steamer in Racine and made it to Canada, where he married and lived as a free man for the rest of his life.[4]

Joshua Glover was not the first fugitive slave to use the Underground Railroad in Wisconsin. In all likelihood, it was Caroline Quarlls, a sixteen-year-old fugitive slave who, like Glover, was also from St. Louis. A house slave who, in her own words, was "treated well enough for a slave," although she had been "whipped," fled on July 4, 1842, after saving $100.

Caroline was fair-skinned. She most likely was an octoroon—a person who is one-eighth African American. Passing as white, she booked passage on a steamboat from St. Louis to Alton, Illinois. Arriving in Alton, she was in a free state but still in danger of capture. After some time in Alton, she took a stagecoach to Milwaukee, arriving in early August. Pursued by bounty hunters, she was hidden by abolitionists in Milwaukee, Prairieville (now Waukesha) and Spring Prairie. In early September, Lyman Goodnow, a Prairieville abolitionist, escorted her to Chicago, across Indiana and Michigan to Detroit, where she crossed into Canada. In Canada, she married another escaped slave, Allen Watkins, and raised six children with him in Sandwich (modern Windsor), Ontario, Canada. She lived until 1892.[5]

The same year that Glover made his escape to Canada, a father and two children passed through Chilton, Wisconsin, aided by Stockbridge Indians, who saw them safely to Green Bay and then to Canada by ship. Between 1842 and 1861, it is estimated that more than one hundred slaves used the Underground Railroad in Wisconsin to escape to freedom. Antislavery sentiment in Wisconsin was strong.[6]

The man who spearheaded the breakout of Glover, the abolitionist newspaper editor Sherman Booth, was arrested by federal authorities for assisting in the escape of a fugitive slave. This

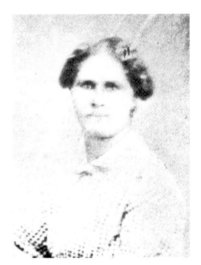

The only known image of Caroline Quarlls Watkins, taken when she lived in Sandwich, Ontario. *Wisconsin Historical Society*.

was a violation of the 1850 Fugitive Slave Act, which required people to help return escaped slaves to their owners. The Fugitive Slave Act rallied antislavery sentiment in Wisconsin, as it did throughout the North. For Booth, it was the beginning of a six-year legal odyssey that resulted in the Wisconsin Supreme Court declaring the Kansas-Nebraska Act unconstitutional, the U.S. Supreme Court overturning the Wisconsin decision and reaffirming the constitutionality of the Fugitive Slave Act, and the Wisconsin state legislature passing the Wisconsin Declaration of Defiance in response to the U.S. Supreme Court decision—arguing that a state could declare a law unconstitutional in opposition to the U.S. Supreme Court. Two days before Abraham Lincoln's inauguration in March 1861, President James Buchanan had Booth's fines remitted, allowing his release from federal confinement.[7]

THE CREATION OF THE REPUBLICAN PARTY

A lot happened in Wisconsin in 1854. Less than three months after the rescue of Joshua Glover and the arrest of Booth, the Kansas-Nebraska Act became law. The Kansas-Nebraska Act, the brainchild of Illinois senator Stephen A. Douglas, specified that settlers in the Kansas and Nebraska Territories would decide whether to be slave or free when their state entered the Union. This idea of popular sovereignty nullified the Missouri Compromise of 1820, which prohibited slavery north and west of 36°30 latitude, Missouri's southern border.[8]

The Kansas-Nebraska Act created an anti-Nebraska movement in Wisconsin and throughout the North. People of all political persuasions—Whig, Free Soil and Democrat—opposed the opening up of the territories to slavery. In early 1854, political leaders across Wisconsin called for meetings to oppose the act. One of these meetings, held in Ripon, Wisconsin, on March 20, 1854, is considered one of the founding meetings of the Republican Party.[9]

Many years later, George F. Lynch remembered when, as a twenty-seven-year-old, he met his friend Alvin E. Bovay on a street in Ripon. Bovay told him, "You've got to come to our meeting in the schoolhouse tonight. We're going to organize our party." Lynch and sixteen other men, including Bovay, met "in the little old schoolhouse" after Lynch's sister, who was the schoolteacher, dismissed her students for the day. In Lynch's view, Bovay was "the brainiest man" in Ripon. Bovay had been thinking about naming

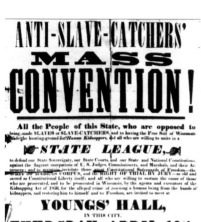

ANTI-SLAVE-CATCHERS'
MASS
CONVENTION!

All the People of this State, who are opposed to
being made SLAVES or SLAVE-CATCHERS, and to having the Free Soil of Wisconsin
made the hunting-ground for *Human Kidnappers*, and all who are willing to unite in a

☞ **STATE LEAGUE,** 🖐

to defend our State Sovereignty, our State Courts, and our State and National Constitutions, against the flagrant usurpations of U. S. Judges, Commissioners, and Marshals, and their Attorneys; and to maintain inviolate those great Constitutional Safeguards of Freedom—the WRIT OF HABEAS CORPUS, and the RIGHT OF TRIAL BY JURY,—as old and sacred as Constitutional Liberty itself; and all who are willing to sustain the cause of those who are prosecuted, and to be prosecuted in Wisconsin, by the agents and executors of the Kidnapping Act of 1850, for the alleged crime of rescuing a human being from the hands of kidnappers, and restoring him to himself and to Freedom, are invited to meet at

YOUNGS' HALL,
IN THIS CITY,

THURSDAY, APRIL 13th,

At 11 o'clock A. M., to counsel together, and take such action as the exigencies of the times, and the cause of imperiled Liberty demand.

FREEMEN OF WISCONSIN! In the spirit of our Revolutionary Fathers, come up to this gathering of the Free, resolved to speak and act as men worthy of a Free Heritage. Let the plough stand still in the furrow, and the door of the workshop be closed, while you hasten to the rescue of your country. Let the Merchant forsake his Counting Room, the Lawyer his Brief, and the Minister of God his Study, and come up to discuss with us the broad principles of Liberty. Let Old Age throw aside its crutch, and Youth put on the strength of manhood, and the young men gird themselves anew for the conflict; and faith shall make us valiant in fight, and hope lead us onward to victory; "for they that be for us, are more than they that be against us." Come, then, one and all, from every town and village, come, and unite with us in the sacred cause of Liberty. Now is the time to strike for Freedom. Come, while the *free* spirit still burns in your bosom. *Come!* ere the fires of Liberty are extinguished on the nation's altars, and it be too late to re-kindle the dying embers.

BY ORDER OF COMMITTEE OF ARRANGEMENTS.
MILWAUKEE, April 7, 1854.

Poster for an Anti-Slave-Catchers'
meeting at Youngs' Hall in Milwaukee,
Wisconsin, on April 13, 1854. *Wisconsin
Historical Society.*

the proposed new political party, which would combine all the parties opposed to the extension of slavery, "Republican." At the meeting Lynch suggested "Democratic-Republican." There were other suggestions, but Bovay's name won. "And it was largely due to his facile pen and his connection with the leading newspapers in the country," Lynch noted, that the name *Republican* was adopted by the new party first in Wisconsin and later throughout the country.[10]

The Republicans broke over the political scene like a tidal wave. In the elections of 1854, the Wisconsin state legislature elected the country's first Republican U.S. senator, Charles Durkee of Kenosha. Two years later, the Republican Party held its first national convention in Philadelphia, and its presidential candidate, John C. Frémont, won Wisconsin with 55 percent of the vote and ten of the sixteen northern states. Governor Alexander Randall, reelected in 1859 to a two-year term, also declared himself a Republican. As the country rapidly approached the crisis over slavery and disunion, Republicans greatly outnumbered Democrats in the political landscape of Wisconsin.[11]

WISCONSIN IN 1860

In 1860, Wisconsin had been a state for twelve years. Most of the state's 775,000 people lived along Lake Michigan and in the southern counties. Milwaukee, known as the "Cream City" because of the light-colored brick used in many of its buildings, was the largest city in the state with more than 45,000 people. Initially settled by French-Canadian fur traders in 1795, Milwaukee was located on the shore of Lake Michigan at the confluence of three rivers: the Milwaukee, the Menomonee and the Kinnickinnic. Milwaukee grew rapidly. Because the public lands office was located there, it became the favored landing place for settlers. When it was incorporated in 1846, it equaled Chicago in size.[12]

The population of Wisconsin was a varied one. A little more than a third of the people living in the state were foreign born. Of these, 44 percent were from the German states. This was, by far, the largest group of immigrants, the result of a wave of German immigration that occurred between 1846 and 1854. It was due in part to the Wisconsin Commission of Emigration, which encouraged European immigrants to settle in Wisconsin between 1852 and 1855. Pamphlets were published in German, Norwegian, Dutch and English and distributed across Europe and the port cities of the East. This German migration brought industrial skills, Catholicism and liberal politics. Milwaukee became a center for machinery and metalworking industries and, because Germans liked their beer, a center for grain trading and brewing. Their importance is demonstrated by the fact that in 1860, there were twenty German-language newspapers published in Wisconsin.[13]

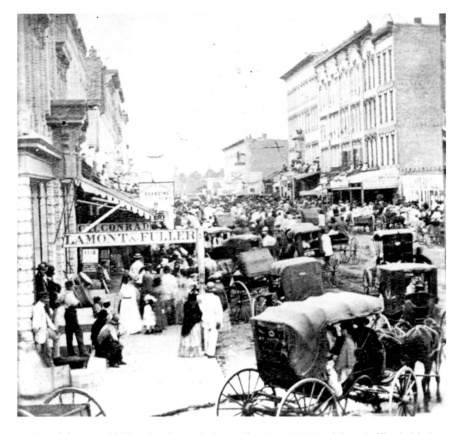

A view of Court and Milwaukee Streets in Janesville, circa 1868–71. *Wisconsin Historical Society.*

Of the remaining immigrants, the next largest groups were from Ireland and Great Britain, 50,000 and 44,000, respectively. Norway also provided large numbers of immigrants: 21,442. Many of these immigrants settled in Milwaukee County, where the foreign born outnumbered the "native" born 33,144 to 29,374.

The remaining two-thirds of the people in the state were born in the United States—about half of them in Wisconsin. The others migrated from elsewhere in the country. New York State provided 120,637, Ohio 24,000 and Pennsylvania 21,043. New Englanders were also numerous, numbering 54,000. Southerners, in contrast, made up less than 1 percent of the population.

This diverse population of East Coast Yankees and immigrants from central and northern Europe reacted differently to the reform movements

of the first half of the century—particularly to the question of slavery and abolition.

The antislavery movement in Wisconsin was made up mainly of former Yankees and the so-called "Forty-Eighters," liberal reformers who had fled Europe after the failure of the 1848 revolutions. Carl Schurz was Wisconsin's best known Forty-Eighter. Many German and Irish immigrants in Wisconsin feared emancipation, however, thinking it would flood the North with cheap labor that would compete for jobs.

The "free colored" population was small in Wisconsin, numbering only 1,171. Of these, 737 were classified as "mulattoes." Most lived in Milwaukee and Racine Counties. Racine County was where Joshua Glover was living when captured.[14]

The federal census only counted Native Americans living in the general population. It did not include Native Americans on reservations, although it estimated their numbers. In 1860, there were 1,017 Native Americans living in Wisconsin; 613 were enumerated as "Indian," while 404 were defined as "half-breed." The estimate of Native American population "retaining their tribal character" was 2,833. This totals about 4,000 Native Americans living in Wisconsin at the beginning of the Civil War.[15]

The living conditions on the reservations in Wisconsin varied, but generally they were not good. The Menominee, who had the distinction of being the oldest known continuous residents in Wisconsin and who still lived in their ancestral lands, had a reservation northwest of Green Bay. A report from the commissioner of Indian affairs noted that the reservation was "not well adapted for agricultural pursuits." The land was heavily timbered and needed clearing in order to be farmed. This had been done "to some extent." Eventually, the tribe survived by using its most abundant resource, trees, and created a successful logging business.[16]

In 1856, the Menominee ceded land in the southwest corner of their reservation to the Stockbridge and Munsee tribes, who were originally from the upper Hudson River Valley. Although the Stockbridge and Munsee spoke an Algonkian language similar to those of the Chippewa, Menominee and Potawatomi, by 1860, they were English-speaking tribes. A commissioner's report noted that the tribe members "justly complain that the lands given to them are poor and barren, and unfit for their use." Crop failures "discouraged them very much" and resulted in a desire to "sell and remove to some more genial climate."[17] Only half of the tribe members lived on the reservation. The rest were scattered among local farms and worked as laborers.[18]

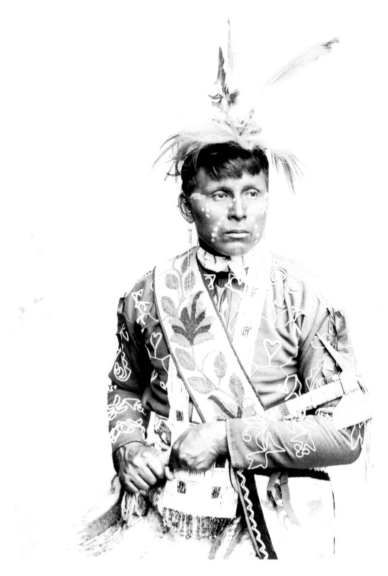

A postwar photo of Chach-scheb-nee-nick-ah, or Young Eagle, a Winnebago man, holding a tomahawk. Taken in Kilbourn City, Wisconsin. *Library of Congress.*

The Oneida, who were originally part of the Iroquois Confederation in upstate New York, had a reservation near Green Bay. It included "an abundance of good land" but was used "to a very limited extent" by the tribe. The crop yield in 1860 was good, however, and "furnished them a sufficient subsistence."[19]

In the far north, the Chippewa of Lake Superior lived in seven reservations in three states: two in Minnesota, one in the Upper Peninsula of Michigan and four in Wisconsin. Clark W. Thompson, superintendent of Indian affairs, wrote that the Chippewa of Lake Superior were "very much scattered, and give the whites some trouble on the frontier" because "their wants" had been neglected.[20] The agent of the Red Cliff Agency, C.K. Drew, worried about their future and envisioned putting all of the Chippewa together on one or more of the Apostle Islands to more efficiently "advance their interest" and protect them from "the grasping avarice of the white man."

There was also an "Agency for the Winnebagoes, Potawatomies, etc., in Wisconsin." These tribes were "wandering bands, having no settled homes" in the northwestern counties of the state. They had refused to move west with their tribes and subsequently eked out "a precarious subsistence by hunting, fishing, gathering berries in their season, and by begging." In 1865, there were an estimated 1,500. It is unknown how many there were in 1860. Eventually, the Potawatomi established a reservation at Mole Lake in northeastern Wisconsin, and the Winnebago secured tribal lands near present-day Wisconsin Dells, Tomah and Black River Falls.[21]

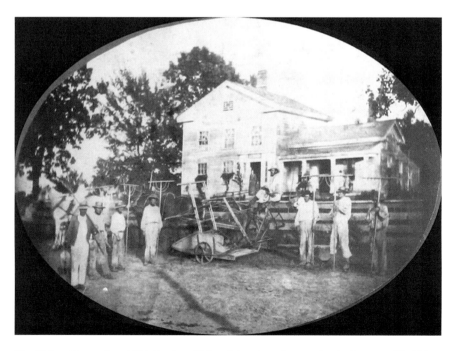

The Pickett Farm, circa 1860. In the middle of the photo is a mechanical reaper. *The Pickett Community Center.*

The vast forests in the northern part of the state gave birth to a thriving lumber industry. In the southwestern part of the state, lead mines had brought early wealth to the state. Unfortunately, production peaked in 1847 and had declined since then.

Far from the wilds of northern Wisconsin, the southeastern half of the state benefited from some of the richest soil in the country. The use of the McCormick reaper enabled Wisconsin to become part of the "wheat belt," ranking second in wheat production nationally. The 1860 census characterized Michigan, Wisconsin, Iowa and "the States of the Northwest" as "the granary of Europe" because they were "the chief source of supply in seasons of scarcity for the suffering millions of another continent." The importance of agriculture is demonstrated by the fact that of the 233,523 people listed by occupation in the 1860 census for Wisconsin, 125,000 were identified as farmers or farm laborers.[22]

THE ELECTION OF 1860 AND THE SECESSION CRISIS

The election of 1860 brought the crises of slavery and secession to a head. Wisconsin, instrumental in forming the Republican Party in 1854, was a wellspring of Republican support. In the election of November 4, 1860, Republicans carried the state by more than twenty thousand votes. Forty-six of the state's fifty-eight counties had Republican majorities, and Wisconsin Republicans increased their hold on the state legislature. Milwaukee and Brown Counties, which includes Green Bay, were Democratic strongholds and went for Douglas.[23]

In the end, the split of the Democratic Party between northern and southern factions doomed them. Abraham Lincoln was elected president. After the election, southern "fire-eaters" called for special state conventions to consider secession from the Union. South Carolina was the first state to hold a convention and passed a unanimous resolution of secession on December 20, 1860. Mississippi seceded on January 9, and within a month, five more states—Florida, Alabama, Georgia, Louisiana and Texas—had followed.

On January 10, 1861, Governor Randall addressed a joint session of the Wisconsin legislature stating that Lincoln's election was constitutional and he must be recognized as the president. Randall also strongly declared his opposition to both slavery and secession. He had long held the view

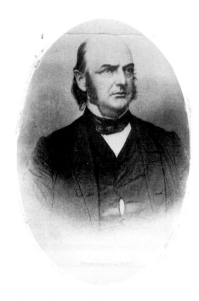

Alexander Randall, the first war governor of Wisconsin. *Wisconsin Veteran's Museum.*

that secession was unconstitutional. In an address in January 1859, he had said Wisconsin would "never consent to a disunion of states."[24]

In the 1861 address, Randall argued, "When the government was made, it was intended to be permanent, and no plan or device was suggested or conceived whereby it could be destroyed." The right of a state to secede from the Union "can never be admitted," he asserted, and as long as any state assumed a position "foreign, independent, and hostile to the government, there can be no reconciliation." The government, he said, "must be sustained, the laws shall be enforced! Secession is revolution; revolution is war; war against the government of the United States is treason."[25]

Given that none of the northern states was adequately prepared for the war that was to come, Wisconsin was, perhaps, no worse than most. Governor Randall had pushed the adjutant general to increase the readiness of the state militia and ready plans if the federal government called on the state to furnish troops.[26]

In 1860, James A. Swain, Wisconsin's adjutant general, reported that there were fifty-two organized volunteer companies totaling 1,993 men. However, because many of the companies were late or failed to make their annual reports, Swain found it "impossible to report to the Legislature the correct condition of the organized militia." The 1860 census listed 159,335 men in Wisconsin between the "military ages" of eighteen and forty-five. Wisconsin and the other "newly settled States of the west" had a larger proportion of men of military age than the eastern states because, as the census observed, "emigrating ages are allied to the military ages." In other words, men of military age tended to move from the East to the West, bolstering the West's numbers of military-age men.[27]

Senator Durkee, writing to his brother in New York, saw that "a dark cloud is fast gathering over our beloved country; this beautiful land of our is about to pass through such a terrible, such a scorching and devastating ordeal, as history has nowhere furnished a parallel." He was right.[28]

3

The Crisis of the Union

The Call to War

News of the firing on Fort Sumter reached Wisconsin on April 13, 1861. The response was electric. In Kenosha, the *Weekly Telegraph* reported that the news created an excitement "never equaled" and that "treason and rebellion must be met and crushed at once." "The Secessionists have precipitated the war," the newspaper charged, "and they will be held responsible for the consequences before the civilized world."[29]

While many Democrats in Wisconsin supported President Lincoln and the use of force after Fort Sumter, not all did. Beriah Brown, the Democratic editor of the *Daily Milwaukee Press and News*, foreshadowed the partisan divide that was to grow in the coming months and years. He argued that the northern people were "made the victims" of an "unreasoning" element in the Republican Party that demanded war and that the Lincoln administration "inaugurates war to save the party from dissolution."[30]

On April 15, 1861, President Lincoln called for seventy-five thousand state militiamen to serve for three months. Wisconsin was asked to provide one regiment. The following day, Governor Randall issued a proclamation offering "opportunities" to all existing militia companies for enlistment. Although Randall and others had tried to ready their state forces before the war, they were ill-prepared. William Utley, the Wisconsin adjutant general, whose job it was to prepare Wisconsin's militia in 1861, wrote, "It would be

impossible to imagine a more defenseless state of things than existed in the free States at the breaking out of this rebellion."[31]

Not only was there the question of raising the men to form the required regiment, but there was also the question of who was to lead them. Utley appreciated the necessity of a "thorough knowledge of military tactics" but was "unwilling to believe" it was necessary that a man should have graduated from a military school in order to lead the soldiers. "Some of the most useless, impracticable creatures in the army," he noted, "are graduates at West Point." A military education was a great value to a person with a "sound practical mind," he thought, but was "of no great use to a vain, conceited coxcomb."[32] He believed that to "bring out the best portion of our citizens as volunteers," it was necessary for an "influential citizen," who had the confidence of the community, to "call upon his neighbors to rally under his banner." In this way, a company would be raised "within a small circle" and would "stand by each other as neighbors and friends." The experience of the next four years would largely prove him correct.

Within days of Randall's call, militia companies from across the state offered their services. The *Kenosha Telegraph* reported, "All over the North and West the utmost enthusiasm prevails," and that volunteering was "going on everywhere." The most difficult question, the editor thought, was which of the many companies offered would be accepted."[33]

Because the militia system drew from all classes of society, Utley felt it "formed an army of intelligence such as was never before seen upon the earth." In the ranks, he argued, you could find men "competent to perform any act known in mechanism or art."

Within ten days of Randall's call for volunteers, he had enough for five regiments. Illinois, with slightly more than double the population of Wisconsin, was asked to supply six regiments by the War Department. Wisconsin was only asked for one. This caused Governor Randall "extreme dissatisfaction." He felt it was "disproportionate" and unfair. Randall wanted seven regiments to be fully trained and equipped, with the emphasis on trained. "The men sent to war should be soldiers when they go," he warned, otherwise, "there will be few of them living soldiers when it is time for them to return."[34]

Organizing the First Wisconsin Volunteer Infantry Regiment, however, demonstrated the state's lack of preparedness and resulted in "embarrassments." "There has never been an efficient military organization in this State," the governor noted, and the men who had experience "were

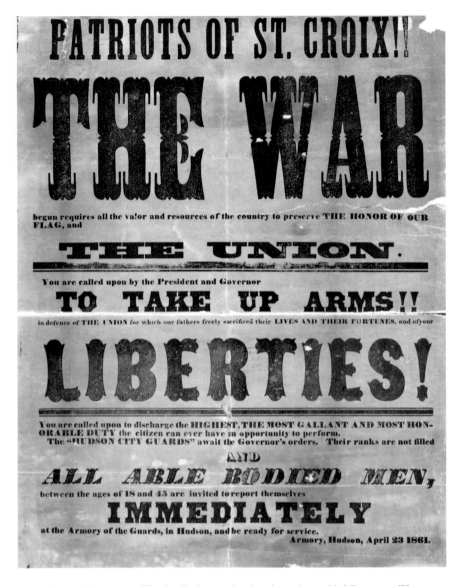

An early recruiting poster. The St. Croix was the river boundary with Minnesota. The meeting was to be held in Hudson, Wisconsin. *Wisconsin Historical Society.*

very few, or were almost entirely unknown." The proper ways to equip and train soldiers "for rugged war" were mysteries, he wrote, "the solution of which could only be found by actual experiment."[35]

Two scenes that took place in Beloit and Kenosha were repeated across the state as militia companies left for training. In Beloit, the Beloit City

Guards were assigned to be Company F of the First Wisconsin Infantry. Their departure was described in the local newspaper:

> *Never did this city witness such a spectacle as...upon the departure of the Beloit City Guards, for their rendezvous at Milwaukee. The entire population of the city, and many persons from the adjacent country, assembled to witness the embarkation of the first company from Rock County. The streets were thronged with people, and every available position in the vicinity of the depot was occupied by spectators. The rooms and platform of the depot were occupied by the relatives of the soldiers that were to leave. The time for the departure of the train having arrived, the Company was ordered aboard, and hasty words of parting were exchanged between husbands and wives, mothers and sons, sisters and brothers. The scene at this moment was most touching and solemn. Stout hearts melted, and eyes "unused to weep[ing]" were suffused with tears.*[36]

In Kenosha, the sendoff was a little more formal. On the afternoon of April 25, a large crowd, including thirty-four young women wearing colors representing all the states of the Union, assembled at a park near Lake Michigan. They were to present the Park City Grays, Kenosha's militia company, with a flag:

> *The ladies of our city made a very rich and elegant Flag for the Park City Grays. About four o'clock, the company marched into the park, which was already filled with a large concourse of citizens....The ladies and speakers took a raised platform while the exercises were opened by a very eloquent and appropriate prayer by Rev. J.T. Matthews....Mrs. F.S. Lovell presented the flag to the Park City Grays with a short, patriotic speech. The flag was received on the part of the company by Colonel Lane, in some appropriate remarks. The band then played The Star Spangled after which* [there were] *three cheers for the ladies of Kenosha.*[37]

The next day, carrying the flag ahead of them, the Park City Grays, assigned to become Company G of the First Wisconsin Infantry, marched to the railroad station and boarded a train for Milwaukee.

The ten militia companies that made up the First Wisconsin Volunteer Infantry Regiment rendezvoused at Camp Scott in Milwaukee, which was named after General Winfield Scott, general-in-chief of the U.S. Army. The

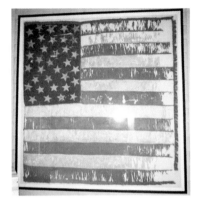

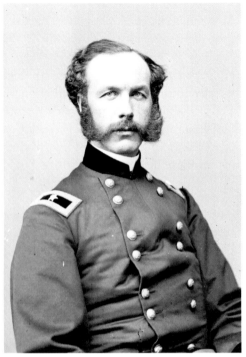

Above: The flag of Company G, First Wisconsin Infantry. Note how the blue field of stars is different in shape from modern ones. *Civil War Museum, Kenosha, Wisconsin.*

Right: Colonel John C. Starkweather, a Milwaukee militia officer who commanded the First Wisconsin Infantry. He later became a brigade commander. *Library of Congress.*

newly established "camp" on the fair grounds did not exist. There were no barracks, so the volunteers were put in public buildings, halls and hotels. When enough barracks and mess halls were built, the troops moved in. But the environment still took on a carnival-like atmosphere, with soldiers receiving "large numbers of visitors."[38]

The soldiers were also without weapons or regimental uniforms. The uniforms, if they had any, were the company militia uniforms, all different from one another. As Adjutant General Utley wrote in his year-end report, "We have had no trouble to get men; the trouble has been to sustain them, and to fit them out for the service."[39]

Wanting to get uniforms as quickly as possible, the governor and Wisconsin's quartermaster general, William T. Tredway, ordered cloth from different suppliers and had the uniforms made as quickly as possible. The militia tradition in Wisconsin, like many other states, was to have gray uniforms. As a result, the first eight Wisconsin regiments initially wore gray, the same color adopted by the Confederacy, which Randall and the other state officials were unaware of. Because the cloth for the uniforms was purchased from different companies, it had differing shades of gray, and the

coats and pants varied in color. This gave "a somewhat unique appearance when the Regiment was on parade."[40]

Although the regiment had no weapons, Colonel John C. Starkweather, the Milwaukee militia officer in command of the First Wisconsin, conscientiously drilled his men, trying to ready them for the battlefield. While still encamped in Milwaukee, the first solider died. On June 3, 1861, John Monroe, a private in Company C, went for a swim in the Milwaukee River. He reportedly stepped into a hole and drowned. He was Wisconsin's first death in the Civil War.[41]

THE FIRST WISCONSIN INFANTRY

The First Wisconsin was sworn into Federal service on May 17, 1861, and left for the East on June 9.

The regiment was assigned to Major General Robert Patterson's Department of Pennsylvania and stationed near the Potomac River north of Harpers Ferry. Prior to the advance of the main Federal army on Manassas, Virginia, by Brigadier General Irvin Mcdowell, General Patterson was ordered to cross the Potomac and advance toward the Shenandoah Valley to prevent General Joseph Johnston's forces from reinforcing the Confederate forces near Manassas.[42]

On July 2, General Patterson's force crossed the Potomac River near Williamsport, Maryland, and marched toward Martinsburg (now West Virginia). The First Wisconsin took the lead wading the Potomac; the water was above their knees. Near Hoke's Run, the Union forces encountered Colonel Thomas J. Jackson's Confederate brigade. Confederate pickets fired at the Federals, then retreated. Patterson's men, with the Wisconsin troops in the lead, advanced toward Martinsburg. After about six miles, the regiment suddenly "received a volley of musketry from the enemy, and immediately returned the fire." Other units, including the Eleventh Pennsylvania, supported the Wisconsin men, and the firing "became very general and rapid." The Confederates were strongly positioned in woods and behind houses, barns and fences.

The First Wisconsin got within three hundred yards of the Confederates. Major Lane and Captain Mitchell, caught up in the excitement of their first battle, borrowed muskets and joined the enlisted men in firing at the enemy. Captain George Bingham, of Company A (who would later

George Drake, of Milwaukee, the first Wisconsin soldier killed in action. He is buried at Antietam National Cemetery. *Milwaukee County Historical Society.*

command the regiment) stood in front of his company and "coolly pointed out to his men where and how to shoot to the best advantage." Colonel Starkweather, in his official report of the battle, wrote, "Officers and men behaved with the utmost bravery, and are entitled to great credit as raw troops."[43]

The battle, known as the Battle of Falling Waters or Hoke's Run, cost the First Wisconsin two dead, four wounded and one taken prisoner. The first man to die on the battlefield was eighteen-year-old George Drake, of Company A. He was the only son of William and Jane C. Drake of Milwaukee and had been gone from home for only three weeks and two days when he was killed. As he was loading for a second volley, a bullet hit him in the chest, near his heart.[44]

Sergeant W.M. Graham, of Company B, was mortally wounded—shot in three separate places. One bullet hit him in the right side and went through his chest. Another went through his wrist, and the third blasted through his knee. Despite these wounds and being covered in blood, he reached a fence some distance away and tried to stop the bleeding. The Confederates fired at him again. By the time his comrades reached him he had fainted. After almost two months of suffering, he died on August 26, 1861.[45]

Born in New York, Graham came to Wisconsin as a young child. At the age of twelve, he began working as a printer for the *Ozaukee Advertiser*. By the age of sixteen, he was the editor of the *Daily Wisconsin*, a Milwaukee newspaper. After enlisting in the First Wisconsin, he was quickly promoted to sergeant in Company B. He was nineteen years old.

The First Wisconsin spent the rest of its service in camps near Martinsburg and Winchester, Virginia, and in Maryland. With its three-month enlistment expiring, the First returned to Milwaukee and was mustered out of service the third week of August 1861. Many of the men reenlisted in the regiment for the new term of three years that was required for all new regiments. They were to see more and much harder service in the coming years.[46]

CAMP RANDALL

Although the ranks of the First Wisconsin had been filled, thousands more men had volunteered. Governor Randall, anticipating the need for more troops, called for a second infantry regiment to be organized. It was to rendezvous at the State Agricultural Society Fairgrounds in Madison. Approximately fifty-three and a half acres in size, the camp was a mile west of the city.[47]

In the spring of 1861, however, like Camp Scott in Milwaukee, the training camp had to be built. The colonel of the Second Wisconsin Infantry, S. Park Coon, named the planned training camp "Camp Randall" in honor of the governor who gave him his commission. Unlike Camp Scott in Milwaukee, the troops were not quartered in the buildings of the city. As a result, they suffered from "very inclement weather, amid almost constant storms and cold winds" and lacked "proper shelter and clothing."

Eventually, barracks were built and tents set up. A letter written by John Cronk of Company A, Sixteenth Wisconsin Infantry, which was organized

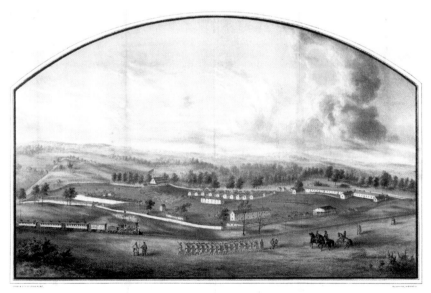

CAMP RANDALL, MADISON, WIS.
TAKEN FROM STATE UNIVERSITY

An image of Camp Randall from later in the war after wooden barracks had replaced tents. *Library of Congress.*

a half year after the Second Wisconsin, gives a good idea of the layout and living conditions at Camp Randall:

> *The campground is anything but square....On the east and southeast sides there are barracks and the guard house and a place called LL. Andrews where our sutter [sutler] keeps his shop. On the north side there is some more barracks and our old eating house....On the west side is the hospitals quarter-masters departments tents and the officers quarters.... We stay in the barracks. These barracks are shanties that was used for stabling horses and cattle at the time of the fare [sic]. They have been white washed inside and cleaned out and fixed up for men. They are quite comfortable and I think there is more room in them than there is in the tents....When we came down here we had our victuals cooked for but now we draw our rations and cook them ourselves. We have bread, beef, pork, potatoes, rice, sugar, beans, syrup and butter four or five times per week. We have built an eating house by ourselves. We have plenty of food here some times and not much at others. There is considerable sickness here at present with measles, sore throat and bad colds.*[48]

Eventually, more than seventy thousand men would be trained at Camp Randall, securing it a place in Wisconsin history. It also hosted Confederate prisoners of war, some of whom never made it back to their homes.

THE SECOND WISCONSIN INFANTRY

The Second Wisconsin Infantry was organized in May 1862 at Camp Randall and mustered into Federal service on June 11, 1861, for "three years or during the war." It left the state for the East on June 20. Like most of Wisconsin's regiments, the Second Wisconsin drew recruits from across the populated southern half of the state. Nine counties were represented in the ten companies that gathered at Camp Randall. S. Park Coon, a former Wisconsin attorney general, was named the colonel. Henry W. Peck, a graduate of West Point, was made lieutenant colonel. It was expected that his military experience would compensate for Coon's lack of it.[49]

Arriving in Arlington Heights, Virginia, the regiment was brigaded with the Thirteenth, Sixty-Ninth and Seventy-Ninth New York infantry regiments and Company E, Third U.S. Artillery, all commanded by Colonel

William T. Sherman. Sherman quickly decided that Coon's lack of military knowledge was a liability and removed him of command by appointing him to his staff. Colonel Coon resigned on July 30, and Henry Peck commanded the regiment during its first battle.[50]

Near the end of July 1861, the Union army began its long-awaited advance on the Southern capital of Richmond. The Second Wisconsin Infantry took part in the Federal advance on Manassas and fought in the First Battle of Bull Run on July 21, 1861. During the battle, Sherman's brigade attacked Henry Hill. Colonel Sherman observed the Second's attack. "This regiment ascended to the brow of the hill steadily," he wrote, "received the severe fire of the enemy, returned it with spirit, and advanced delivering its fire." Thomas S. Allen, captain of Company I, wrote:

> *The crest of the hill in front of us, upon which the rebels had massed their infantry and artillery, was of a semi-circular form, so that when our regiment pushed on to the summit…no command could be heard along the whole line, nor was more than half the regiment visible at the same time. As we mounted the crest we were met by distinctive volleys of musketry, which were promptly returned, but it was impossible to push our line forward against the evidently superior forces massed in our front.*[51]

The regiment advanced to a Confederate battery and let loose "a murderous fire" on it. But the position occupied by the Confederates "was alive with men, and a stream of fire poured from their whole line." The Second "stood this fire for some minutes, returning it steadily, and with terrible effect," but then fell back, "firing all the time."[52]

As the Second began to slowly withdraw, it was fired on by other Federal troops. The gray-clad Second soldiers were mistaken for Confederates. The regiment was fired on from both front and rear. A short while later, the regiment was again ordered to attack the hill. Sherman noted, "The regiment rallied again, passed the brow of the hill a second time, but was again repulsed in disorder. [T]here was one battery of artillery, which poured an incessant fire upon our advancing columns, and the ground was very irregular.…The fire of rifles and musketry was very severe."[53]

About this time, the Union regiments in the rear fired a volley into the Second Wisconsin Infantry again. Lieutenant Colonel Peck appeared in the rear of the regiment and gave an order: "Fall back to re-form!" It was then that the "confusion" began, according to Captain Allen, "owing to the mixture of men of the different companies it was impossible to maintain

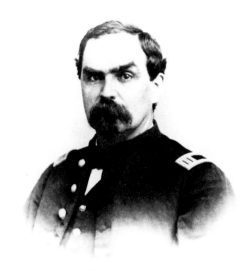

Aaron A. Meredith of Madison enlisted in the Second Wisconsin Infantry on May 1, 1861, and was promoted to first lieutenant on May 9, 1861. Wounded at First Bull Run, he was promoted to captain on June 11, 1862, and brevet major on September 21, 1865. He was mustered out on October 9, 1865. *Civil War Museum, Kenosha, Wisconsin.*

order or discipline. The result was that the whole regiment fell back across the turnpike, where there was a rally around the colors and a movement with nobody in command toward the ford by which we had crossed."[54]

The Second Wisconsin Infantry was fired on by Federal troops at least twice. There was also a report of Confederates using a Federal flag to fool the Second into thinking that they were firing at Union soldiers and then firing into the Second. There was much confusion in this battle for the Second Wisconsin Infantry. This extends to its casualties. There was never an official report published of the casualties for the Second Wisconsin Infantry at First Bull Run. Historians have calculated the casualties variously at 19 to 30 men killed; 65 to 105 wounded, some of whom died of their wounds; and 63 to 69 taken prisoner or missing. This comes out to 150 to 200 casualties—almost 25 percent of the more than 800 men in the regiment. This is a large number of men to lose in a single battle. Given that it was shot at by both sides, the Second Wisconsin Infantry acquitted itself well.[55]

First Bull Run would only be the first in a series of costly battles for the Second Wisconsin Infantry, which, when brigaded with other regiments from Wisconsin, Indiana and Michigan, would earn a distinction that no regiment would seek: suffering the highest percentage of battle deaths by any regiment in the Union army.[56]

After Bull Run, the North knew it had a real war on its hands. Governor Randall's foresight in organizing regiments paid off. By the end of 1861,

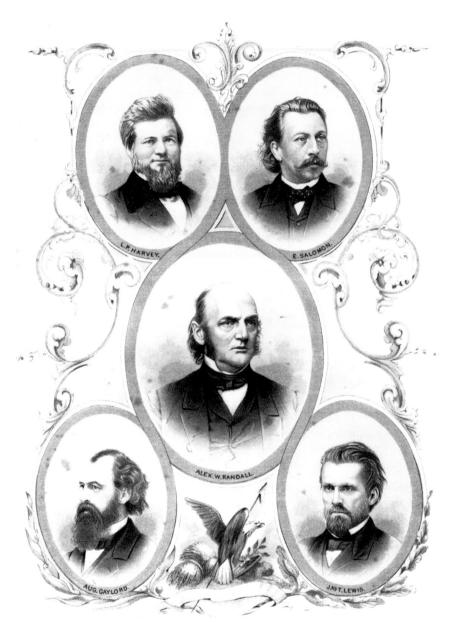

The four war governors: Harvey, Salomon, Randall and Lewis. Augustus Gaylord (*lower left*) was the adjutant general of Wisconsin for most of the war and was the most responsible for Wisconsin's contributions during the war. *From Quiner,* The Military History of Wisconsin.

Wisconsin had mustered thirteen infantry regiments, a cavalry regiment, seven batteries of light artillery and a battery of heavy artillery. Many more were in the pipeline. The people of Wisconsin, like the rest of the nation, knew they were about to enter a potentially bloody and destructive time.[57]

Although governors played important roles in Wisconsin's war effort during the Civil War, perhaps the single most important figure was Adjutant General Augustus Gaylord. Appointed by Governor Louis Harvey on January 7, 1862, and given the rank of brigadier general, he was responsible for Wisconsin's military contribution to the war more than anyone. Born in Connecticut, Gaylord moved to St. Croix Falls, Wisconsin, a logging town in northwest Wisconsin, in 1857, and opened a general store. He became involved in politics, and when Louis P. Harvey was elected secretary of state in 1860, Harvey hired Gaylord to be his clerk. After Harvey became governor in January 1862, he appointed Gaylord adjutant general and consolidated all military affairs in his office. Each subsequent war governor kept Gaylord at his post. His duties included recruiting, training and equipping Wisconsin's soldiers; appointing officers; and managing the transportation of regiments. He served until May 1, 1866, when he resigned and returned to private life.[58]

ON SOURCES AND NUMBERS

One would think the number of soldiers lost by a regiment in a particular battle or during the war would be settled. This is not the case. Most authoritative sources often give contradictory numbers. In terms of Wisconsin, the main sources used to determine the numbers for regiments' strength and casualties are E.B. Quiner's *Military History of Wisconsin* and William DeLoss Love's *Wisconsin in the War of the Rebellion*, both published in 1866, and Charles E. Estabrook's *Wisconsin Losses in the Civil War*, published in 1915. The *Roster of Wisconsin Volunteers*, published in 1886, is crucial for checking individuals' service records, but it does not provide summary numbers for regiments.

General works that look at Wisconsin's regiments in detail are William F. Fox's *Regimental Losses in the American Civil War*, published in 1889; Frederick H. Dyer's *Compendium of the War of the Rebellion*, published in 1908; and *The Union Army: A History of Military Affairs in the Loyal States, 1861–65*, also published in 1908. The fourth volume contains information about Wisconsin regiments.

Quiner's and Love's books, published immediately after the war, are invaluable for accounts of the service of regiments but are probably the least accurate in terms of numbers. The books published years or decades later, such as Estabrook's or Fox's, are the result of "many years study and tabulation" of "all reliable and available sources" and would seem the most reliable. *The Union Army*'s numbers are suspect because they are the same as Quiner's. Usually, Fox's numbers agree with Dyer's. Either Dyer looked at the same information as Fox or simply took his numbers. Estabrook's *Wisconsin Losses*, the last to be written and published by the State of Wisconsin, often disagrees with Fox and Dyer. Usually, Estabrook's numbers are lower. It seems the choice is between Estabrook and Fox/Dyer. Generally, I have chosen to use Estabrook's numbers, as it was published the most recently and by the authority of the state.

The numbers given in this book, or in any history, must not be considered definitive. The inability to know the final fate of every soldier, whether through insufficient recordkeeping or human error, makes 100 percent reliable numbers impossible.

4

THE BATTLEFRONTS

East

The more they serve the less they look like soldiers and the more they resemble day-laborers who have bought second-hand military clothes. I have so come to associate good troops with dusty, faded suits, that I look with suspicion on anyone who has a stray bit of lace or martial finery.
—*Colonel Theodore Lyman, aide-de-camp to Major General George G. Meade*

Aside from the Iron Brigade regiments, seven other Wisconsin infantry regiments served in the East. Two of them, the Third and the Twenty-Sixth Wisconsin Infantries, are unique in that they served in the East and were then transferred to the West. The Third Wisconsin Infantry was organized in Fond du Lac, Wisconsin. Its sergeant major, Edwin E. Bryant, observed, "The regiment could find in its ranks men adapted to any service from running or repairing a locomotive to butchering an ox." Although Colonel Charles S. Hamilton was placed in command, the officer most responsible for turning the civilians into soldiers was twenty-eight-year-old Lieutenant Colonel Thomas H. Ruger. Ruger, a lawyer from Janesville, had graduated third in his West Point class of 1854. After a brief stint in the U.S. Corps of Engineers, Ruger resigned and returned home to study law. The regiment was fortunate because five of its company commanders had served in the Mexican War.[59]

The Third Wisconsin Infantry was assigned to Major General Robert Patterson's army in the Shenandoah Valley and took part in the fighting at Winchester, Virginia, on May 2, 1862, and Cedar Mountain, Virginia,

on August 9, 1862. It lost almost two hundred men. Colonel George H. Gordon, the regiment's brigade commander, said after the Battle of Cedar Mountain, "I know of no other regiment in Banks' entire corps [that] stood so unflinchingly before numbers and fire[d] so overwhelming."[60]

After its service in the Shenandoah Valley, the Third Wisconsin Infantry was in the Battle of Antietam. Fighting in the Miller cornfield near the Iron Brigade, the Third Wisconsin lost almost 60 percent of its men. The regiment took 340 officers and men into the battle and lost 198. Of 12 officers with the regiment during the battle, only 4 escaped death or wounds. Most were severely wounded. Brigadier General George Gordon wrote that "from sunrise to sunset ever under fire, at times very severely, never free from musketry or artillery, officers and men behaved with most praiseworthy intrepidity and coolness." Shortly after Antietam, Ruger was promoted to brigadier general and replaced Gordon as commander of the Third Brigade. Captain William Hawley of Company H replaced Ruger as commander of the regiment. On May 1–3, 1863, the Third Wisconsin Infantry took part in the Battle of Chancellorsville, losing 21 men killed and 80 wounded. The Battle of Chancellorsville was the baptism by fire for another Wisconsin regiment, the Twenty-Sixth Wisconsin Infantry.[61]

Approximately 25 percent of the Union army was foreign born, and Germans accounted for one-tenth of it. The Twenty-Sixth Wisconsin Infantry was named the "Sigel Regiment" after German American general Franz Sigel. With the exception of Company G, the entire regiment was composed of Germans by birth or parentage.

Attached to O.O. Howard's Eleventh Army Corps in the Army of the Potomac, the regiment found itself the victim of Jackson's surprise attack at Chancellorsville on May 2, 1863. Overwhelmed, outflanked and in a crossfire, the regiment, under Colonel William Jacobs, refused to fall back until ordered to do so twice.[62]

One member of the regiment was twenty-one-year-old Charles Wickesberg, a carpenter from Sheboygan who enlisted on August 15, 1862, because of a broken love affair. He had come to America as a child with his family. He wrote to his family after Chancellorsville strongly objecting to reports of his regiment's cowardice:

> The Christliche Beobachter *writes that Schurtz's division and the whole 11th Corps in general ran away in wild flight even before the enemy had fired one shot. That is not true. Our regiment was in front and was attacked first. We stood firm. And first receded after we saw the superior*

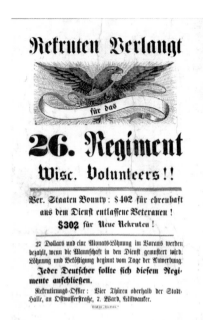
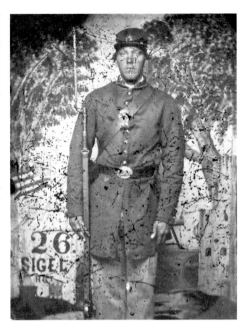

Left: A recruiting poster for the Twenty-Sixth Infantry. As this poster indicates, the Twenty-Sixth was made up mainly of German-speaking men. The highlighted numbers $302 and $402 refer to bounties. *Wisconsin Historical Society*.

Right: Charles Wickesberg of Sheboygan enlisted in Company H, Twenty-Sixth Wisconsin Infantry. He was wounded at Gettysburg and died of wounds received at Resaca, Georgia, on May 15, 1864. His transcribed letters are in the Civil War Museum in Kenosha, Wisconsin. *Wisconsin Veteran's Museum*.

> *force of the enemy and were ordered to recede. We fired about 8 or 10 shots....And there they say we ran away out of our trenches. I would have liked to see some trenches. We were standing in front of a bush. About 70 steps and no cannons or anything else with us. Now, all of a sudden the enemy comes. Some of us are boiling coffee, some are sleeping....And the bullets come flying right in our midst. But like lightning we were in battle formation. And stood there coldbloodedly and shot at the Rebs. It was all General Howard's fault.*[63]

The Twenty-Sixth Wisconsin Infantry lost more than 180 men. Two months later, at Gettysburg, this time under Lieutenant Colonel Hans Boebel, the regiment suffered similar bad luck. Wickesberg wrote to his parents, brothers and sisters:

The reason that I am in the hospital is that I was wounded on my right arm—my wrist. It is a light wound and the bone is not hurt. We were wet as cats, hungry as wolves—our thirst was satisfied by the good citizens when we ran in full gallop through their town. The small town where the battle was fought is called Gettysburg…

When we, the 11th Corps, joined the battle, the First Army Corps was in line of fire already.…The enemy was too strong for us and we had to yield. The bullets came as thick as hail. That is where I got my bullet too. When we came back and a woman saw my bloody hand, she called me into the house, washed my wound and bandaged it. And then I had to stay for dinner yet, which did me a world of good. In the meantime, the cannonballs were flying in to the town. Our regiment was completely annihilated.[64]

The regiment lost more than 230 men. The Third Wisconsin was luckier. It saw limited action at Gettysburg. After the battle, however, it was sent to New York City on July 13, 1863, to help quell draft riots, camping in City Hall Park until September 5, 1863, when it returned to Virginia.

In September 1863, the Third Wisconsin Infantry and the Twenty-Sixth Wisconsin Infantry were transferred to Chattanooga, Tennessee, which was under siege. Wickesberg wrote, "The whole army was on half rations. And then the things we got were rotten yet. The crackers, for instance, had worms in them. And we did not have anything else except that lousy stuff and a little coffee with it, and a little bacon. But everyone who had only a penny left bought himself some bread for it. Because there are bakeries here."[65]

In December, the War Department called for the reenlistment of the three-year volunteer regiments. All 27 officers and 240 out of the 314 men in the Third Wisconsin Infantry reenlisted. The Twenty-Sixth Wisconsin Infantry, having formed in 1862, did not have to reenlist. In the reorganization of the army for Major General Sherman's advance on Atlanta, the Third and Twenty-Sixth Wisconsin Infantries were assigned to the Tenth Army Corps, commanded by Major General Joseph Hooker.

When the campaign began, the Twenty-Sixth Wisconsin had a strength of 417 men; the Third Wisconsin, its ranks swelled by 300 recruits, had nearly 600. On May 13–15, 1864, the Third Wisconsin Infantry took part in the Battles of New Hope Church and Peachtree Creek. On May 15, 1864, the Twenty-Sixth Wisconsin took part in the Battle of Resaca and lost 44 men. One of them was Sergeant Charles Wickesberg. Promoted to corporal on March 15, 1863, he was promoted again to sergeant on January 1, 1864, after recovering from his wounding at Gettysburg. Wounded

at Resaca, Georgia, he died the next day, May 16, 1864. Wickesberg's uncle received a letter from Charles's company commander enclosing a death certificate and the comment that "your nephew owes 6 dollars to a sergeant of my company. He had lent it to him for the purchase of a watch. He would be very grateful to you if you could send him this sum. Sergeant Nytes of Sheboygan is in possession of the watch and will deliver it to you." The family received a death notice and request for payment of debt all in one.[66]

By the time Atlanta fell on September 2, 1864, the Third Wisconsin Infantry had lost almost 200 men killed, wounded and missing. The Twenty-Sixth Wisconsin Infantry fought throughout the campaign, at Dallas, Kennesaw Mountain and Peach Tree Creek, losing another 100 men. Afterward, the Third and the Twenty-Sixth Wisconsin Infantries took part in the March to the Sea and the Carolinas campaign, ending with the surrender of the Confederate forces under General Johnston on April 26, 1865. The Third Wisconsin Infantry participated in the Grand Review at Washington, was transferred to Louisville, Kentucky, and then returned to Madison, Wisconsin, where it was disbanded on July 23, 1865. Of the original 978 "Boys of '61," only 194 were in the last formation; 154, in the regiment, had been killed in action or died of wounds, and another 105 died of disease. In the Twenty-Sixth Wisconsin Infantry, 1,089 men had served and 254 had died, more than 23 percent.[67]

Five other Wisconsin infantry regiments, three batteries of light artillery and a company of sharpshooters served exclusively in the East. The Fifth Wisconsin Infantry was an early 1861 regiment that was sent east. It was commanded by Colonel Amasa Cobb, the speaker of the state assembly from Mineral Point. The regiment was assigned to the defenses of Washington, D.C. In March 1862, it took part in the Peninsular campaign, where it was dubbed the "Bloody Fifth" by its brigade commander Brigadier General Winfield Scott Hancock after the battle at Williamsburg. James Anderson, a tall, fair-haired Glasgow, Scotland native from Manitowoc, wrote, "Our boys fought like devils and have earned a name for themselves and their state. I do not think there was another regiment on the field [that] fought so desperate as ours." Two days after the battle, on May 7, 1862, Major General George B. McClellan addressed the regiment: "My lads, I have come to thank you for the bravery and discipline which you displayed the other day. On that day, you won laurels of which you may well be proud— not only you, but the army, the state and the country to which you belong." The regiment lost fifteen killed or died of wounds and sixty wounded.[68]

On December 25, 1862, Colonel Cobb resigned after being elected to the U.S. House of Representatives in November. Thomas S. Allen was made colonel. The losses of the regiment were beginning to take a toll. "We have none of our original field officers left," complained one of James Anderson's friends in January 1863, and "there are so many of the old hands leaving and new recruits coming in that it scarcely seems like the same regiment."

In February 1863, the "Light Division" was organized in the Sixth Corps. The Light Division was formed to provide a fast-moving unit that could make rapid marches not slowed down by cumbersome supply wagons. All rations and ammunition were carried by pack mules.[69] The Fifth Wisconsin Infantry was assigned to it. In April 1863, the Light Division crossed the Rappahannock River and occupied Fredericksburg, in front of the Confederate-occupied Marye's Heights, the scene of the December 13, 1862 debacle at which Major General Ambrose Burnside lost five thousand men. On May 3, 1863, the Light Division was ordered to take Marye's Heights. The men felt it was a suicidal attack. Colonel Allen addressed his men, "Boys! You see those heights! You have got to take them! You think you cannot do it; but you can! You will do it! When the order 'Forward' is given, you will start at double quick—You will not fire a gun—you will not stop until you get the order to halt! You will never get that order." Ordered to attack with bayonets only, the Wisconsin men loaded their guns anyway. As they charged, a deadly fire met them one hundred yards from the stone wall. They rushed on, climbing over the wall and into the enemy's fortifications at the top. "Our Boys dashed forward furiously," Anderson later wrote, "bayonet[ing] many of the Rebels where they stood and taking nearly all the rest prisoners." Anderson told his family that Lewis La Count, one of his best friends, "was shot down by my side and cried out for me to help him back but I told him I could not then but would come back after we had carried the Heights." Anderson returned but could not find La Count. Instead, he helped other wounded soldiers to a field hospital. In the attack, the Fifth Wisconsin Infantry lost about one-third of the four hundred men in the regiment.[70]

During the winter of 1863–64, 204 veterans reenlisted. The reenlisted veterans went home on their thirty-day furlough and returned in time for Grant's 1864 Overland campaign in Virginia. As part of the Sixth Corps, the Fifth Wisconsin Infantry lost 200 men at the Wilderness, Spotsylvania and Cold Harbor in May and June.

On the muster out of the regiment that August, Governor James T. Lewis authorized its reorganization and recommissioned Colonel Allen. Seven

A carte de visite of an unidentified Civil War drummer boy holding drumsticks and seated on a drum. His youth is shocking. *Wisconsin Veteran's Museum.*

companies were recruited and left the state on October 2, 1864, to join those who had reenlisted in Virginia. On December 1, 1864, Colonel Allen was put in command of the brigade. Spending the winter in the trenches before Petersburg, the Fifth Wisconsin Infantry took part in the April 2, 1865 assault on Petersburg and lost another eighty men. Reportedly, "the colors of the Fifth were the first planted on the enemy's works, that regiment being the first to enter the captured works of Petersburg."

On April 3, 1865, the regiment joined the pursuit of Lee. The Sixth Corps encountered Ewell's forces at Little Sailors' Creek on April 7, 1865, and the Fifth lost almost another one hundred men killed and wounded.

During its service, the regiment lost 179 enlisted men killed and mortally wounded and 129 enlisted men by disease, accident, or missing, for a total of 308. Of the 96 Manitowoc volunteers who left with James Anderson in 1861, only 15 returned home with him.[71]

Three Wisconsin light artillery batteries served in the East. The Second Wisconsin Light Artillery was stationed in coastal Virginia at Fortress Monroe, Suffolk, Williamsburg and Yorktown, eventually moving to Point Lookout, Maryland, in 1864 to guard Confederate prisoners.

The Fourth Wisconsin Light Artillery was recruited by Captain Vallee of Beloit and attached to Fortress Monroe, Virginia. The Fourth manned the gun "Union," a twelve-inch Rodman rifled gun, and reportedly took shots at the CSS *Virginia* during the Battle of Hampton Roads. During the summer of 1862, it took part in Keyes's Expedition on the Peninsula and did garrison duty in Virginia and North Carolina until it was attached to the Eighteenth Army Corps, Army of the James. It took part in Butler's operations on the south side of the James River against Petersburg and Richmond at Bermuda Hundred in May 1864. One man was wounded.[72]

On September 29, 1864, the battery moved to Richmond "in full view of the city and under the uninterrupted fire of the enemy." The right section under Lieutenant D.L. Noggle approached to within eight hundred yards of the main Confederate defense line and engaged it. Lieutenant Noggle elevated his guns and fired 140 shells "into the streets of Richmond." This is believed to be the only time artillery was fired into Richmond during the war.

On October 7, 1864, at Darbytown Road, the battery was attacked "on both flanks at the same time" and lost four cannons and caissons, forty-five horses and four men wounded (one mortally) and one missing. In his report, Lieutenant Noggle wrote, "The men all behaved well; I could not ask for better soldiers." The battery took part in the Siege of Petersburg and the occupation of Richmond. During its service, twenty-four men of the battery died. Two were killed in action, twenty-one men succumbed to disease and one died by accident.[73]

The other Wisconsin battery in the East was the Eleventh Wisconsin Light Artillery, which, interestingly, was mustered into service as Battery L of the First Illinois Light Artillery. When the Seventeenth Wisconsin Infantry was organized in 1862, eleven companies had been recruited. The Oconto Irish Guards, recruited by Captain McAfee of Oconto, wanted to become artillery, so they were transferred to the Irish Brigade organizing at Camp Douglas in Chicago. It left Camp Randall in Madison on April 6, 1862, and was brought to full strength by Illinois recruits.

From February to June 1862, the Eleventh guarded prisoners at Camp Douglas. It left Camp Douglas in June 1862 and went to Harpers Ferry, Virginia, where it guarded the line of the Baltimore & Ohio Railroad. In January 1863, it was attached to the defenses of the Upper Potomac, taking part in relief of Phillippi and Grafton, in western Virginia, on April 25–27, 1863. From June 1863 to end of war, it was stationed in West Virginia. During its service, three men of the battery died by disease.[74]

The Nineteenth Wisconsin Infantry also served in the East. It's first duty was to guard several hundred Confederate prisoners captured at Fort Donelson and Island No. 10, who were held at Camp Randall in Madison. It did this until the prisoners were sent to Chicago in May 1862. Then the Nineteenth left for Virginia, where the soldiers were employed as provost guards for Norfolk and Portsmouth. The following April, it was used to construct rifle pits and corduroy roads, often without shelter, working all day in the rain and mud. This made "sad havoc with the health of the regiment."[75]

On April 26, 1864, the regiment was ordered to join the Eighteenth Army Corps at the James River under General Benjamin Butler. At Drewry's Bluff on May 16, 1864, it lost more than 30 men killed. At Fair Oaks, Virginia (also known as Boydton Plank Road), on October 27, 1864, the Nineteenth was sent forward to charge a six-gun fort, passing over an open plain three-fourths of a mile wide and subject to fire from the fort as well as a crossfire. In crossing the open field, half of the brigade fell. The advance reached to within one hundred yards of the fort but could go no farther. For protection, the men laid down and stayed there two hours, expecting support. About 5:00 p.m., the Confederates charged and captured most of the regiment. It went into the battle with 189 officers and men and lost at least 144. Of the 91 enlisted men reported as missing, 17 were killed or died of wounds; most of the remainder were taken prisoner.

After the Battle of Fair Oaks, the remainder of the regiment—about 80 men—returned to Chapin's farm, where they were joined by others of the regiment, who had been doing provost guard duty at Norfolk. Until the fall of Richmond, it was engaged in picket duty on the front lines. Afterward, it occupied Richmond and then Fredericksburg. The regiment lost 42 men killed in action or died of wounds during its service and 114 by disease or accident.[76]

The Thirty-Sixth, Thirty-Seventh and Thirty-Eighth Wisconsin Infantry were three regiments formed in 1864 to support the final push in Virginia. The Thirty-Sixth Wisconsin Infantry was commanded by Colonel Frank A. Haskell, a Vermont native and an 1854 graduate of Dartmouth College. Prior to the war, Haskell was a lawyer in Madison and drillmaster for a militia company.

When the Civil War began, Haskell enlisted in the Sixth Wisconsin Infantry as adjutant with the rank of first lieutenant. In April 1862, he was made aide-de-camp to Brigadier General John Gibbon, who commanded the Iron Brigade. Haskell saw action during the Second Battle of Bull Run

Colonel Frank A. Haskell, a lawyer in Madison prior to the war, wrote a famous account of the Battle of Gettysburg. He was killed leading his troops at Cold Harbor on June 3, 1864. *Wisconsin Veteran's Museum.*

and Antietam campaigns. When Gibbon was promoted to command of the Second Division, I Corps, Haskell went with him. During Pickett's Charge at Gettysburg, Haskell rallied Gibbon's men after the Confederates had breached the stone wall and Gibbon had been wounded. Gibbon later wrote, "I have always thought that to him, more than to any one man, are we indebted for the repulse of Lee's assault." A few weeks after the battle, Haskell wrote an account of his experiences at Gettysburg and sent it to his brother Harrison in Portage, Wisconsin. It was later published and is considered a classic of military memoir. On February 9, 1864, Haskell was appointed colonel of the Thirty-Sixth Wisconsin Infantry. The regiment was assigned to the Army of the Potomac and took part in the 1864 Overland campaign.[77]

The Thirty-Seventh Wisconsin Infantry was mustered in between April 13 and August 24, 1864, at Camp Randall. On April 28, 1864, six companies (A–F) left the state for Washington, D.C. Two more followed a few days later. In June, the Thirty-Seventh joined the Army of the Potomac.[78]

The Thirty-Eighth Wisconsin was organized under Colonel James Bintliff, an Englishman by birth and ardent abolitionist and Republican by choice. Bintliff, a veteran of the Twenty-Second Wisconsin Infanty, was captured with much of it at Brentwood, Tennessee. He was sent to Libby Prison in Richmond and later exchanged. The Thirty-Eighth left Wisconsin by detachments. Companies A, B, C and D left in May 1864 and went directly to Virginia.

On the morning of June 3, 1864, the Thirty-Sixth Wisconsin Infantry took part in the assault at Cold Harbor. The brigade commander, Colonel McKean, was killed, and Colonel Haskell took command. He ordered the brigade forward. "The men arose to obey and were met by a shower of bullets. The other parts of the line halted under the tremendous fire." Colonel Haskell gave the order for the men to lay down, and he was hit in the head by a bullet and instantly killed. The regiment had heavy losses that day. The Thirty-Sixth also suffered in an assault on Petersburg, Virginia, on June 16, 1864.

The Thirty-Eighth Wisconsin Infantry was assigned to the Ninth Army Corps; the battalion took its place in line before Petersburg on June 12 and participated in the fighting in front of Petersburg on June 17 and 18, losing several dozen men. Afterward, it was put in reserve. The battalion had been reduced to forty men fit for duty. They returned to the front, reinforced by newly arrived Company E led Captain Newton S. Ferris of New Lisbon, Wisconsin. This added three officers and sixty-six men.

From June 16 to 18, 1864, the Thirty-Seventh Wisconsin Infantry took part in the fighting around Petersburg and suffered severely when it advanced "under a perfect storm of shot, shell and canister" in its first battle. On June 17, 1864, Sergeant William H. Green of Company C was recommended for promotion for gallantry in action when he was wounded in both legs and crawled from the field, dragging the regimental colors in his teeth. He died from his wounds that same day. The regiment lost more than 160 killed and wounded.

During the Battle of the Crater, on July 30, 1864, when the regiment selected to lead the charge faltered, Brigadier General John Hartruft ordered the Thirty-Eighth Wisconsin Infantry, numbering 100 men, to take the lead. Company B, under Lieutenant Ballard, and Company E, under Captain Ferris, advanced toward the crater "under a terrific fire, which swept through their ranks." When they reached the crater, Captain Ferris was killed. The men remained in the crater until 4:00 p.m., when they retreated with the brigade. The small regiment had lost 30 men. The Thirty-Seventh also took part in the July 30 assault. Out of 250 men who went out in the morning, only 95 answered the roll call that evening.

At Reams Station, Virginia, on August 25, 1864, the Thirty-Sixth Wisconsin Infantry was posted in a railroad cut. The Confederates attacked and broke the line to the right, advancing to the rear of the regiment, completely surrounding it. Because of its position in the railroad cut, it was impossible to maneuver. A few of the men cut their way out, but most were captured. Of 186 officers and men who went into the fight, only 48 escaped; 10 were killed or wounded and 125 reported as missing, most taken prisoner. Of the 128 men sent to Salsbury Prison, in North Carolina, fewer than 6 returned to the regiment. Very few left the prison. On October 1, 1864, newly recruited Companies F, G, H, I and K of the Thirty-Eighth Wisconsin Infantry joined the regiment, increasing it to "a good sized regiment."

All three regiments took part in the April 2, 1865 assault in Petersburg. The Thirty-Eighth Wisconsin Infantry led the right of the assaulting column on Fort Mahone. One of the advancing soldiers later described the "mighty cheer" that went up from hundreds of throats as they charged. Lieutenant Hazard Stevens remembered it: "Defiance, force, fury, determination and unbounded confidence were expressed and hurled forth in that mighty shout. It swept away all misgivings, fear, and doubt from every manly breast like mists before the whirlwind.'" The Thirty-Eighth lost more than sixty killed or wounded.

The Thirty-Seventh also assaulted Fort Mahone, charging through "a perfect storm of shot and shell." The men rushed over the abattis and into the fortifications, turning the fort's cannon on the Confederates, who repeatedly tried to retake the fort but were repulsed. In the assault on the fort, the Thirty-Seventh lost about 40 men killed or wounded, and Colonel Harriman was brevetted brigadier general for bravery. For its part, the Thirty-Sixth Wisconsin captured 150 prisoners and three cannons. The regiment joined in the pursuit of Lee's army and was present at the surrender at Appomattox Court House on April 9, 1865.[79]

All three regiments participated in the Grand Review at Washington. Part of the Thirty-Eighth remained in the city and was on duty at the arsenal during the trial and execution of the Lincoln assassination conspirators. The Thirty-Sixth Wisconsin Infantry lost 296 men during its service, 132 killed in action or died of wounds. The Thirty-Seventh Wisconsin Infantry lost 223 men in service, 144 of them—almost two-thirds—in combat. The Thirty-Eighth Wisconsin Infantry lost 108 men, more than half, 57, in battle.[80]

COMPANY G, FIRST U.S. "BERDAN'S" SHARPSHOOTERS

Early in the war, the War Department authorized the organization of two regiments of sharpshooters and appointed Colonel Hiram Berdan of New York to organize them. One company was recruited in Wisconsin, leaving Camp Randall on September 19, 1861. In New York City, it was mustered into service as Company G of the First Regiment U.S. Sharpshooters. The company elected Edward Drew of Buffalo, New York, as its captain. The recruits called themselves the Badger Scouts.

Initially armed with Colt five-shooting rifles, they were subsequently armed with the Sharpe's rifle. They passed the winter training near Washington. In March 1862, the company participated in the Peninsula campaign. On May 1, 1862, while a small party of Company G was protecting a fatigue party in the construction of a rifle pit near the enemy, Private Joseph Durkee was killed by a Confederate rifle shot. A report from the *New York Herald* noted, "His head was riddled by a dozen bullets. The presumption is that he must have been shot after being killed, as gratification to the fiendish hatred entertained toward our sharpshooters, who, through their watchful vigilance and unerring rifles, have worked such terrible destruction in their ranks."[81]

June 30, 1862, was a particularly deadly day for Company G. Accompanying the retreat of McClellan's army, the sharpshooters took part in the Battle of Charles City Cross Roads, known as Glendale or Nelson's Farm. They were on the left of the Union forces. A regiment in their front was forced back by charging Confederates, running over the company of sharpshooters. The Confederates turned their fire on Company G, which lost five killed and six wounded.

On July 29, 1862, Lieutenant Marble was commissioned as captain. At the Second Battle of Bull Run in 1862, the company had two men killed and at least six wounded. At Antietam, it was held in reserve and not actively engaged. After the Battle of Fredericksburg, on December 12, 13 and 14, the sharpshooters were present and engaged in picket duty. Company G was the last company to cross the Rappahannock on the retreat to Falmouth.

At Gettysburg, on July 2, 1863, Companies G and B did picket duty to the right of the center of Sickles's Third Corps. Two men were killed. Two more died of wounds, one on July 3 and the other on July 15, 1863. Four others were wounded but survived. One man was taken prisoner. On November 26, 1863, the company took part in the Mine Run expedition and participated in the Battle of Locust Grove, where it was under heavy fire, losing two dead and three wounded.

During the 1864 Overland campaign, Company G of Berdan's Sharpshooters was very active. Between May 7 and August 16, 1864, the company had eight men killed. When their term of service expired, they were mustered out. Those who reenlisted were transferred to other companies of the regiment. In total, twenty-two men of Company G were killed in action or died of wounds. Thirteen of them died of disease.[82]

A Legacy of Bravery

The men were cheerful, quiet and orderly. The dust and blackness of battle were upon their clothes, and in their hair, and on their skin. But you saw none of these; you only saw their eyes, and the shadows of the "light of battle."...I could not look upon them without tears, and could have hugged the necks of them all.
—*Frank A. Haskell of the Sixth Wisconsin Infantry describing men of the Iron Brigade after the Battle of Brawner Farm on August 28, 1862*[83]

The Iron Brigade

One of the most famous units in the Union army was an infantry brigade made of regiments from Wisconsin, Indiana and Michigan. Called the Iron Brigade, it earned a reputation as one of the best fighting brigades in the war. Much has been written about the Iron Brigade, so only a summary of it will be given here.

The brigade was organized in August 1861 and consisted of the Second Wisconsin Infantry, the Sixth Wisconsin Infantry, the Seventh Wisconsin Infantry and the Nineteenth Indiana Infantry. After October 1862, the Twenty-Fourth Michigan Infantry was added. Originally under the command of Brigadier General Rufus King of Wisconsin, the brigade earned its reputation under the command of Pennsylvania-born and North Carolina–raised Brigadier General John Gibbon. Gibbon, a West Point graduate, was a regular army officer who had taught artillery tactics at West Point—literally writing the manual for artillery in 1859.

Gibbon also gave the brigade its distinctive look. Shortly after taking command in May 1862, Gibbon had his men outfitted in a new uniform that consisted of a dark-blue frock coat, light-blue trousers, white leggings and the regular army black Hardee hat. Fighting in some of the most bloody and decisive battles of the war, the brigade was virtually destroyed on the battlefield within a year of earning its distinctive name.[84]

At its first battle on August 28, 1862 (known by three different names: Brawner Farm, Gainsville and Groveton), it fought the famed Stonewall Brigade in a stand-up fight at dusk with neither side giving ground. When dark and mutual exhaustion ended the fighting, the brigade had lost 725 of the approximately 2,000 men it took into the fight. Because of the terrain and the movements of Confederate forces, the casualties were not equally distributed among the brigade's regiments.

The Sixth Wisconsin and Seventh Wisconsin suffered the least, losing only 15 percent and 28 percent, respectively. The Nineteenth Indiana Infantry, attacked from the front and side, lost terribly: 210 out of the 423

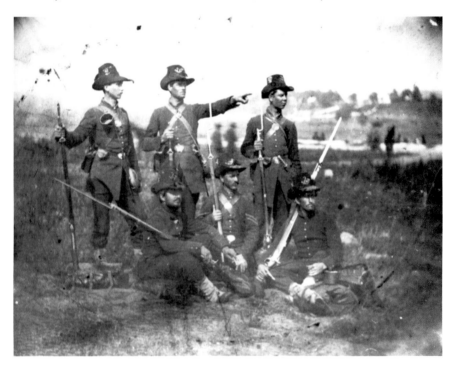

Members of Company C, Second Wisconsin Infantry, wearing the black Hardee hats, frock coats and leggings of the Iron Brigade. Corporal Spencer Train (*front row, center*) died at Gettysburg. *Wisconsin Historical Society.*

it took into action, almost 50 percent. The Second Wisconsin, the first to enter the fight, suffered the worst, losing 273 of 430 men, a staggering 62 percent. Company F lost 26 men out of 38, Company H 36 out of 46. Company G suffered the worst. First Lieutenant Alexander Hill (formerly of the Portage Light Guards), who commanded Company G, wrote, "I went into the fight of Thursday, the 28th, with fifty-one men, and came out with only eight!" Hill would be wounded three weeks later at the Battle of Antietam.[85]

Over the next two days, the men of the Iron Brigade were again bloodied in the Union defeat at Second Bull Run, acting as the rear guard of the retreating army, losing 143 killed, wounded or missing. The Second Wisconsin Infantry was last regiment to cross the stone bridge at Bull Run. In three days, the brigade had lost almost 900 men—more than 40 percent of its strength.[86]

Less than three weeks later, on September 14, 1862, the Iron Brigade earned its nickname at South Mountain, Maryland, when it was ordered to clear Confederate defenders from the mountain pass at Turner's Gap. The Army of the Potomac was pursuing Lee's Army of Northern Virginia into Maryland, and the Confederates wanted to delay them. In order to clear the Confederates, the Iron Brigade had to advance up the slope of the mountain pass and drive the Confederates from "positions in the woods and behind stone walls." Major General McClellan, the commander of the Army of the Potomac, witnessed the fight. Seeing the brigade advance up the mountain in the face of the strong Confederate opposition, McClellan is reported to have said, "They must be made of iron," asserting that "they fight equal to the best troops in the world." After the battle, Major General Joseph Hooker, who commanded the corps the brigade was in, saw General McClellan and shouted to him, "General, what do you think of my Iron Brigade?" Having heard of the exchanges between Hooker and McClellan, the soldiers of the brigade took ownership of the name with "the entire Army of the Potomac conceding to them that right." The brigade was also known as the "Iron Brigade of the West" and, particularly by the Confederates, the "Black Hat" brigade because of the distinctive black Hardee hats they wore.[87]

The Iron Brigade—which had about 2,100 men three weeks before—had about 800 men in its ranks as it entered the Battle of Antietam on September 17, 1862, the bloodiest day in American history.[88] The Iron Brigade, one of the first units to begin the battle, advanced through a cornfield toward the Confederate line:

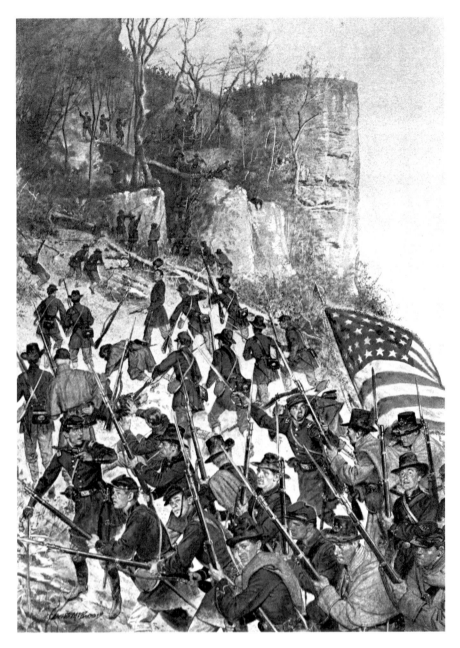

The Sixth Wisconsin Infantry advance up Turner's Gap at South Mountain in 1862. This is where the Iron Brigade earned its name. *U.S. Army Center for Military History.*

As we appeared at the edge of the corn, a long line of men in butternut and gray rose up from the ground. Simultaneously, the hostile battle lines opened a tremendous fire upon each other. Men, I cannot say fell; they were knocked out of the ranks by dozens. But we jumped over the fence, and pushed on, loading…and firing with demoniacal fury and shouting and laughing hysterically.[89]

Afterward, Major Dawes wrote that the Sixth Wisconsin Infantry had 314 officers and men on the morning of the battle. Company C, however, numbering 35 men, acted as skirmishers and was not with the main body of the regiment. Dawes concluded, "Of two hundred and eighty men who were at the cornfield and turnpike, one hundred and fifty were killed or wounded. This was the most dreadful slaughter to which our regiment was subjected in the war."[90]

Overall, the brigade lost 340 men of the 800 engaged—more than 42 percent. Depleted by its determined and sanguinary fighting, the Iron Brigade was reinforced in October 1862 by the Twenty-Fourth Michigan Infantry, a newly recruited and full strength regiment. Because the Michiganders were westerners, the brigade maintained its all-western character.[91]

Nine months later, at Gettysburg, the Iron Brigade suffered its worst percentage of loss in any of its battles. It was one of the first infantry brigades on the battlefield, relieving John Buford's cavalry, and essentially sacrificed itself to delay Lee's advancing army long enough for the Army of the Potomac to occupy the high ground south of Gettysburg. In the fighting of July 1, 1863, the brigade suffered approximately 1,200 men killed, wounded or missing out of 1,883 men engaged—a staggering 63 percent—the largest percentage of casualties sustained by any Union brigade at Gettysburg.

Each regiment suffered losses depending on the flow of the battle. The Seventh Wisconsin Infantry suffered 42

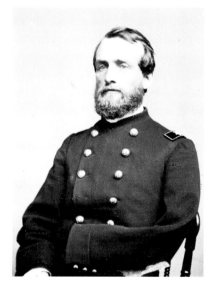

Lucius Fairchild was the colonel of the Second Wisconsin Infantry from South Mountain to Gettysburg, where he lost an arm. He became a postwar governor of Wisconsin. *Library of Congress.*

percent losses; the Sixth Wisconsin Infantry, 48 percent; and the Nineteenth Indiana Infantry, 71 percent. The Second Wisconsin Infantry lost the most: 77 percent. The Twenty-Fourth Michigan Infantry, the new regiment that had yet to prove itself on the battlefield, lost 73 percent. The men from Detroit and Wayne County, Michigan, proved themselves worthy of membership in the Iron Brigade.[92]

In a letter written on August 6, 1863, after a year of experiencing some of the bloodiest fighting in the Army of the Potomac, Major Dawes of the Sixth Wisconsin Infantry described the reason for the brigade's effectiveness in battle:

> *A battle to veterans is an awful experience. There is not with our men the headlong recklessness of new men, who start in, acting as though they would rather be shot than not, and then lose their organization and scatter like sheep, but there is a conviction from much experience in fighting, that safety is best had by steadiness, persistence in firing, and most of all by holding together. So, with the inducement of pride, duty, patriotism and personal preservation, they will stand together till the last.*[93]

After Gettysburg, a series of eastern regiments were added to the brigade, and it lost its distinctive western character. In 1864, after three years of service, the Second Wisconsin Infantry and the Nineteenth Indiana Infantry were mustered out. Those soldiers choosing to reenlist served in the Sixth Wisconsin Infantry and Twentieth Indiana Infantry, respectively.

Three of the brigade's regiments and the attached artillery battery hold deadly distinctions. The Second Wisconsin Infantry suffered the greatest percentage killed in battle or died of wounds of any regiment in the Union Army: 238 men, or 19.7 percent. In the words of historian William Fox, "The loss in the Second Wisconsin indicates the extreme limit of danger to which human life is exposed in a war similar in duration and activity to the American Civil War."

The Seventh Wisconsin Infantry earned its own dreadful distinction; depending on the sources used, it suffered either the most or third most killed or died of wounds of any Union regiment. War Department records show the Seventh Wisconsin as first with 280 killed or died of wounds. Historian William Fox put the Seventh Wisconsin at third, crediting the Fifth New Hampshire Infantry with 295, the Eighty-Third Pennsylvania Infantry with 282 and the Seventh Wisconsin Infantry with 281. Fox noted that the Seventh stood high in the list because of its "persistency with which

it would hold its ground in the face of the deadliest musketry." The Seventh Wisconsin Infantry also suffered the sixth-highest battlefield loss percentage at 17.2 percent (tied with the Twenty-Sixth Wisconsin Infantry).[94]

The Twenty-Fourth Michigan's terrible distinction is that it lost more men at Gettysburg than any other Union regiment. Most sources state the Twenty-Fourth Michigan Infantry lost 363 men out of the 496 engaged (73 percent).[95]

The artillery battery assigned to the brigade was Battery B, Fourth U.S. Artillery. This battery filled out its ranks from members of Iron Brigade regiments and lost the greatest number of men of any light artillery battery in the Union army during the war.[96]

Overall, the brigade lost 1,131 men killed or mortally wounded, 15.7 percent of its enrollment. In proportion to its numbers, this was the heaviest loss of any brigade in the Union army during the war. These men from the Upper Midwest, primarily from Wisconsin, bequeathed a legacy of courage and sacrifice that echoes to this day.[97]

MEDALS OF HONOR

The Medal of Honor, the highest military award for bravery, was established by Congress for the U.S. Navy on December 21, 1861. Six months later, on July 12, 1862, Congress established a Medal of Honor for the U.S. Army. It was to be presented "to such non-commissioned officers and privates as shall most distinguish themselves by their gallantry in action, and other soldier-like qualities, during the present insurrection." Eighty-eight soldiers would be awarded the medal retroactively for actions performed before the creation of the medal. On March 3, 1863, presentations of the Army Medal of Honor was extended to officers. The navy medal was only awarded to enlisted sailors and marines.[98]

In its history, 3,499 medals have been awarded. Of these, 19 were to men serving in Wisconsin regiments during the Civil War. The winners reflected the immigration patterns to Wisconsin. Of the 19, 5 were born outside the United States: Canada, England (2), Ireland and Norway; 10 were born in other states: Illinois, Massachusetts (2), New York (5), Ohio and Pennsylvania; and 4 were born in the state. In the following descriptions, it will be noted that a number of the Medal of Honors were awarded long after the war.[99]

PETER ANDERSON: Private, Company B, Thirty-First Wisconsin Infantry
PLACE: Bentonville, North Carolina, March 19, 1865
DATE OF ISSUE: June 16, 1865
CITATION: "Entirely unassisted, brought from the field an abandoned piece of artillery and saved the gun from falling into the hands of the enemy."

FRANCIS JEFFERSON COATES: Sergeant, Company H, Seventh Wisconsin Infantry
PLACE: At Gettysburg, Pennsylvania, July 1, 1863
DATE OF ISSUE: June 29, 1866
CITATION: "Unsurpassed courage in battle, where he had both eyes shot out."

Sergeant Francis Jefferson Coates, a farm boy from Boscobel, won the MOH at Gettysburg. Blinded by his wounds, Coates learned broom making, married and had five children. *Wisconsin Veteran's Museum.*

Coates was wounded at the Battle of South Mountain the previous year. He was made brevet captain for his actions at Gettysburg and was mustered out on September 1, 1864. Coates was one of four Seventh Wisconsin Infantry soldiers awarded the Medal of Honor for bravery during the war.[100]

JAMES E. CROFT: Private, Twelfth Battalion, Wisconsin Light Artillery
PLACE: At Allatoona, Georgia, October 5, 1864
DATE OF ISSUE: March 20, 1897
CITATION: "Took the place of a gunner who had been shot down and inspired his comrades by his bravery and effective gunnery, which contributed largely to the defeat of the enemy."

Croft was born in Yorkshire, England, and entered service at Janesville, Wisconsin. He was mustered out on June 7, 1865.

ALONZO H. CUSHING: First Lieutenant, Battery A, Fourth U.S. Artillery, Second Corps, Army of the Potomac

PLACE: Gettysburg, Pennsylvania, July 3, 1863

DATE OF ISSUE: November 6, 2014

CITATION: "First Lieutenant Alonzo H. Cushing distinguished himself by acts of bravery above and beyond the call of duty while serving as an artillery commander in Battery A, Fourth U.S. Artillery, Army of the Potomac, at Gettysburg, Pennsylvania, on July 3, 1863, during the American Civil War. That morning, Confederate forces led by General Robert E. Lee began cannonading First Lieutenant Cushing's position on Cemetery Ridge. Using field glasses, First Lieutenant Cushing directed fire for his own artillery battery. He refused to leave the battlefield after being struck in the shoulder by a shell fragment. As he continued to direct fire, he was struck again—this time suffering grievous damage to his abdomen. Still refusing to abandon his command, he boldly stood tall in the face of Major General George E. Pickett's charge and continued to direct devastating fire into oncoming forces. As the Confederate forces closed in, First Lieutenant Cushing was struck in

Alonzo Cushing (*standing center*), who was killed at Gettysburg, was awarded the MOH in 2014 for his actions there. Born in Delafield, his family moved to New York State when he was young. He is shown here with fellow artillery officers in 1862. *Library of Congress.*

the mouth by an enemy bullet and fell dead beside his gun. His gallant stand and fearless leadership inflicted severe casualties upon Confederate forces and opened wide gaps in their lines, directly impacting the Union force's ability to repel Pickett's charge. First Lieutenant Cushing's extraordinary heroism and selflessness above and beyond the call of duty at the cost of his own life are in keeping with the highest traditions of military service and reflect great credit upon himself, Battery A, Fourth U.S. Artillery, Army of the Potomac, and the U.S. Army."

Cushing was born in what is now Delafield, Wisconsin. When he was young, his family moved to Fredonia, New York. Cushing was appointed to West Point in 1857 and commissioned a first lieutenant in the army in June 1861. He was one of three Cushing brothers to serve during the Civil War. His younger brother, Lieutenant William B. Cushing, also born in Delafield, became a celebrated Union naval officer. His older brother, Howard, born in Milwaukee, served in the cavalry and was killed fighting the Chiricahua Apache in 1871.

JOHN S. DURHAM: Sergeant, Company F, First Wisconsin Infantry
PLACE: Perryville, Kentucky, October 8, 1862
DATE OF ISSUE: November 20, 1896
CITATION: "Seized the flag of his regiment when the color Sgt. was shot and advanced with the flag midway between the lines, amid a shower of shot, shell, and bullets, until stopped by his commanding officer."

Durham was mustered out in October 1864 when his three-year enlistment expired.

HORACE ELLIS: Private, Company A, Seventh Wisconsin Infantry
PLACE: Weldon Railroad, Virginia, August 21, 1864
DATE OF ISSUE: December 1864
CITATION: "Capture of flag of 16th Mississippi (C.S.A.)."

A resident of Chippewa Falls when he enlisted, Ellis was attached to Battery B, Fourth U.S. Artillery from February 7, 1863, until January 1864. Ellis reenlisted as a veteran after three years. He was wounded on the day he captured the flag, winning the Medal of Honor. He was mustered out July 3, 1865.

WILLIAM ELLIS: First Sergeant, Company K, Third Wisconsin Cavalry
PLACE: Dardanelle, Arkansas, January 14, 1865
DATE OF ISSUE: March 8, 1865
CITATION: "Remained at his post after receiving three wounds and only retired, by his commanding officer's orders, after being wounded the fourth time."

Born in England, Ellis gave his residence as Watertown in the southeastern part of the state when he enlisted in the Third Wisconsin Cavalry. Ellis reenlisted as a veteran after his first three-year enlistment, rising to the rank of first sergeant. He was transferred to Company E on February 1, 1865.

BENJAMIN F. HILLIKER: Musician, Company A, Eighth Wisconsin Infantry
PLACE: Mechanicsburg, Mississippi, June 4, 1863
DATE OF ISSUE: December 17, 1897
CITATION: "When men were needed to oppose a superior Confederate force, he laid down his drum for a rifle and proceeded to the front of the skirmish line, which was about 120 feet from the enemy. While on this volunteer mission and firing at the enemy he was hit in the head with a minié ball, which passed through him. An order was given to 'lay him in the shade; he won't last long.' He recovered from this wound being left with an ugly scar."

Hilliker enlisted from Waupaca. He was discharged due to his wound on August 20, 1863.

JOHN JOHNSON: Private, Company D, Second Wisconsin Infantry
PLACE: Fredericksburg, Virginia, December 13, 1862; Antietam
DATE OF ISSUE: August 28, 1893
CITATION: "Conspicuous gallantry in battle in which he was severely wounded. While serving as cannoneer he manned the positions of fallen gunners."

Johnson was born in Toten Christiana (Oslo), Norway. A laborer, he enlisted at Janesville, Wisconsin, on April 20, 1861. On November 27, 1861, he was attached to Battery B, Fourth U.S. Artillery. It appears his award was for actions at both Antietam and Fredericksburg. His medal reads, "For distinguished bravery, coolness in action, soldierly conduct, and conspicuous gallantry at the battles of Antietam and Fredericksburg."

At Fredericksburg, he was carrying two cases of shot toward his cannon when a piece of shell hit him, severing his right arm at the shoulder. His fellow artillerymen reported that he inserted the shot he was carrying into his cannon before he fell. He survived and was discharged on April 10, 1863.

ARTHUR MACARTHUR JR.: First Lieutenant and Adjutant, Twenty-Fourth Wisconsin Infantry
PLACE: Missionary Ridge, Tennessee, November 25, 1863
DATE OF ISSUE: June 30, 1890
CITATION: "Seized the colors of his regiment at a critical moment and planted them on the captured works on the crest of Missionary Ridge."

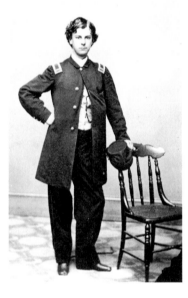

Arthur MacArthur moved to Wisconsin as a boy. He entered service at Milwaukee as a first lieutenant and adjutant of the Twenty-Fourth Wisconsin Infantry. *Wisconsin Historical Society.*

MacArthur was only eighteen years old when, on November 25, 1863, he was awarded the Medal of Honor for his leadership at Missionary Ridge, Tennessee. The Twenty-Fourth Wisconsin Infantry was part of the attack on Missionary Ridge when the regiment's color bearer fell. MacArthur picked up the regimental flag and, waving it to inspire his men, shouted "On, Wisconsin!" and ran forward (giving the University of Wisconsin Badgers the title to their fight song). Inspired by his actions, the men of the Twenty-Fourth Infantry followed him. Wounded twice during his rush toward the Confederate line, MacArthur planted the regiment's flag on the Confederate fortifications. The Federals carried the position and broke the Confederate siege of Chattanooga.

At the Battle of Franklin on November 30, 1864, he was again wounded twice: shot in the chest and leg. He survived and rejoined his regiment, serving until the end of the war. After a brief separation, MacArthur was commissioned in the regular army and campaigned against Geronimo in 1885, served as a

brigade commander in the Spanish-American War and was made military governor of the Philippines, retiring in 1909 as a lieutenant general. He died in 1912. He passed his love of the military to his son Douglas, who would rise to the rank of general and also win the Medal of Honor for his service in the Philippines campaign during World War II. This made them the first father and son to be awarded the Medal of Honor.

DANIEL B. MOORE: Corporal, Company E, Eleventh Wisconsin Infantry
PLACE: Fort Blakely, Alabama, April 9, 1865
DATE OF ISSUE: August 8, 1900
CITATION: "At the risk of his own life saved the life of an officer who had been shot down and overpowered by superior numbers."

Moore, a resident of Mifflin, Wisconsin, when he enlisted, reenlisted after his three-year term, rising to the rank of sergeant. He was wounded during his heroic action at Fort Blakely and was made a brevet captain for his actions. He mustered out on September 4, 1865.

DENNIS J.F. MURPHY: Sergeant, Company F, Fourteenth Wisconsin Infantry
PLACE: Corinth, Mississippi, October 3, 1862
DATE OF ISSUE: January 22, 1892
CITATION: "Although wounded three times, carried the colors throughout the conflict."

Born in Ireland, Murphy entered service at Green Bay. He was wounded four times at the Battle of Corinth. He was discharged for disability on November 13, 1862. He was then commissioned a second lieutenant on December 17, 1862 "for gallant conduct in action" at Corinth and assigned to Company B, Thirty-Fourth Wisconsin Infantry. He was mustered out on September 8, 1863, at the end of his term of service.

ALBERT O'CONNOR: Sergeant, Company A, Seventh Wisconsin Infantry
PLACE: Gravelly Run, Virginia, March 31 and April 1, 1865
DATE OF ISSUE: Unknown
CITATION: "On 31 March 1865, with a comrade, recaptured a Union officer from a detachment of 9 Confederates, capturing 3 of the detachment and

dispersing the remainder, and on 1 April 1865, seized a stand of Confederate colors, killing a Confederate officer in a hand-to-hand contest over the colors and retaining the colors until surrounded by Confederates and compelled to relinquish them."

Born in Hereford, Canada, O'Connor entered service at West Point Township, Columbia County, Wisconsin. He reenlisted in the Seventh Wisconsin Infantry as a veteran at the expiration of his initial three-year enlistment. He was wounded at the Battle of the Wilderness and made a brevet captain on March 31, 1865. He was mustered out on July 3, 1865.

GEORGE F. POND: Private, Company C, Third Wisconsin Cavalry
PLACE: Drywood, Kansas, May 15, 1864
DATE OF ISSUE: May 16, 1899
CITATION: "With 2 companions, attacked a greatly superior force of guerrillas, routed them, and rescued several prisoners."

Enlisting on December 27, 1861, Pond was not mustered out until February 17, 1865. His brother James Pond was also awarded the Medal of Honor, but for a different action.

JAMES B. POND: First Lieutenant, Company C, Third Wisconsin Cavalry
PLACE: At Baxter Springs, Kansas, October 6, 1863
DATE OF ISSUE: March 30, 1898
CITATION: "For extraordinary heroism on 6 October 1863, while serving with Company C, 3d Wisconsin Cavalry, in action at Baxter Springs, Kansas. While in command of 2 companies of Cavalry, was surprised and attacked by several times his own number of guerrillas, but gallantly rallied his men,

First Lieutenant James B. Pond, Third Wisconsin Cavalry. Pond, from Janesville, Wisconsin, was an abolitionist and member of the Underground Railroad. *Civil War Museum, Kenosha, Wisconsin.*

and after a severe struggle drove the enemy outside the fortifications. First Lieutenant Pond then went outside the works and, alone and unaided, fired a howitzer 3 times, throwing the enemy into confusion and causing him to retire."

The detachment Pond commanded was attacked by William C. Quantrill's raiders. Accompanying Pond's troops was the Second Kansas Colored Volunteers. In a postwar book about his experiences, he wrote that "the darkies…fought like devils" during the battle. Pond enlisted on November 2, 1861, from Janesville, Wisconsin, and was commissioned a second lieutenant. He was promoted to first lieutenant on August 29, 1862, and captain on October 19, 1864.

WILLIAM H. SICKELS: Sergeant, Company B, Seventh Wisconsin Infantry
PLACE: Gravelly Run, Virginia, March 31, 1865
DATE OF ISSUE: Unknown
CITATION: "With a comrade, attempted capture of a stand of Confederate colors and detachment of 9 Confederates, actually taking prisoner 3 members of the detachment, dispersing the remainder, and recapturing a Union officer who was a prisoner in hands of the detachment."

Sickels enlisted from Fall River on May 11, 1861, and reenlisted after his three-year term. He was mustered out on July 3, 1865. A total of four Sickelses enlisted from the neighboring communities of Fall River and Otsego, Wisconsin. It seems likely they were related. Henry was wounded at Gettysburg and mustered out at the end of the war, Daniel E. discharged by order in 1862 and Charles discharged for disability in 1862.

THOMAS TOOHEY: Sergeant, Company F, Twenty-Fourth Wisconsin Infantry
PLACE: Franklin, Tennessee, November 30, 1864
DATE OF ISSUE: Unknown
CITATION: "Gallantry in action; voluntarily assisting in working guns of battery near right of the regiment after nearly every man had left them, the fire of the enemy being hotter at this than at any other point on the line."

Toohey enlisted from Milwaukee on August 6, 1862, and rose to the rank of first sergeant. He was wounded at Franklin where he won his MOH. He mustered out on June 10, 1865.

EDWIN M. TRUELL: Private, Company E, Twelfth Wisconsin Infantry
PLACE: Near Atlanta, Georgia, July 21, 1864
DATE OF ISSUE: March 11, 1870
CITATION: "Although severely wounded in a charge, he remained with the regiment until again severely wounded, losing his leg."

Truell was made a brevet first lieutenant for his actions on July 21. Despite losing his leg, he remained in service until he was mustered out on May 31, 1865.

Francis "Frank" Waller of the Sixth Wisconsin Infantry was a first lieutenant when mustered out in July 1865. He fought in every battle and skirmish of the regiment. *Scott D. Hann Collection.*

FRANCIS ASHBURY WALLER: Corporal, Company I, Sixth Wisconsin Infantry
PLACE: Gettysburg, Pennsylvania, July 1, 1863
DATE OF ISSUE: December 1, 1864
CITATION: "Capture of flag of 2d Mississippi Infantry (C.S.A.)."

During the opening of the Battle of Gettysburg, the Sixth Wisconsin Infantry along with the Fourteenth Brooklyn Infantry and the Ninety-Fifth New York Infantry trapped Brigadier General Joseph R. Davis's brigade of Mississippians and North Carolinians in an unfinished railroad cut. Many of the Confederates surrendered; others fought their way out. The fighting became hand-to-hand. During the fighting, Waller grabbed the flag from Corporal William B. Murphy, the color bearer of the Second Mississippi Infantry. Waller later described his actions:

I did take the flag out of the color bearer's hand.... [M]y first thought was to go to the rear with it for fear it might be retaken, and then I thought I would stay, and I threw it down and loaded and fired twice standing on it. While standing on it there was a 14th Brooklyn man took hold of it and tried to get it, and I had to threaten to shoot him before he would stop. By this time we had them cleaned out....I still had the flag, and when ordered to go on the skirmish line, asked Colonel Dawes what I should do with the flag, he said, "give it to me" and I did.

Waller was promoted to first sergeant, reenlisting as a veteran in 1864. He was commissioned a second lieutenant on December 21, 1864, and first lieutenant on March 23, 1865, mustering out on July 14, 1865. The Waller family of DeSoto, Wisconsin, sent three sons to serve in Company I, Sixth Wisconsin. Frank and Sam both enlisted on July 16, 1861. Thomas, the youngest, enlisted on February 16, 1864. All three survived the war.[101]

The Homefront

Politics

Hell's vice-agent on earth.
—*Marcus "Brick" Pomeroy's description of Abraham Lincoln,
from the* La Crosse Weekly Democrat, *1864*

Copperheads

Those opposed to the Lincoln administration and the prosecution of the war were called "Copperheads" after the venomous snake. Generally speaking, they were Democrats who did not think the emancipation of the slaves should be a legitimate war aim and that a reunion of the states could be achieved peacefully and politically rather than through war.

In response to being called Copperheads, some Democrats cut the head out of the goddess of liberty on the copper penny and wore it as a badge of honor—symbolizing that they were one and the same.

The causes of Copperheadism were complex and varied from state to state. In the Upper Midwest, sectionalism influenced the movement. Many Copperheads believed that the Lincoln administration was the puppet of New England capitalists and New York manufacturers and that their economic ties were stronger with the agrarian South than the industrial Northeast. When an economic crisis hit in the first year of the war because of the closure of the Mississippi River trade, farm prices collapsed and a bank crisis ensued.

The economic crisis undermined the patriotic consensus that had papered over the partisan differences between Republicans and Democrats. Once pocketbook issues came to the fore, political partisanship returned, becoming another element of Copperheadism.

Politically, there were genuine differences between the Democrats and the Republicans. Many of the Democrats who became Copperheads were conservatives in the Jeffersonian tradition of small government. They opposed an expanding and centralizing federal government and the nationalization of business.[102]

When Lincoln issued the Emancipation Proclamation in 1862, most Democratic editors condemned it. The editor of the *Oshkosh Courier* wrote, "If this is a war…of ABOLITION, then, the sooner the Union goes to the devil the better." Marcus "Brick" Pomeroy of the *La Crosse Democrat* condemned it as "unnecessary" and "unconstitutional" and believed it would produce "evil results." Like many others, he accused Lincoln of illegally changing a war to save the Union into a war of abolition. Some moderate Democrats who had supported Lincoln prior to the Proclamation became critics afterward. Emancipation of the slaves was a bridge too far for them.[103]

Copperheadism also had a religious dimension. The Republican party had incorporated members who were previously Know-Nothings, an anti-Catholic movement in the 1850s. Many prominent Copperheads were either Irish or German Catholics and they feared New England Protestants would force their dogmas of abolition and temperance on them. The Germans and Irish had little desire for temperance and feared that "abolition measures" would result in an influx of "contrabands." Catholics, in fact, were major participants in an anti-black riot in Cincinnati in July 1862, the Port Washington, Wisconsin draft riot of November 1862 and the New York City draft riot of July 1863. Catholics, however, also supported the war effort. More than 200,000 served in the military during the course of the war.

In addition to sectional, economic, political and religious grievances, military failures in the first two years of the war also fostered an anti-Lincoln, anti-Republican sentiment. Wisconsin Democrats claimed Lincoln was a failure as a commander-in-chief, citing every military defeat. Finally, some Copperheads opposed the war on humanitarian grounds and felt that war was not a legitimate means to keep the country unified.

The early military defeats and economic crisis carried over into the fall elections of 1861 and 1862. The election in November 1862 was a landslide

Copperhead Marcus "Brick" Pomeroy. *Wisconsin Historical Society.*

for the Democrats in Wisconsin. They polled twenty thousand more votes than they had in the 1861 gubernatorial election.[104]

The first six months of 1863 were the worst days for the Lincoln administration. The military defeats, the implementation of the federal draft and the unpopularity of the Emancipation Proclamation combined to create an atmosphere of war weariness and defeatism, and Copperheads took advantage of it.

While people all of occupations became Copperheads in Wisconsin, those who were most influential were politicians and newspaper editors. Perhaps the most influential was Edward George Ryan, an Irish-born politician and lawyer who ultimately rose to lead the Democratic Party in Wisconsin in its opposition to Lincoln.

Born in Ireland, Ryan immigrated to the United States in 1830 at the age of twenty. He moved to Racine, Wisconsin, in 1842 and served as a delegate to the first state constitutional convention in 1846. Moving his legal practice to Milwaukee two years later, Ryan prosecuted Sherman Booth for violating the Fugitive Slave Law in 1855.[105]

In early 1861, after the lower South seceded, Ryan urged compromise and supported Lincoln. He thought Lincoln would "shut his eyes to party and be the President of the people." After Fort Sumter, he helped raise volunteers for Union regiments. Ryan declared the "revolt" of the South as "unnecessary, unjustifiable, and unholy." But, he argued, "the abolition party at the north produced the disunion party at the south." By "abolition party" he meant the Republican Party.

As battlefield defeats mounted and the Lincoln administration suspended the writ of habeas corpus and instituted the draft, Ryan's support faded. In a statewide convention of Democrats in September 1862, he wrote the Democratic Party's platform and attacked the administration for the draft and the suspension of habeas corpus. He viewed them as unconstitutional and wanted to maintain "the Constitution, the Union, and the rights of the states" and the "supremacy of the civil over the military authority, and the preservation of civil rights." He faulted the "the abolition party" for having "treasonable" and "unconstitutional doctrines" in "its crusade against the south and its institutions." Ryan condemned the president and Congress for turning the war into "an abolition crusade" and changing the "old system" of government into "military despotism."[106]

Ryan's address, known as the "Bible of Copperheadism," was condemned by all Republicans and many Democrats. Despite this, the Democrats won a sizeable vote in the November 1862 election, winning three of the six seats in the U.S. House of Representatives. Republican gerrymandering of congressional districts and a newly enacted law allowing soldiers in the field to vote undoubtedly prevented the Democrats from winning more seats.

In September 1863, the "Loyal Democracy" led by Matthew H. Carpenter, a lawyer known as "the Webster of the West"; Charles Robinson, the editor of a Democratic paper, the *Green Bay Advocate*; circuit court judge and state assemblyman Levi Hubbell; and circuit court judge Arthur McArthur Sr.

(the Scottish-born father of Arthur McArthur Jr., the Civil War Medal of Honor winner who was the father of Douglas McArthur) held a convention of "War Democrats" in Janesville and denounced Ryan's platform.

Another Wisconsin Copperhead who achieved national renown was Marcus "Brick" Pomeroy, the editor of the *La Crosse Democrat*. Born in Elmira, New York, he apprenticed as a printer and moved to Horicon, Wisconsin, in 1857, taking over the failing *Horicon Argus*. It was while at the *Argus* that Pomeroy earned the nickname "Brick," which means a "facetious, funny fellow who says smart things." Pomeroy became active in Democratic politics and supported Stephen Douglas in 1860. In November 1860, he became the founding editor of the *La Crosse Democrat*.[107]

Originally a supporter of the Lincoln administration's use of force, Pomeroy changed his mind after after two events. The first was the Emancipation Proclamation, which made the abolition of slavery in the South a war aim. "We are willing to fight till death for the common good of a common man," he wrote, "but will not be forced into a fight to free the slaves."[108] Pomeroy also spent two months in Arkansas, where he saw the horrors of war firsthand and experienced its attendant financial and moral corruption. Brick chronicled his observances for Democratic newspapers across the nation. Pomeroy returned to La Crosse and, prior to the 1864 election, wrote vicious anti-Lincoln editorials. The *La Crosse Democrat* editorial of August 15, 1864, is a good example:[109]

> *The Widow Maker of the 19th Century and Republican Candidate for Presidency ABRAHAM LINCOLN*
>
> *Let the broken families—the deserted tenements—the ruined hopes of millions of orphans—the million of widows he has made in four years look upon his face not as that of an honest man or a statesman equal to the emergency, but as the fanatical tool of fanatics—the greatest widow maker God ever cursed mankind with. What he has done for his country? Ruined it! He has filled the land with fear and mourning. He has caused a million of brave men to be sacrificed for nothing.*[110]

Pomeroy's anti-Lincoln vitriol ultimately hurt his paper's circulation and, more importantly, the Copperhead movement in Wisconsin.[111]

Other important Copperhead editors were Stephen D. "Pump" Carpenter of the *Madison Patriot*, Peter V. Deuster of the German-language *Milwaukee See-Bote*, Flavius J. Mills of the *Sheboygan Journal* and George H. Paul of

the *Milwaukee News*. Other prominent political Copperheads were former state assemblyman Moses M. Strong of Mineral Point and former attorney general George B. Smith of Madison.

The Union victories at Gettysburg and Vicksburg in 1863 turned the tide of the war. In the November 1863 elections for governor, the Democrats lost by twenty-five thousand votes. The following year, Sherman's capture of Atlanta and economic prosperity further shored up the Lincoln administration. The Republicans won sweeping victories in the election of 1864. The high tide of the Copperheads and Edward G. Ryan had ebbed.[112]

John F. Brobst of the Twenty-Fifth Wisconsin Infantry expressed the sentiments of many in the army when he wrote on September 6, 1864, "I could shoot a copperhead with as good hart [*sic*] as I could shoot a wolf." He continued, "I would shoot my father if he was one but thank god he is not one of the miseirablest of all God's creatures, a copperhead, a northern traitor."[113]

THE SOLDIER VOTE AND ARMY POLITICS

In the 1860s, Wisconsin held annual November elections. During the odd-numbered years, state officials, such as governors, were elected. In the even-numbered years, the congressional elections were held.

Prior to the Civil War, soldiers were not allowed to vote in the field. After the outbreak of the war, many Southern states guaranteed voting rights to their soldiers with the idea that this would allow Secessionists to keep political control. Republicans in Missouri followed this model, using pro-Union soldiers' ballots to help keep the state loyal. Iowa governor Samuel J. Kirkland saw the success in Missouri and followed suit.

Horace Rublee, editor of the *Wisconsin State Journal* in Madison and chairman of the Republican Central Committee, convinced Governor Edward Salomon that the "army-voting scheme" would be politically beneficial. Governor Salomon called a special session of the legislature. It met on September 10, 1862. Governor Salomon told the legislators that he "who bears arms should not be disfranchised" and that their "patriotism" should not be "rewarded" by the loss of "one of the most important rights of citizenship." The governor wanted the soldiers be able to vote in the field and for the three highest-ranking officers in each regiment be "inspectors of the election." The Republicans reasoned that if soldiers were allowed

to vote under the supervision of Republican regimental officers, who were in charge of the process of counting the votes and reporting the results, it would work to the Republicans' political advantage.

The Democrats, for their own partisan reasons, opposed it, arguing, "It was never intended by the Constitution that any person should be permitted to vote...while such person was outside the territorial limits of his state, beyond the reach of its Constitution, laws, and process of its courts." By a strict party-line vote of 19–7, the senate passed the bill on September 16, 1862. The Republican-dominated assembly also passed it. On September 25, 1862, acting governor James T. Lewis signed the bill into law; Wisconsin's soldiers could now vote in the field in the November 1862 elections.

During the Civil War, there was no private ballot. A soldier approached a table and selected either a Democratic or Republican card (Union Party in 1864) and placed it in the ballot box. Obviously, each man knew who voted for whom.[114]

Although the soldiers' vote was only 8 percent of the total, it could and did have a bearing on close contests. Democrats won three of the six congressional districts and outvoted the Republicans 62,122 to 53,466.

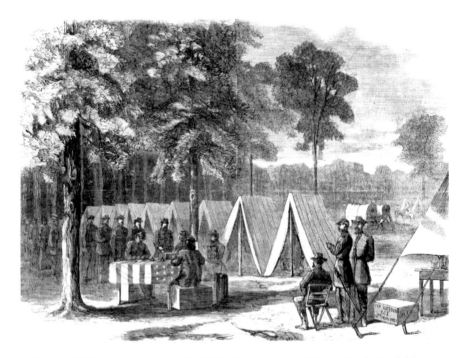

A *Harper's Weekly* engraving of an Alfred Waud drawing of soldiers voting in the field. *Library of Congress.*

The soldier vote helped prevent the Democrats from seizing control of the state legislature and reversed numerous local elections. The *Sheboygan Journal* noted that "Republican State and military officers are very smart in manufacturing votes from the army." It is worth noting that a quarter of the soldiers voted Democratic.[115]

Having injected politics into the army in a way that it had not been before, the Republican administration tried to prevent Democrats from being commissioned field officers, and Republican officers tried to prevent Copperhead newspapers from circulating in their regiments.

The emergence of economic "war prosperity" and the victories at Gettysburg and Vicksburg helped the Republicans turn back the Democrats and win a majority in the legislature in November 1863. This time, the soldier vote was better managed, with Republicans receiving 14.45 out of every 15 soldier votes cast.[116]

The presidential election of 1864 was essentially a referendum on Lincoln and the war. Edwin Kimberly, from Brodhead, Wisconsin, and a member of the Third Wisconsin Infantry Band, expressed some of the anti-abolition sentiment in the army when he wrote his parents on August 24, 1864: "The rebels will hear to no terms of peace under our present Administration. Should Lincoln be reelected it will undoubtedly prolong the war for he will sacrifice the last drop of white blood to save the accursed negro....We want no such man as this as the head of our government...I find the army universally against Lincoln."[117]

Two and a half months later, after the Democrats adopted a "peace platform" at their convention, Kimberly reversed himself: "Three fourths of the Army are for Lincoln. The Chicago Platform has placed McClellan in obscurity—we would have voted for him had it been for this." James F. Sawyer, a soldier from Omro, Wisconsin, explained why: "If Mr. Lincoln is elected we will have four years of war and blood shed and if McClellan is elected we will have a dishonorable and cowardly surrender and so I would prefer Mr. Lincoln after all because surrender does not sound agreeable to my ear"[118]

Undoubtedly, being a soldier and putting one's life on the line affected one's opinion on policy. James Nugent, while training at Camp Randall, noted, "It is strange how soldiering changes a persons politics. Good McClellan men come here and in two weeks they are loud for Old Abe."[119] After the election, Edward Levings of the Twelfth Wisconsin Infantry spoke of the voting demographics:

Most all of the men who went for McClellan & Pendleton are recruits, or men who do not know enough to poll an intelligent vote. I was clerk of our Co. election and I know who voted the Democratic ticket and will vouch that those men actually do not know enough to give an intelligent vote. I never saw one of them with a newspaper in their hands....There were just three men of Co. "A" who voted for him....Each one put in his contemptible ticket and sneaked away like a dog with his tail between his legs, not daring to look a man in the face....A man who votes for McClellan is looked upon by his comrades as an ignoramus or a coward & wants to get out of service & so voted for Mac.[120]

Of course, soldiers tried to sway the votes of their comrades. James F. Sawyer wrote, "We had two more copperheads in our Co. but they would not vote for either candidate because I endeavored to show to them their folly in voting for a party so dishonorable and disgraceful." Lloyd Nanscawen from Hartford, Wisconsin, a private in the Twenty-Ninth Wisconsin Infantry, said he was "proud of our Co., for every man had common sense enough to vote for Lincoln."[121]

The Democratic nominee, George B. McClellan, won twenty-two out of fifty-eight counties in the state and won the city of Milwaukee by a ratio of more than 2–1. But with the help of the soldier vote, Lincoln won the state by a vote of 68,887 to 62,586.[122]

7

The Homefront

Economic Crisis

An economic crisis hit the Upper Midwest in the first year of the war. With the beginning of hostilities, the Mississippi River was closed for trade to the Upper Midwest and was unable to export crops down the river through New Orleans. Farm prices fell dramatically in 1861.[123]

Fortunately, the transportation needs of the region's farmers and industries no longer relied on the Mississippi River. Railroads were in place that could transport midwestern produce to the East. Wisconsin alone had two railways running west from Lake Michigan to the Mississippi River: the Milwaukee & Mississippi completed in 1857 and the La Crosse & Milwaukee completed in 1858.

By the beginning of the Civil War, Wisconsin had nine hundred miles of railroad track, all having been built in the preceding ten years. They were crucially important during the Civil War. Had the war occurred a decade earlier, the underlying economic infrastructure would have been very different and much less favorable to the North.

As an editorial in the *Milwaukee Sentinel* of January 24, 1863, noted, the Northwest "no longer faces New Orleans; it looks eastward, its outlet is the Erie Canal, and its future lies with New York." The farmers of Iowa, Illinois, Minnesota and Wisconsin were able to use the Erie Canal and the eastern railroads because they could easily transport products to Lake Michigan using railroads that terminated in Milwaukee and Chicago.

The 1861 harvest was excellent, but prices remained low and continued to stagnate through the winter and spring of 1862. In the summer of

1862, however, things turned around. The wheat harvest was less than usual and European crop shortages helped raise prices. Prices continued to rise into 1863 as the demand created by the need to feed the large Union armies increased.[124]

THE BANKING CRISIS

The secession of the South and the beginning of hostilities in 1861 precipitated a banking crisis in Wisconsin. Many state banks, which used southern bonds to back up their paper money, went bankrupt. Of the more than one hundred banks in Wisconsin, a third went bankrupt. The value of currency fell to cents on the dollar. Business transactions came to a halt. The money in circulation fell from $4.5 million at the beginning of 1861 to $1.5 million by the end of the year. Wisconsinites lost approximately $1 million in financial value. During the summer of 1861, many miners, farmers and traders only accepted payment in specie. On June 24, 1861, angry depositors rioted in Milwaukee. Banks were gutted and their furniture piled in the street and set on fire. Troops arrived and quieted the situation.[125]

Action was taken by the state, and by September 1861, $800,000 in Wisconsin state bonds, and the sound policies of the Wisconsin Bankers' Association led by financier Alexander Mitchell, had stabilized the state's currency. For a year and a half, Wisconsin suffered from the economic and financial crises, but it was not alone. The East also suffered. In the Midwest, Illinois, Indiana and Missouri were hit hard as well.

In the end, the crash of 1861 was a blessing for Wisconsin. It provided an opportunity to reform banking and currency practices that were inherently weak. By 1863, the increased demand of the needs of huge Federal armies had brought full employment to Wisconsin, and the economic crisis lifted.[126]

PRICES AND WAGES

Industrial workers in the state did not fully share in the prosperity that followed 1863. Prices rose faster than wages. The lag between wages and prices led skilled labor to organize for the first time in Wisconsin. This occurred mainly in Milwaukee, where of course, most skilled workers

were concentrated. Between 1863 and 1865, the bricklayers and masons, carpenters and joiners, machinists and blacksmiths, custom tailors, iron molders and sailors formed organizations to protect their interests. The printers and the cigar-makers who had organized before the war and the ship carpenters and caulkers, who organized in 1861, became more outspoken and aggressive in their tactics.

During 1864 and 1865, the printers, bricklayers, masons, iron molders and sailors in Milwaukee struck for higher wages. Although concentrated in Milwaukee, the union activity spread across the state, with sawmill operators in Oshkosh and custom shoemakers in La Crosse, Madison and Portage also striking.

The situation improved in 1864 and 1865 as more troops were sent to the front (and consequently out of the labor market). In the last year and a half of the war Wisconsin sent to "the seat of war" as many soldiers as it did in the previous two and a half years. As this was happening, the expanding industries in the state needed more workers, which resulted in a scarcity of labor. Wages for unskilled labor rose from $1.25 a day in the spring of 1864 to $1.75 per day in the fall.

In the spring of 1865, when it became clear that the war would soon end, prices fell, reaching their lowest point during the summer. Wages stayed the same, however, leaving labor in a better position than it had been in years. It is estimated that during the war prices rose about 100 percent in the North

A Civil War–era print of LaCrosse, Wisconsin, showing the economic activity of the Mississippi River town. *Library of Congress.*

as a whole, while wages in Wisconsin rose 60 to 75 percent, better than in many other parts of the North.

When the war ended most of the Union army was mustered out in the summer of 1865. This meant about forty thousand Wisconsin soldiers returning home. Fortunately, they came home during the late summer and autumn and were "readily absorbed by the harvest fields."

The influx of ex-soldiers still did not fill the demand for farm labor. On January 11, 1866, Governor Lucius Fairchild, former colonel of the Second Wisconsin Infantry, speaking of the country as whole, noted, "A million of men have returned from the war, been disbanded in our midst and resumed their former occupations, and yet from all sides we hear the surest of all signs of national prosperity, complaints of the scarcity of labor."[127]

WHEAT

When the Civil War began cotton may have been king in the South, but wheat was king in Wisconsin. In 1864, J.C. Kennedy, superintendent of the 1860 census, declared, "There can be no doubt that the West, directly or indirectly, is the source of all the wheat that is exported from the United States, and this in addition to supplying New England with breadstuffs." The 1860 harvest was the greatest crop in state history. Approximately twenty-eight million bushels were harvested, almost twice that of any previous harvest.

The grain surplus, the *Milwaukee Daily Wisconsin* noted on November 1 1861, "put England and France under bonds to keep peace with us," and the money financed the war effort. "The farmers of the Northwest, in producing this surplus grain, have fought a battle for the Union of greater significance than any possible achievement of the Grand Army of the Potomac," it declared. Wheat, which sold for $0.70 a bushel during the summer of 1861, sold for $1.18 in October 1863.

From 1860 to 1865, Wisconsin produced approximately 100 million bushels of wheat, two-thirds of which was exported. Wheat dominated Wisconsin agriculture.[128]

THE REAPER REVOLUTION

What made the wheat surpluses possible, with the loss of thousands of able-bodied farm workers to the army, were the mechanical reapers and mowers. They revolutionized agriculture. Brought into Wisconsin in 1844, mechanical reaping equipment was particularly well suited to the broad, level prairies of the Upper Midwest and its emphasis on mono-cropping.

In 1860 about three thousand reapers of differing designs, but all using McCormick reaper patents, were sold in Wisconsin. The majority of farmers in Wisconsin still sowed and reaped by hand. The war, however, stimulated the use of the mechanical agricultural equipment. The *Wisconsin State Journal* explained on May 6, 1861:

> *But this season the prospect is almost certain, that many thousands of our most active and efficient harvest hands, the very bone and sinew of the harvest fields, will be called away to other fields of toil and danger.... The only way to make up for short manual help, is to substitute as far as possible, the horses and machinery....Every good reaper counts daily equal to from five to ten men. Hence the thousands of reapers in the State, represent from five to ten times as many thousand men.*

The threshing machine manufacturer Jerome I. Case built his factory in Racine. Originally from the East, he began threshing grain for farmers in Racine County in 1842. By the beginning of the Civil War, the J.I. Case factory was one of the largest in the Northwest. At the end of the 1860s, it was one of the largest in the country.

In 1860, the J.I. Case Company produced 300 threshing machines, 500 in 1865 and 1,300 in 1870. At Horicon, Wisconsin, the Van Brunt Company manufactured 60 seeders in 1861, 700 in 1863, 1,300 in 1866 and 3,800 in 1869. In Madison, E.W. Skinner & Company began the manufacture of sorghum mills in 1861 with a single mill. In 1863, it built 100—in 1865, 500. During the Civil War, a mechanical farming revolution took place in Wisconsin.

In 1868, the secretary of the Wisconsin State Agricultural Society observed that "the mechanical branch of agriculture, we may safely assert...has made more progress during the years embraced in this Report [1861–68] than ever before within the same length of time."

Economic historian Frederick Merk wrote, "The importance of agricultural machinery in the economy of the war can scarcely be overemphasized." A.

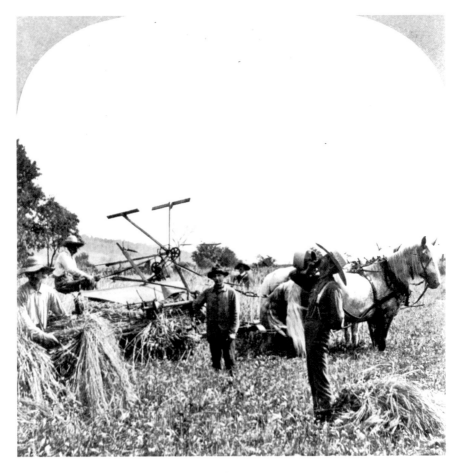

A mid-nineteenth-century reaper. *Library of Congress.*

single mechanical reaper released half a dozen men from the harvest fields. "It is impossible to conceive," he noted, "how the enormous wheat crops of the war period could have been garnered" without it.[129]

BREWING

The Civil War stimulated the brewing industry not only in Wisconsin but also across the country. In the early nineteenth century, prior to large-scale German immigration to the United States, the beer known by most Americans was the dark English-style ale, which was not as popular as hard cider or liquor.

The German immigrants introduced a new kind of beer: the lager. It was a lighter beer, in taste and color, and had a lower alcohol content. Prior to the war, it was almost exclusively drunk by German-speaking immigrants. As tens of thousands of German American soldiers joined regiments and traveled throughout the country, non-Germans were exposed to the drink for the first time and developed a taste for it. It might be a slight exaggeration, but as historian Maureen Ogle puts it, "This war was fought with beer."[130]

The first beer was brewed in Milwaukee in 1841. In that decade, ten breweries were established in Milwaukee. By 1860, Wisconsin was producing 36,000 barrels of beer. By 1865 it had increased to 55,000 barrels and, in 1873, to 260,000 barrels. A "hop craze" swept Wisconsin from 1864 to 1870.

It was during this time that Wisconsin became known for its beer and the names that "made Milwaukee famous." In 1863, the Pabst Brewing Company produced 3,677 barrels; in 1865, 10,908 barrels; and in 1873, 100,028 barrels. By 1872, Pabst was the largest brewer in America. The Joseph Schlitz Company produced 1,605 barrels in 1862, 4,400 in 1865 and 32,608 in 1872.[131]

CHEESE

Another Wisconsin product that rose to the fore during the Civil War was cheese. The fields of eastern and southern Wisconsin experienced soil exhaustion due to the intense wheat cultivation. This, in addition to high prices paid for cheese during the later years of the Civil War, caused many farmers to substitute "the cow for the plow."

Milwaukee exported butter for the first time in 1858. In 1861, 637,706 pounds were shipped—in 1865, 1,263,740 pounds. During this time, the "American factory system of associated dairying" came to Wisconsin. In 1864, Chester Hazen, an immigrant from New York, established the first cheese factory in Wisconsin at Ladoga, in Fond du Lac County. In his method, the milk of entire neighborhoods was collected and manufactured into cheese or butter by an expert.

By the end of the Civil War, thirty cheese factories were operating in Wisconsin, primarily in Kenosha and other southeastern counties. By the end of the 1860s, more than one hundred were operating throughout the state. Dairies in Wisconsin increased their production from 1,104,300

pounds of cheese in 1860 to approximately 6,000,000 pounds in 1871, reaching almost 10,000,000 pounds in 1873. The output of butter increased from 13,611,328 pounds in 1860 to 22,473,036 pounds in 1870.[132]

MEATPACKING

It was also in the decade of the Civil War that Milwaukee became an important meatpacker. Companies such as Plankington and Armour built packing plants in the 1860s that were some of the largest in the country. Using hogs from Wisconsin, Iowa and Minnesota, these companies sent barreled pork, lard and hams to the East as well as England.

In 1860, Milwaukee packers butchered 60,129 hogs. In 1866, it rose to 133,370. By 1871, it had reached 313,118—a fivefold increase in eleven years. In the decade that began with a civil war, Milwaukee rose from "comparative insignificance" to fourth among the pork-packing centers in the country.[133]

WOOL

Sheep husbandry also prospered during the Civil War. Wool was in great demand because it replaced Southern cotton and was needed by the Federal government for blankets and uniforms. Wisconsin fleeces rose in value from $0.25 cents per pound at the beginning of the war to $1.05 by the fall of 1864. Wool production in the state increased from about 1,000,000 pounds in 1860 to 4,000,000 pounds in 1865. The number of sheep in the state rose from 332,954 in 1860 to 1,260,900 by the end of 1865. Wool shipped from Milwaukee, almost all of which was produced in Wisconsin, increased from 669,375 pounds in 1860 to 1,000,225 pounds in 1861 and 2,277,850 pounds in 1865. Increased production meant an increase in the number of mills. In 1859, there were fifteen in Wisconsin. By 1865 there were nineteen. In 1871 there were fifty-four.

It was during the period of the Civil War that economic and cultural changes began that were to give Wisconsin its unique character. The tragedy and the costs of the Civil War stand in contrast to the establishment of industries and culinary and cultural traditions that last to this day.[134]

The Battlefronts

West

Oh, Sarah, you cannot imagine the horror of war. No pen nor tongue can begin to tell the misery that I have seen. For the last two days we were placed in a corn-field on a hill between our battery and the enemy. Was ordered to lay down and lay their until the enemy got within four rods of us, and then we fired on them and retreated back to the foot [of] the hill. But the rebels came on us with such numbers that we had to retreat. The result of the battle is that they whipped us on the left—and we whipped them—about 100 killed, wounded, and missing… Now, Sarah, you must not worry about me. I am slightly wounded in the foot. Had one of my toes taken off. This morning am in some pain now, but think I will get around in the corse [sic] of six weeks.
—Charles W. Carr, Twenty-First Wisconsin Infantry[135]

Most of Wisconsin's military units served in the area west of the Appalachian Mountains. The East had the Iron Brigade; the West had the numbers. The first year of the war in the West saw campaigns in Kentucky, Tennessee and northern Mississippi. Wisconsin regiments took part in all of these.

The Fourteenth, Sixteenth and Eighteenth Wisconsin Infantry were the first Wisconsin regiments to experience battle in the West. The Sixteenth Wisconsin Infantry was organized under Colonel Benjamin Allen and arrived at Pittsburg Landing, Tennessee, on March 20, 1862. It was attached to Colonel Everett Peabody's Brigade of Brigadier General Benjamin M. Prentiss's Division of Major General U.S. Grant's Army of the Tennessee. As part of Prentiss's Division, it fought at what became known as the Hornet's Nest at the Battle of Shiloh on April 6, 1862.

The McGillin brothers, from Eau Claire, enlisted in Company G, Sixteenth Wisconsin Infantry. Michael (*left*) enlisted on October 12, 1861, and Thomas on December 5, 1861. At Shiloh, Thomas received severe wounds in both legs. The following October, Michael was wounded in the left cheek at the Battle of Corinth. Both survived the war and were mustered out at Savannah, Georgia, on December 20, 1864. *Civil War Museum, Kenosha, Wisconsin.*

The after-battle report by Colonel Allen describes the determined but ultimately doomed holding action carried out by the Federal regiments that first met the overwhelming Confederate attack:

> We…delivered our fire with great effect, checking the advance of the enemy on our front, until we were ordered by Gen. Prentiss to fall back,…forming my second line about 40 rods in front of my camp….We maintained this position against a greatly superior force of the enemy until again ordered to fall back. I made my next stand directly in front of our camp….A desperate conflict here ensued, in which Lieut. Col. Fairchild was wounded in the thigh and carried from the field. I also had my horse shot under me and my second horse was shot dead as I was about to remount. I was again ordered by Gen. Prentiss to fall back, take to the trees, and hold the enemy in check as much as possible until re-enforcements could arrive. My men immediately took to the trees and fell back slowly, firing upon the enemy…. My men were nearly exhausted, having been engaged since 6 o'clock without food or water, contesting the field inch by inch with a greatly superior force of the enemy….This position we maintained until we were flanked by the enemy on our left and were compelled to fall back. In this engagement I received a wound, the ball passing through my left arm, a little below the elbow, and I was obliged to leave the field about 3 p.m.[136]

At Shiloh, the Sixteenth Wisconsin Infantry lost more than 200 men killed and wounded. The Eighteenth Wisconsin Infantry arrived at Pittsburg Landing, Tennessee, on April 5, 1862, the day before the battle. Although the Eighteenth had not been assigned to a brigade, it fought in the battle, losing 250 men. The regiment was not only inexperienced but also untrained. Governor Louis Harvey, visiting wounded soldiers from Wisconsin, wrote in a letter published in the *Wisconsin State Journal* that "many of the men heard the order to load and fire for the first time in their lives, in the presence of the enemy."[137] A week after the battle, Sergeant Calvin Morley of Company C wrote to his family:

> Some of the wounded laid on the field from Sunday morning until Tuesday, in the rain….The wounded are generously taken on the boats. Those who die during the night are brought on shore and laid on the bank in rows. The carts for carrying the dead are constantly running and hundreds and thousands will thus be disposed of and their friends never know what became of them. Hundreds would recover if they had proper treatment and

care. A bandage and cold water is all they get....It is an awful sight to see the ground covered with dead and dying—mangled in all shapes—some with an arm off, some with severed heads and others with both legs cut off. In one place I saw five rebels killed with a cannon ball. I saw many of them with broken limbs, left to linger out a few days of pain and die for want of medical aid.[138]

The Fourteenth Wisconsin Infantry had arrived at Savannah, Tennessee, on March 28, 1862. On the morning of April 6, 1862, the regiment could hear the sound of cannon and rifle fire coming from Pittsburg Landing, only nine miles away. The regiment, with Brigadier General William "Bull" Nelson's division, marched overland to a point opposite the landing, arriving at 11:00 p.m. It crossed the river and formed a battle line and spent the night, like everyone else, in a heavy rain. Early the next morning, the regiment was temporarily attached to General Crittenden's division and ordered to the front. During the day, the Fourteenth was "constantly engaged" and made three separate charges on a Confederate artillery battery, finally capturing it. During the day, the Fourteenth Wisconsin Infantry lost more than ninety men killed or wounded and earned the sobriquet of "Wisconsin Regulars"

The men of Company B, Eighteenth Wisconsin Infantry. The twenty-four pictured here may be the full strength of the company. The company commander is on the left, with the sash. The drummer, in a shell jacket, is on the right. *Wisconsin Veteran's Museum.*

because of their "soldierly conduct" during the battle. After the engagement, the Fourteenth remained at Pittsburg Landing, serving as provost guard.[139]

Later in the year, all three regiments took part in the Battle of Corinth, Mississippi, on October 3–4, 1862. The Sixteenth Wisconsin Infantry lost about forty men killed or wounded, the Eighteenth lost thirty men and the Fourteenth Wisconsin Infantry lost another ninety. Its brigade commander, Colonel John M. Oliver, wrote in his report that the Fourteenth Wisconsin Infantry was "always steady, cool, and vigorous" and was a regiment "to rely upon in any emergency." Of its actions during the battle, Oliver commented, "Though suffering more loss than any regiment in the command, they maintained their lines and delivered their fire with all the coolness and precision which could have been maintained upon drill."[140]

Both the Fourteenth and the Eighteenth Wisconsin Infantries joined the advance on Vicksburg. In the spring, the Eighteenth Wisconsin worked on the failed canal authorized by Grant to enable the army to pass below Vicksburg. The regiment then took part in the attack on Jackson, Mississippi, on May 14, 1863, losing about thirty men—a third taken prisoner—and the ensuing Battles of Champion's Hill on May 16 and the Black River Bridge on May 17, as well as the Siege of Vicksburg. The Fourteenth Wisconsin Infantry took part in the assault of May 22, 1863, losing one hundred men.[141]

Colonel Allen's Shiloh wound never properly healed, and he resigned on July 17, 1863. Lieutenant Colonel Cassius Fairchild, the brother of Lucius Fairchild, the commander of the Second Wisconsin Infantry, was placed in command of the Sixteenth. Through the summer and fall, the Sixteenth Wisconsin became so reduced by casualties and sickness that on November 3, 1862, it was consolidated into five companies. The Eighteenth Wisconsin, as a part of the Fifteenth Army Corps, marched 250 miles to Chattanooga and participated in the attack on Missionary Ridge on November 25, 1863. The following year, it took part in the defense of the Allatoona Pass on October 5, 1864, losing more than eighty-four men, at least seventy-seven of them captured. Most of the captured later died in Confederate prisons.[142]

The Sixteenth Wisconsin reenlisted as a veteran regiment over the winter and joined Major General Sherman's army in the Atlanta campaign. After the fall of Atlanta, both the Sixteenth and part of the Eighteenth Wisconsin Infantries took part in Sherman's March to the Sea, with the Sixteenth "doing its share towards the destruction of the railroads."

Part of the Eighteenth Wisconsin took part in Sherman's March to the Sea and the Carolina campaign. The part that stayed in Tennessee joined Sherman at Goldsboro, North Carolina, in March 1865. The regiment took

part in the Grand Review in May 1865, returning to Madison on May 29 where it was publicly received and disbanded. During its service, 276 men died in the regiment, more than 60 of them killed or mortally wounded in battle. The Sixteenth was mustered out in July 1865. It lost 393 men, 141 of whom were killed in battle or died of wounds.

In March 1864, the Fourteenth Wisconsin Infantry joined the Red River Expedition and in July, the Tupelo, Mississippi expedition, engaging with Confederates on July 13, 14 and 15, 1864. In November, the regiment was transferred to Nashville and took part in the Battle of Nashville on December 15–16, 1864. In January 1865, it was transferred to New Orleans and took part in the Mobile campaign and the siege and capture of Spanish Fort on April 8, 1865. It was mustered out in October 1865 in Mobile, Alabama. During its service, the Fourteenth Wisconsin Infantry lost a total of 301 men, a third of them in battle.[143]

One of the more well-known Wisconsin regiments to serve in the West was the Eighth Wisconsin Infantry, known as the "Eagle Regiment." It was called the Eagle Regiment because it carried a live bald eagle named Old Abe as a mascot. In the spring of 1862, the regiment joined Major General Halleck's forces during the Siege of Corinth, Mississippi. It lost two dozen men. At the Battle of Corinth on October 3, 1862, the regiment "held the enemy at bay and under a most terrific fire" losing more than eighty men.

During the Vicksburg campaign, the Eighth was sent to Young's Point, Louisiana, and was "actively engaged" until the surrender of Vicksburg on July 4, 1863. Afterward, it took part in the Meridian, Mississippi campaign and the Red River campaign in March and May 1864. In November 1864, it took part in the pursuit of Confederate general Sterling Price in Arkansas and Missouri then was transferred to Nashville to reinforce the army under General Thomas. It fought in the Battle of Nashville December 15–16, 1864, losing sixty men, and then took part in subsequent pursuit of Confederate General Hood's forces.

The Eighth was sent to help forces trying to take Mobile, Alabama, and participated in the siege of Spanish Fort, the assault and capture of Fort Blakely on April 9 and of Mobile on April 11, 1865. After the Mobile campaign, the Eighth stayed in Alabama until September 1865, when it was mustered out and left for Madison and disbanded. The regiment lost a total of 272 men, 53 killed in action or dead of wounds.[144]

Most of Wisconsin's light artillery batteries served in the West. Those that were most active were the First, Third, Fifth, Sixth, Seventh, Eighth, Tenth and Twelfth Light Artillery. Two of the first to experience battle were

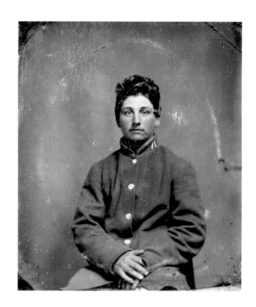

An unidentified, youthful soldier of the Eleventh Wisconsin Infantry. *Wisconsin Veteran's Museum.*

the Fifth Wisconsin Light Artillery and the Tenth Wisconsin Light Artillery. The Fifth Wisconsin Light Artillery was organized under the command of Captain Oscar Pinney of Monroe, Wisconsin, and took part in the Siege of Corinth and the Battles of Perryville, Stones River and Chickamauga. Later, it was at the Siege of Chattanooga. On January 2, 1864, enough men reenlisted for it to become a veteran unit. The veterans took part in Sherman's Atlanta campaign, ending at the Battle of Bentonville in North Carolina in 1865.

Captain Joseph McNight commanded the battery at the end of the war. In his report detailing the actions of the battery during Sherman's Atlanta campaign, which McNight considered "the longest and most arduous" of the war, he noted that the battery had fired 4,232 rounds while suffering only four slightly wounded "and perhaps a dozen others struck with spent balls or pieces of shell, and none prisoners of war." During its service, twenty-four men of the battery died. Five were killed in action or died of wounds, and nineteen men died from disease.[145]

The Tenth Wisconsin Light Artillery was organized at New Lisbon, Wisconsin, under Captain Yates Bebee. In early 1862, it joined Federal forces in southern Tennessee after the Battle of Shiloh, serving at the Siege of Corinth and at Iuka, Mississippi. It was then assigned to garrison duty at Nashville. The battery escorted forage trains and did guard duty in central Tennessee and northern Alabama through the winter and spring. Early in May 1864, the battery was assigned to Kilpatrick's Cavalry Division of the

Army of the Cumberland and took part in the Atlanta campaign and the March to the Sea. It marched 520 miles and came under fire seven times. It lost one wagon, fifty horses and one caisson but captured two horses, ten mules and two cannons.[146] Private John Murray, a thirty-four-year-old native of Ireland, wrote a letter to his mother on December 19, 1864, describing the march. After describing how "our men burned all the large houses within my view," he admitted:

> *Our men take horses, sheep, oxen, goats, hogs, chickens, geese, turkeys. What they cannot drive they kill and leave to rot by the way side....There is very few people to be seen. The men all taking arms and going into the army.... There is not mothers in the houses but old women and children. The houses are set fire to. The flour and meal is scattered through the hills. The corn cribs are burned to ashes. Everything is destroyed. Could you people North but see the gray hairs of an old woman her beggin [sic] that she might be allowed one bushel of corn meal...to support her tattering frame a few days longer, I think it would make you pray for this war to be ended. The history of this war when written, if written truly, will be dreadful to look at. People are robbed of watches, rings, money, and clothing. Girls' overdresses...[and] children's shoes...are either burned or thrown down stream or left in the woods to rot. The churches are broke open and the pulpit robbed of its ornaments. But enough it may be imagined but never can be described the Horrors of this war....You see, a man never steals anything in the army, he merely captures it.[147]*

In his official report, General Sherman admitted his men were "a little loose in foraging" and "did some things they ought not to have done," yet he believed they "supplied the wants of the army with as little violence as could be expected."[148]

On January 28, 1865, the Tenth Light Artillery began the march through the Carolinas. The battery participated in many actions and lost a man killed in action in February. On March 10, 1865, the Tenth Wisconsin Light Artilley was surprised in camp by General Wade Hampton's cavalry and had ten men taken prisoner, thirty horses killed and captured and one gun disabled.

The battery reached Bentonville, North Carolina, on March 22, 1865. In the nearly five hundred miles the battery traveled, it drew only five days' rations of "hard bread" and eight of coffee; otherwise, it subsisted "almost entirely on the country."[149]

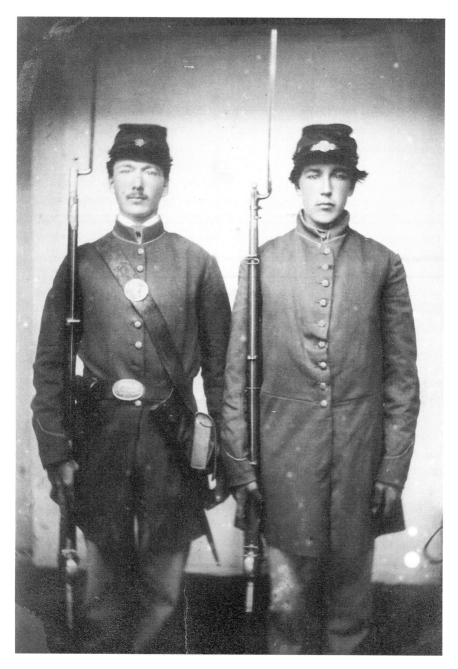

Brothers Herman and Lewis Gudmundsen from Dunkirk, Wisconsin, aged twenty-two and nineteen, respectively, enlisted into Company A, Twenty-Third Wisconsin Infantry on August 15, 1862. Herman was taken prisoner at Mansfield, Louisiana, on April 8, 1864, and mustered out on June 21, 1865. Lewis died from disease in New Orleans on October 13, 1863. *Wisconsin Historical Society.*

The soldiers who chose not to reenlist were ordered to Madison on April 13, 1865, and mustered out. Veterans and recruits were transferred to the Twelfth Wisconsin Light Artillery and mustered out in June 1865. During its service, twenty-eight men of the battery died. Two were killed in action, and twenty-six men died from disease.[150]

Another infantry regiment of note was the Seventeenth Wisconsin Infantry. It was organized under the command of Colonel John L. Doran and took part in the advance on Corinth and the siege that followed. Many of its members were Irish immigrants. Like other Wisconsin regiments, the Seventeenth took part in the Battle of Corinth on October 3, 1862, where it charged a Mississippi brigade of four regiments, driving them "a considerable distance." The regiment lost twenty-five killed and wounded.

During the Vicksburg campaign it took part in the assault of May 17, 1863, "exposed to a murderous fire of musketry and artillery." The regiment worked its way "over fallen timber and broken ground," reaching a ravine—within seventy-five yards of the Confederate works— which it held for two hours. "Owing to a misunderstanding," the rest of the brigade did not follow, and the Seventeenth "withdrew in good order." The regiment lost more than fifty men.

In January 1864, seven-eighths of the regiment reenlisted, making it a veteran regiment. On May 5, 1864, the Seventeenth Wisconsin Infantry was assigned to Sherman's army and, like so many other Wisconsin regiments, participated in the Atlanta campaign, fighting at Kennesaw Mountain and Jonesborough. It took part in the March to the Sea and the campaign in the Carolinas, ending its service with the Grand Review in Washington in May 1865. Its loss during its service was 240 men, 39 of whom were killed in battle or died of wounds.[151]

The Sixth Wisconsin Light Artillery and Twelfth Wisconsin Light Artillery, like a number of other Wisconsin regiments, received their baptism of fire at the Battle of Corinth in October 1862. The Sixth Wisconsin, also known as the "Buena Vista Artillery," was organized by Captain Henry Dillon of Lone Rock and sent to New Madrid, Missouri, in late March 1862. After the surrender of Island No. 10, the Sixth was transferred to Corinth, Mississippi, and participated in the siege that May. In the fighting of October 4, 1862, at Corinth, the battery fought bravely and suffered for it. When advancing Confederates were a few hundred yards away, the battery opened up with canister and explosive shells, "which swept destruction through their ranks, but did not check their advance in the least." The Confederates kept advancing with the battery, "pouring in a steady fire of canister at short

range." Several of the men in the battery were killed or wounded. As a contemporary historian wrote, "The men were exposed on open ground, without protection of any kind, but there was no faltering or giving way." Captain Dillon had his horse shot from beneath him. Unable to remove the cannon, Captain Dillon ordered the limbers and caissons to the rear. Lieutenant Daniel T. Noyes of Spring Green, wounded and left on the field, was reportedly bayoneted by the Confederates. The Sixth Wisconsin Light Artillery lost five men killed and twenty-one wounded. The cannons were recovered after the Confederates withdrew.

In early in 1862, William A. Pile, a Missouri chaplain, received permission from Governor Louis Harvey to recruit a company for the First Missouri Light Artillery Regiment, to be known as the Twelfth Wisconsin Light Artillery. Organized in Madison, it was sent in squads to Jefferson Barracks, Missouri. Part of the battery participated the Siege of Island No. 10 in early April 1862. The two sections left at Jefferson Barracks joined the Siege of Corinth in May 1862. Captain William Zickrick was given command of the battery and furnished with four ten-pounder Parrot guns on August 11, 1862.

The battery took part in the Battle of Iuka on September 19, 1862. The men were commended by their divisional commander Brigadier General Charles S. Hamilton for the "unyielding skill and bravery they displayed in handling their guns." The battery also took part in the Battle of Corinth, Mississippi, on October 4, 1862. It occupied an elevated and exposed position firing on advancing Confederates with shell and case shot. As the Confederates came nearer, the guns fired double loads of canister causing "terrible destruction." The battery held the position through the battle without losing a man. First Sergeant Samuel E. Jones and Corporal Marcus Amsden were "noticed" in the official report for their bravery.

The following year, the Sixth Wisconsin Light Artillery and the Twelfth Wisconsin Light Artillery both took part in Grant's Vicksburg campaign. The Twelfth crossed the Mississippi River below Vicksburg with Grant's army on May 1, 1863, and fought in the battle at Raymond on May 12. The Sixth fought at Jackson, Mississippi, on May 14 and Champion Hill on May 19, 1863. Afterward, it took part in the siege, losing one man killed by a Confederate sniper on July 3, 1863. The Twelfth was also outside Vicksburg and remained there until September when the battery was reinforced with two lieutenants and seventy-one recruits, mostly from Janesville.

On July 14, 1864, the Twelfth Wisconsin Light Artillery was assigned to the garrison at Allatoona Pass and participated in its defense on October 5,

1864. This is where it suffered its greatest number of casualties. Lieutenant Amsden, who commanded the battery during the fight, was mortally wounded. Private James Croft was awarded the Medal of Honor for taking the place of a gunner who had been shot and inspiring the others by his "bravery and effective gunnery."[152]

On November 15, 1864, the Twelfth rejoined Sherman's army in Atlanta and took part in the March to the Sea and the Carolinas campaign. It took part in the Grand Review at Washington and was transferred to Madison, Wisconsin, and mustered out in June 1865. During its service, thirty-two men of the battery died. Nine were killed or died of wounds, twenty-two men died of disease and one by accident.[153]

After the surrender of Vicksburg, the Sixth Wisconsin Light Artillery served in northern Mississippi and southern Tennessee and took part in the Battle of Missionary Ridge on November 25, 1863. It was engaged in garrison duty until the latter part of November 1864, when the battery was transferred to Nashville, Tennessee. It was on duty there during the Battle of Nashville, December 15–16, 1864. In February 1865, it was transferred to Chattanooga, Tennessee, where it remained until it mustered out. During its service, twenty-eight men of the battery died, six were killed in action or died of wounds, twenty men died from disease and two died from accidents.[154]

For a number of regiments, the Battle of Perryville (or Chaplin Hills) on October 8, 1862, was their baptism of fire. This included the First, Tenth and the Twenty-First Wisconsin Infantries. After fulfilling its three-month service, the First Wisconsin Infantry was reauthorized to serve for three years. It was mustered under Colonel John C. Starkweather, the same colonel from the three-month stint, and left the state for Louisville, Kentucky. On April 5, 1862, Colonel Starkweather was appointed to the command of the brigade the First Wisconsin was in. Lieutenant Colonel George Bingham then took command of the First, which was sent to Major General Buell's Army of the Ohio in Tennessee. In the fall of 1862, General Buell moved against Confederate general Braxton Bragg in Tennessee. The Battle of Perryville in Kentucky was the result.

The Battle of Perryville was the first real engagement for the reorganized First Wisconsin Infantry. It was also the baptism of fire for the Twenty-First Wisconsin Infantry. The Twenty-First was composed of companies enlisted from Fond du Lac, Winnebago, Outagamie, Waupaca, Calumet and Manitowoc Counties. Under the command of Colonel Benjamin J. Sweet, it was mustered in at Camp Bragg in Oshkosh and assigned to the same brigade as the First Wisconsin Infantry.

At Perryville, Colonel Starkweather formed his brigade on the left of the Federal line and was soon engaged. The First Wisconsin Infantry held the extreme left of the line. The Twenty-First was put about one hundred yards in front of the main line, between the two armies. As the Confederates attacked, they were met by a "spirited fire" from the Twenty-First. Colonel Sweet was severely wounded and Major Schumacher was killed. This left the regiment without a field officer to follow the orders of Colonel Starkweather. The Confederates attacked the regiment on both flanks, driving it back "with severe loss."

The First Wisconsin Infantry was advanced to the front, supported by the Seventy-Ninth Pennsylvania Infantry and an artillery battery. In the fighting, the artillery horses were killed or became unmanageable. Part of the First Wisconsin charged, and Private Rice of Company H captured the flag of the First Tennessee Infantry. The fire of the Twenty-Four Illinois Infantry and the Seventy-Ninth Pennsylvania Infantry held the Confederates at bay while the First Wisconsin withdrew every remaining cannon and caisson from the field by hand.

Generals McCook and Rousseau complimented Colonel Starkweather's brigade. The flag of the First Wisconsin Infantry was riddled by bullets and the flagstaff severed in two places. The color sergeant was badly wounded, and all but three of the color guard were killed or wounded. For its service in withdrawing the cannon of the Fourth Indiana Light Artillery, the First Wisconsin received the thanks of the battery and was given a full set of colors.[155]

At Perryville, the First Wisconsin Infantry lost more than 200 killed and wounded (half of the men engaged) and the Twenty-First Wisconsin lost 160.[156] Mead Holmes Jr. of the Twenty-First Wisconsin Infantry described the work of the burial detail after the battle:

> *The night of the 9th the dead were buried: thirty-three of our regiments were trenched—no coffin or marks, except sometimes a rail or stone....*
> *It seems hard to throw the men all in together, and heap dirt right on their faces, but it is better than to have them lay moldering in the hot sun. Oh! to see the dead rebels in the woods! From one point I counted thirty-one; in a fence corner twenty-four....In our short march we passed at least two hundred...to think of all those soldiers having friends who would give anything for their bloated, putrefying bodies, laying there crows and hogs tearing their flesh.*[157]

At Chickamauga, both regiments suffered terribly, losing three hundred men between them. They went into winter quarters at Chattanooga and, in May 1864, joined Sherman's advance on Atlanta, participating in many of the battles prior to the fall of Atlanta. At Dallas, on May 27, 1864; Kennesaw Mountain on June 21, 1864; and Jonesboro on September 1, 1864, the First Wisconsin Infantry lost a dozen men each time. The Twenty-First Wisconsin Infantry lost forty-eight men at Resaca on May 14, 1864; twenty-one at Atlanta on August 8, 1864; and thirty-one at Bentonville, North Carolina, on March 19, 1865.

The First Wisconsin Infantry was mustered out in October 1864, and the 368 recruits and men who reenlisted were transferred to the Twenty-First Wisconsin Infantry. During its service, the regiment lost 266 men, more than half of them in battle. This was unusual. Usually, more men died of disease than battle wounds. Not in the case of the First Wisconsin Infantry. By the time the Twenty-First Wisconsin Infantry was mustered out it had lost 295, more than 116 of them in battle.[158]

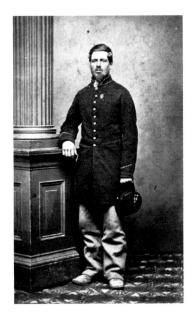

James Livingstone, from Roaring Creek, Wisconsin, enlisted in the Twenty-Fifth Wisconsin Infantry on December 26, 1863. He served in the western theater with his regiment and survived the war. *Civil War Museum, Kenosha, Wisconsin.*

Like the First and Twenty-First Wisconsin Infantries, the Tenth Wisconsin Infantry fought its first battle at Perryville. The Tenth was organized at Camp Holton in Milwaukee in the fall of 1861. Its first duty was to guard the Louisville & Nashville Railway until February 1862. At Perryville, the Tenth fought "under a heavy fire." At one point during the battle, it held its position for twenty minutes—despite having run out of ammunition—so an artillery battery it was supporting could be safely withdrawn. Of 276 men in the regiment, about 159 were killed or wounded. General Rousseau wrote in his report, "For this gallant conduct, these brave men are entitled to the gratitude of their country."

The Tenth Wisconsin Infantry also suffered grievously at Chickamauga, losing more than 200 men, many captured. At one point during the battle, it was fired on from the side and rear and forced to fall back. Not

knowing where the Confederates were, the regiment "ran into the lines of the enemy." Colonel Ely, Major McKercher and most of the officers and most of the men were captured. Captain Jacob W. Roby reported that on the morning of Monday, September 21, 1863, the regiment "numbered 3 officers and 26 men." The next day it was ordered to retire, with the brigade, to Chattanooga. Later that year, the Tenth took part in the Battle of Missionary Ridge on November 25, 1863. In the spring of 1864, the Tenth rejoined its division as part of the Fourteenth Army Corps and took part in the Atlanta campaign. In October, the men whose terms had not expired were transferred to the Twenty-First Wisconsin Infantry, and the Tenth returned to Milwaukee and was disbanded. In its service, the regiment lost 247 men, almost 100 of whom were killed or died of wounds.[159]

Another regiment that lost heavily at Chickamauga was the Fifteenth Wisconsin Infantry. This regiment was recruited mostly from the Scandinavian population of the state. "Scandinavian" generally meant Norwegian. The

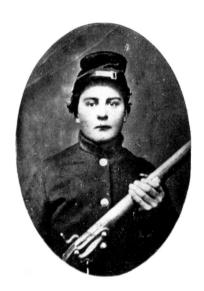

Louis Nelson Bolstad, of Cambridge, Wisconsin, enlisted in Company B, Fifteenth Wisconsin Infantry, on October 10, 1861, at the age of nineteen. Wounded at Stone's River on December 31, 1862, he was killed in action at Kennesaw Mountain on June 28, 1863. *Wisconsin Historical Society.*

regiment was commanded by Hans Heg, a Norwegian immigrant who entered politics in Wisconsin and became the first Norwegian-born candidate to hold a statewide office. Heg used his political and social contacts to raise a regiment of Scandinavian volunteers and was commissioned its colonel. Of the 890 men initially enrolled in the regiment, 115 had the first name Ole. Heg's brother Ole was the quartermaster of the regiment; his brother-in-law served as the surgeon; and the Reverend Claus L. Clausen, the pastor of the First Norwegian Lutheran Church, was its chaplain.

It left the state in March 1862 and supported the siege at Island No. 10, leaving two companies there to garrison it after its surrender. The regiment served in Kentucky, Tennessee and northern Georgia and was at the Battle of Perryville, Kentucky, on October 8, 1862, but suffered no losses. As part of the Army of the Cumberland, it fought at

Stone's River or Murfreesboro on December 30 and 31, 1862, and January 1, 1863. For five days, Colonel Heg's regiment fought or skirmished almost continually, losing 120 men. On May 1, 1863, the regiment was transferred to a brigade that Colonel Heg commanded. Lieutenant Colonel Ole C. Johnson took command of the regiment.[160]

At the Battle of Chickamauga on September 19, 1863, the Fifteenth Wisconsin Infantry was mistaken for a Confederate regiment by other Federal troops and fired on. At the same time, the Confederates began a heavy fire on them. In the midst of this "galling fire," the regiment broke and ceased to function as an organized unit, the men attaching themselves to other commands. Near sundown, Colonel Heg was wounded "by a shot in the bowels." He died the next day. The regiment lost more than one hundred men, reducing its strength to seventy-five. All the field officers were killed or wounded. Captain Grinager took command of the regiment. On September 21, 1863, Companies G and I, which had been at Island No. 10, rejoined the regiment. Their eighty men doubled the number of men in the regiment.

At the Battle of Missionary Ridge on November 25, 1863, the Fifteenth Wisconsin Infantry, in line with the other regiments, advanced "with a yell and cheer" and drove the Confederates from the ridge. The Fifteenth suffered only six men wounded. Afterward, the Fifteenth was ordered to march to Knoxville, Tennessee, under Major General Sherman to relieve Federal forces besieged there. After a tiring march of 110 miles, with few rations and in need of shoes and clothing, the men reached Knoxville on December 7, 1863. The regiment was so disheartened by its service that only seven men reenlisted. As one historian wrote, "There seemed to be an unnecessary amount of hardship put upon this regiment in that campaign."

In the spring of 1864, prior to its term of enlistment expiring, the regiment took part in Sherman's Atlanta campaign, losing seventeen killed and wounded at Resaca on May 14, 1864. At New Hope Church on May 27, 1864, the regiment charged "with a yell," reaching within ten feet of the Confederates' breastworks, but could not take them. The men of the regiment laid down within forty-five feet of the Confederates and kept up "an effectual musketry fire," holding their position until 9:00 p.m., when they fell back under orders. The regiment lost another ninety men.[161]

After the fall of Atlanta, the regiment performed picket and foraging duty before being sent to Chattanooga to guard the railroad bridges until mustered out. During its service, the Fifteenth Wisconsin Infantry lost more than three hundred men, almost a third of them battle deaths.[162]

Another Wisconsin unit to suffer heavily at Chickamauga was the Third Wisconsin Light Artillery, also known as the "Badger Battery." It was recruited in the Madison and Berlin areas under Captain L.H. Drury and organized at Racine. It left for Camp Irvine outside Louisville, Kentucky, on January 23, 1862, and trained there until March 10, 1862. It was equipped with four thirty-two-pound rifled cannons.

During its service, the Third Wisconsin Light Artillery served in Kentucky, Tennessee, Mississippi and Georgia, taking part in the Siege of Corinth, Mississippi, in the spring of 1862 and the Battle of Stone's River on December 30–31, 1862, and January 1–3, 1863. It was stationed at Murfreesboro, Tennessee, until July 5, 1863, when it took part in the Chickamauga campaign. The after-action report of the Battle of Chickamauga by First Lieutenant Cortland Livingston detailed how Confederate

> *musketry was soon telling with fearful effect upon our cannoneers and horses. They also brought two masked guns to bear upon us. I opened my whole battery upon these woods. The enemy made rapid movement under cover of a cornfield, and completely flanked us, pouring volleys of musketry. I lost 30 horses belonging to my first five pieces, which were also lost. One piece was pulled by hand into the woods, but we could not get away with it. I lost 1 horse in getting away with the sixth piece, which was the only piece saved.*

Livingston reported twenty-six men killed, wounded or missing. At least eleven of the missing were taken prisoner. Livingston collected his men and "moved on the ridge of the mountains until I struck the Chattanooga road." In his report, Livingston commended his men: "Great praise is due to our non-commissioned officers and privates, whose terrible loss in the short space of ten minutes testifies the terrible fire under which they were while working their guns. I cannot mention an instance of cowardice during the action."[163]

After the Battle of Chickamauga, the Third Wisconsin Light Artillery was placed in the defense of Chattanooga, taking part in the siege from September 24 to November 23, 1863. It remained there until April 1865, when it was assigned to garrison duty at Murfreesboro, Tennessee, then mustered out. During its service, twenty-five men of the battery died. Four were killed in action or died of wounds and twenty-one men by disease.[164]

One of Wisconsin's "fighting regiments" was the Twenty-Fourth Wisconsin Infantry, or the "Milwaukee Regiment." A historian noted that

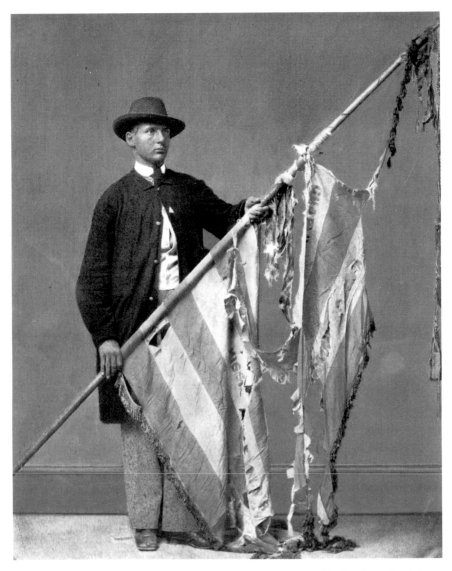

Edward Reed Blake, from Port Washington, was seventeen years old when he enlisted. As color corporal of the Twenty-Fourth Wisconsin Infantry, he protected the flag by wrapping it around his body and buttoning his coat over it. In this photo, Blake is holding the flag he carried into battle. *Wisconsin Veteran's Museum.*

"it was engaged in considerable hot work." About 100 men were killed and mortally wounded out of a total enrollment of 1,077—about 10 percent. In killed, wounded and missing, it lost more than 170 at Stone's River, more than 100 at Chickamauga, 30 at Missionary Ridge and 112 during the

Atlanta campaign; 80 men died of disease or accident. The Twenty-Fourth was one of the few regiments during the war that lost more men in battle than to disease. It was also distinguished by the fact that its adjutant, Arthur MacArthur Jr., would become one of the youngest brevet colonels in the war and win the Congressional Medal of Honor for his actions leading an assault on Missionary Ridge.[165]

Two other Wisconsin light artillery batteries that served in the West are worthy of mention: the First Wisconsin Light Artillery and the Seventh Wisconsin Light Artillery. The First Wisconsin Light Artillery was formed under Captain Jacob Foster around the nucleus of the "La Crosse Artillery," a "well drilled company" in La Crosse. The battery left for Camp Irvine near Louisville, Kentucky, where it was fully trained and equipped with six twenty-pound rifled Parrot cannons. In April 1862, it joined the Cumberland Gap campaign under Brigadier General Morgan. It first came under fire on August 6, 1862, during "a brisk skirmish" near Tazewell, Virginia, where its "well directed fire" caused charging Confederate infantry "to break and run."

The battery took part in Major General McClernand's attack on Arkansas Post on the Arkansas River on January 10, 1863. In his official report, Major General Osterhaus commented on one section of the battery commanded by Lieutenant Daniel Webster:

> *I consider it my duty to state that I never saw a better officer or better men serving artillery. Cool, deliberate and intrepid, they sent their shot against the enemy's stronghold, their commander controlling every round and its effect, the men quietly obeying his orders, without the very superfluous huzzaing and yelling, which is incompatible with the artillery service. I heartily congratulate Lieutenant Webster and his men upon their success. The reduction of the lower casemates and the silencing of three or four formidable guns are their exclusive merit.*[166]

Afterward, the First Wisconsin Light Artillery served in Grant's Vicksburg campaign. At the Battle of Bruinsburg on May 1, 1863, the battery held its position on Thompson's Hill "under a heavy fire" and succeeded in "dismounting" four Confederate cannons. One man, James A. Magill of Hokah, Minnesota, was mortally wounded, dying on May 5. It is interesting to note that the first two men to die from wounds in the battery were from Minnesota. Their hometowns of Caledonia and Hokah were near Lacrosse on the Minnesota side of the Mississippi River.

The First Wisconsin Battery, pictured here as it might be deployed on the battlefield. *From Miller's* Photographic History of the Civil War.

During the Siege of Vicksburg, the battery maintained a position close to the Confederate fortifications, "and by the accuracy of its fire," silenced most of the enemy's guns within range. It lost one man killed, Private Erasmus Rodman, on June 27, 1863.

In December 1863, the battery was assigned to the defense of New Orleans. The battery remained in New Orleans until April 22, 1864, when it took part in the Red River Expedition. It remained at Baton Rouge, Louisiana, until November 26, 1864, when it accompanied the cavalry expedition of Brigadier General John Davidson through Mississippi to Mobile, Alabama, returning to Baton Rouge on January 4, 1865. The battery remained at Baton Rouge until it returned to Wisconsin. It was mustered out at Camp Washburn, Milwaukee. During its service, thirty men of the battery died. Four were killed in action or died of wounds, twenty-five men by disease and one by accident.[167]

The Seventh Wisconsin Light Artillery was known as the "Badger State Flying Artillery." It was organized in Racine under Captain Richard Griffiths. From Racine it moved to St. Louis, Missouri, in March 1862 and was placed in charge of siege guns at Island No. 10 until the surrender of the Confederate fort on April 8, 1862.

The following December, the battery encountered Confederate general Nathan Bedford Forrest during his raid on Grant's communications. On December 20, 1862, Forrest's men captured thirty men of the battery, wounding three. Ten succeeded in escaping with their horses to Jackson, Mississippi.[168]

On December 31, two guns of the battery under the command of Lieutenants Wheelock and Hays again encountered Forrest's men, this time at Parker's Cross Roads. Under the fire of at least eight Confederate cannons,

the two guns kept up an effective fire until their ammunition was exhausted. The battery lost twenty men killed, wounded and taken prisoner.[169]

The Seventh Wisconsin Light Artillery returned to Jackson, Mississippi, where it was reequipped. Remaining at Jackson until June 1, 1863, it moved to Corinth, where it was employed in garrison duty until July 1, when it moved to Memphis. The battery mustered out in July 1865. During its service, thirty men of the battery died. Nine were killed in action or died of wounds, nineteen men died from disease and two were lost in accidents.[170]

THE TWENTY-SECOND WISCONSIN INFANTRY AND JOHN DEARBORN WALKER

The Twenty-Second Wisconsin Infantry regiment was recruited almost entirely in southern Wisconsin from Rock, Racine, Green and Walworth Counties and was particularly antislavery in its sentiment. It left the state on September 16, 1862, to serve in Kentucky.

On March 25, 1863, the regiment, under the command of Colonel Edward Bloodgood, was attacked by overwhelming numbers and forced to surrender. The officers and men were sent to Southern prisons. They were exchanged in May 1863 and sent to St. Louis in June. The regiment was reequipped and returned to the field in Tennessee. It took part in Sherman's Atlanta Campaign as part of the Twentieth Corps. It fought well at Resaca, its first real battle, losing about 70 men. It fought again at Dallas, Kennesaw Mountain and Peach Tree Creek, losing another 100 men. Like so many of Wisconsin's regiments, the Twenty-Second Wisconsin Infantry took part in Sherman's March to Savannah, ending with the Carolina campaign and the Grand Review in Washington. During its service, the regiment lost 231 men, more than a quarter of them in combat.[171]

One of the more renowned members of the Twenty-Second Wisconsin Infantry was John Dearborn Walker. Born in 1851 in Pennsylvania, his parents moved to Racine when he was young. John enlisted in the Union army on September 1, 1862. He was eleven. He was one of the youngest, if not the youngest, soldier in the Union army during the Civil War.

John, who claimed he was fourteen, was taken in as a musician and became a drummer with Company B. He listed his occupation when he joined as "school boy" and was four feet, three inches tall. He was captured at Brentwood, Tennessee, with the rest of the regiment and then exchanged.

 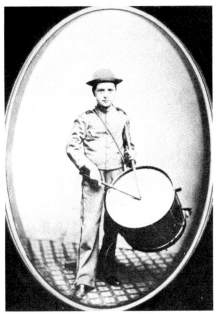

Left: Jesse L. Berch (*left*) of Racine and Frank M. Rockwell of Geneva, of the Twenty-Second Wisconsin Infantry, with the young mulatto slave girl they escorted from Kentucky to the home of Levi Coffin, an Underground Railroad operator in Cincinnati, Ohio. She was eventually sent to Racine, Wisconsin. *Library of Congress*.

Right: John Dearborn Walker. One of the youngest Union soldiers to enlist. *Public domain*.

He was sick for most of 1863 and was discharged for disability on December 28, 1863, at the age of twelve. His discharge papers labeled his sickness "conjunctivitis and chronic catarrh."

The following year, John's health returned. He reenlisted as a musician in Company K of the Eighth Wisconsin Infantry on July 25, 1864. He stayed with that regiment until the end of the war. He was mustered out on September 5, 1865, at the age of fourteen, standing five feet, seven inches tall.[172]

9

THE HOMEFRONT

The Draft and Draft Resistance

THE DRAFT

By the summer of 1862, it was clear the North needed more manpower to defeat the Confederacy. On June 28, 1862, eighteen Northern governors, including Edward Salomon of Wisconsin, sent a letter to President Lincoln asking him to call for more troops. In view of the "reduced condition" of the forces in the field, they requested that Lincoln "call upon the several States" for as many men as required in order to "speedily crush the rebellion that still exists in several of the southern states…restoring to the civilized world our great and good government."

As a result, on July 2, 1862, Lincoln called for 300,000 troops for three years' service. The quotas required from each state were in proportion to its population. Wisconsin's quota was 11,904. The goal was to fill "the old regiments," which had been depleted by the campaigns that year.

Part of the effort to get more men was the Militia Act of July 17, 1862. It authorized the enlistment of African Americans as laborers and soldiers and required governors to draft citizens into state militias to meet their federal manpower quotas. The Militia Act was strongly opposed by "Peace Democrats" because of the draft component. Shortly after its passage, it was also noticed that unusually high numbers of draft-age men (eighteen to forty-five) wanted to visit Canada. On August 8, 1862, Secretary of War Edwin Stanton ordered that "until further order no citizen liable to be

Governor Edward Salomon. *Wisconsin Veteran's Museum.*

drafted into the militia shall be allowed to go to a foreign country." Men caught trying to leave the country were arrested and "conveyed to the nearest military post or depot and placed on military duty for the term of the draft." The secretary also ordered the writ of habeas corpus suspended "in respect to all persons so arrested and detained, and in respect to all persons arrested for disloyal practices." Lincoln affirmed Stanton's suspension of the writ of habeas corpus with his own proclamation on September 24, 1862. It made "resisting militia drafts" a crime subject to military court, not a civil court.[173]

By August 1862, it was clear that states were struggling to meet their quotas. It was also clear that most of the recruits were entering newly formed regiments instead of old ones. This was because the governors didn't understand that the Federal government wanted the old regiments filled first, and as Colonel James B. Fry, provost marshal general of the U.S. Army, noted, "Without the stimulus of commissions in new regiments, individual efforts, heretofore so successful in raising men, would not be made by influential parties in different localities."

As a result of the "failure" of the July 2 call, on August 4, Lincoln called for 300,000 militia to serve for nine months. This was considered a militia call-up, like the original call for 75,000 in 1861. On August 4, 1862, the War Department issued General Order No. 94 specifying that if any state did not fill its quota by August 15, 1862, it would be filled "by special draft from the militia." This was the draft authorized on July 17 in the Militia Act opposed by so many.

Wisconsin's quota for the August 4 call was 11,904 men, the same number as for the three-year volunteers called for on July 2. Prior to these calls, Wisconsin's combined quotas were 21,753, which made a total of 45,561 troops required by the Federal government through 1862. Wisconsin hoped to fill it with volunteers and not have to draft.[174]

On August 8, 1862, the secretary of war ordered Governor Salomon to enroll all "able bodied citizens" between eighteen and forty-five in Wisconsin

by county. Governor Salomon appointed a draft commissioner and surgeon for each county. The draft rolls were to be compiled by the county sheriffs and finished by September 1, 1862.

When they were finished, it was determined that the total number of Wisconsin men subject to military duty was 127,894. Of these, 28,012 were exempted by draft commissioners. Another 299 men were exempted by the governor "on account of errors in returns." The counties "claimed" 41,529 men as having volunteered. (A review by the adjutant general's office the following year would show that this number was not accurate, however.) In the end, Wisconsin determined that 4,594 men needed to be drafted.[175]

Various states allowed exemptions from military service. New York and Pennsylvania, for example, allowed Quakers, Shakers and Mennonites to claim a conscientious objection. New York also exempted "idiots, lunatics, infamous criminals, habitual drunkards, and paupers."[176] Wisconsin allowed exemptions from military service for various reasons, such as for active and retired firemen, those who had or held militia commissions in any state and physical disability. The exemption of firemen and militia officers became a problem. Governor Salomon wrote to the War Department in August 1862 asking if those exemptions could changed: "The number of firemen in companies is unlimited, and those companies are being filled by shirks at a fearful rate." He also noted, "We have a very large number of these paper officers who ought not to be exempt."

Foreign-born men who were not yet citizens also came into question. On August 12, 1862, Governor Salomon, himself a German immigrant, wrote to Secretary of War Stanton that "about one-half of the able-bodied men between eighteen and forty-five years in this State are foreign born." He noted that they had declared their intentions to become U.S. citizens and have "the right to vote under our State constitution if twenty-one years old." "Are they liable to be drafted?" he asked. "They should be liable. Great injustice will be done to our State if they are exempt, and our quota would be too large if they are exempt." That same day, Stanton replied, "Foreigners who have voted at our elections are regarded as having exercised a franchise that subjects them to military duty." If men simply declared their "intention to become naturalized" but had not yet voted, they could take "advantage of their alienage." "But," Stanton declared, "a man who votes must bear arms."[177]

In order to increase volunteerism, the state authorized towns and counties to pay bounties to volunteers. Many towns filled their quotas by offering

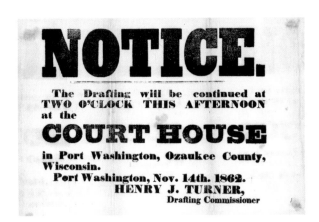

NOTICE.

The Drafting will be continued at TWO O'CLOCK THIS AFTERNOON at the

COURT HOUSE

in Port Washington, Ozaukee County, Wisconsin.
Port Washington, Nov. 14th. 1862.
HENRY J. TURNER,
Drafting Commissioner

Draft notice. *Wisconsin Historical Society.*

bounties. "It became quickly apparent that the draft was not intended as the primary source of man power," wrote a historian of the Union army. "Rather it was merely a whip to encourage volunteers."[178]

Several states began drafting in mid-September. Ohio was drafting by October 5. Indiana drafted on October 6. Violence broke out in Blackford County, a center of Copperhead activity. Rioters there destroyed the enrollment lists and the draft box. Indiana brought in three hundred soldiers to restore order. Wisconsin was the last state to begin drafting.[179]

On October 21, 1862, Governor Salomon ordered that the draft start on Monday, November 10, at 9:00 a.m. and continue daily until completed. Drafting was to be done by each county deficient in its quota.[180]

By the end of October (after the harvest), a little more than half of Wisconsin counties had filled their quote by volunteering; twenty-five had not and were given draft quotas. They were concentrated in counties in eastern and southern Wisconsin. The counties with largest "original" draft quotas were Washington (758), Milwaukee (727), Ozaukee (529) and Manitowoc (438). These counties had large numbers of German and Irish Catholic immigrants and would be scenes of anti-draft violence. Five other counties, four of which bordered Lake Michigan, also had significant draft quotas: Dodge (263), Sheboygan (205), Racine (194), Kenosha (180) and Brown (155), where Green Bay is located. There were also a few counties in southwest Wisconsin that failed to meet their quotas and had to resort to the draft: Iowa (223), LaFayette (148) and Dane (114), which is where Madison is located.[181]

THE PORT WASHINGTON AND WEST BEND DRAFT RIOTS

Ozaukee County, Wisconsin, is immediately north of Milwaukee County. The majority of its 15,682 residents were foreign born, most from Germany and Luxembourg. Saukville, a village a few miles west of Port Washington, was settled primarily by Norwegians. Of the fifty-eight counties listed in the 1860 census, fifteen had no "free colored" population; Ozaukee was one of them.[182]

Because of the demographics, Ozaukee County was heavily Democratic. In the election of 1860, Douglas received 1,823 votes to Lincoln's 627. In 1864, McClellan would receive 2,056 votes, Lincoln only 242.

Many of the residents of the county, especially the Luxembourg Catholic farmers, did not support the Lincoln administration and vehemently opposed the draft. To them, the Republicans represented abolition and nativism. The draft was particularly unpopular with them, as many had left Europe to escape compulsory military service and they believed the draft unconstitutional and something that favored Protestants. Port Washington, with a population of 2,565, was the county seat and the second-largest town in the county. As the county seat, it was the site of the draft drawing.[183]

William Pors, a lifelong Democrat, was appointed draft commissioner for Ozaukee County. Aware of a local group organized to disrupt the draft, he thought it was safe for him to serve as commissioner because he had recently been elected district attorney. The day before the draft was to take place, his life was threatened. He decided to go forward "inasmuch as his honor was involved," and "it was his duty to attend to it."

On Monday, November 10, 1862, Pors, accompanied by Sheriff Jacob Bossler and a crowd of several hundred men, women and children, went to the courthouse to begin the draft. Pors stood on top of the table with the draft box and asked the crowd—armed with clubs, rocks and farming implements—to stand back so they could see the draft was "conducted properly." The crowd attacked him. They destroyed the draft box, grabbed Pors, dragged him to the door of the courthouse and threw him down the steps. The sheriff, who had "warded off a good many blows" to Pors, urged him to "fly for his life." As he ran, Pors was pelted with rocks, one hitting him in the head above the temple, knocking him down. Pors got up and ran to the post office, where he hid in the cellar. The mob followed, but the post office clerk locked the door and told them that Pors was not there. They returned to the courthouse and destroyed the draft lists. A steam-powered

gristmill that produced twelve thousand barrels of flour per year was also destroyed because it was owned by Julius Tomlinson, an abolitionist.

The mob then went to Pors's house, where they tore down the fences, destroyed fruit trees and ransacked the interior—smashing windows and furniture and taking gold and jewelry. Pors's wife and child fled to a neighbor's house moments before the mob arrived. Afterward, the rioters ransacked the Free Mason lodge and four more houses of Republicans (three of whom were also Masons) and assaulted numerous people. The anti-draft rioters considered Free Masons in league with the Republicans to rig the draft against Catholics and Democrats. Hundreds took part in the rioting throughout the day. The state legislature eventually appropriated $3,000 to reimburse Pors for the damage.[184]

After the mob left the post office, Pors climbed into a carriage driven by a friend and escaped to Milwaukee, where he spread the alarm of what had happened. That night, the rioters in Port Washington barricaded the streets with kegs of beer.[185]

Word of the riot reached Governor Salomon in Madison. On the afternoon of November 11, he ordered Colonel James M. Lewis, the commander of the Twenty-Eighth Wisconsin Infantry, to put his troops on steamers and quell the riot in Port Washington. The Twenty-Eighth Wisconsin Infantry, recruited from Waukesha and Walworth Counties, was a newly organized regiment, having been mustered in on October 14, 1862. By midnight, eight companies of the Twenty-Eighth Infantry, accompanied by State Provost Marshal Walter D. McIndoe, were on steamers heading north. Colonel Lewis landed some troops south of Port Washington, ordering them to march so as to surround the town and cut off escape routes. After landing the rest of the regiment, Colonel Lewis and McIndoe reoccupied the courthouse and began making arrests. Citizens who had not taken part in the riot identified those who had. Eventually, about 130 people were arrested. Most would spend a year in prison, without trial, and then be released.[186]

A Milwaukee newspaper noted, "The village looks as though a tornado had swept through some portions of it, completely gutting several fine mansions and devastating the grounds surrounding them." The soldiers, it reported, were treated "in the most hospitable manner by the better class of citizens, who fed them with all they wanted to eat."

On the day after the riot in Port Washington, West Bend, in next-door Washington County, saw similar but less destructive violence. E.H. Gilson, the draft commissioner for the county, had the draft ballots drawn by an eight-year-old girl without incident on Monday. By the next day, however,

word of the riot in Port Washington had reached West Bend. Gilson began drawing ballots on November 11, using the same eight-year-old girl he had the day before. The county courthouse was "densely packed with Germans." After finishing the drawing for Trenton, Wisconsin, the crowd broke out in "unearthly howls." It was a signal to get violent. Sheriff Weimer spoke in German, trying to calm the crowd, but to no avail. Weimer "hurriedly whispered" to Gilson, "For God's sake get out of the courthouse as soon as possible." Taking the little girl, "who was frightened nearly out of her senses," Gilson fled the courthouse. He was overtaken by several dozen members of the mob, who assaulted him. They grabbed him by the throat and hit him with a heavy stone "the size of a man's two fists" on his right side. Gilson eventually escaped, making his way to Hartford, where he took a train to Milwaukee.

A half dozen companies of the Thirtieth Wisconsin Infantry were sent to West Bend on November 22, and the draft for that county was completed on November 24, 1862, by Gilson and Provost Marshal McIndoe. The Thirtieth Wisconsin Infantry, like the Twenty-Eighth, was a new regiment, mustered in on October 21, 1862. It would spend much of its first year and half in service in Wisconsin providing security for draft operations. It was then sent the Dakota Territory and northwest Minnesota as part of General Alfred Sully's campaign against the Native Americans in March 1864.[187]

Governor Salomon was determined that the violence in Ozaukee and Washington Counties would not be repeated in Milwaukee. Consequently, the draft in Milwaukee was postponed until November 19. Salomon placed the military forces in the city under the charge of Colonel John Starkweather, the commander of the recently reorganized First Wisconsin Infantry, who was in Milwaukee on leave. Soldiers were stationed on all the roads leading into the city and placed in different wards, ready to assemble on orders. Companies were also marched on the city's streets. The draft was held without incident. Because of inaccuracies in the Manitowoc County rolls, the draft in that county was not held until months later. In a few other counties, there was "a fractious spirit," but no serious violence occurred.[188]

The drafted men were organized as the Thirty-Fourth Wisconsin Infantry under the command of Colonel Fritz Anneke and left the state for Columbus, Kentucky, in January 1863. Unsurprisingly, it consisted "to a large extent" of Belgians and Germans. Adjutant General Gaylord reported that they "became proficient in drill and attached to the service." They were mustered out on September 8, 1863, and "no inconsiderable number" reenlisted in the Thirty-Fifth Wisconsin Infantry.[189]

In the end, Adjutant General Gaylord reported that of the 4,594 who were to be drafted, after exemptions, discharges for disability, those who volunteered for old regiments and desertions, 961 men were drafted for the nine-month period.[190]

On November 19, 1862, Corporal Adam Muenzenberger, of the Twenty-Sixth Wisconsin Infantry, wrote to his wife: "Report has it that there has been drafting in Wisconsin and great resultant scandal....We have had a great laugh at the simpletons who laughed at us because we volunteered. Please let me know who was drafted if you can find out so that I can laugh at their lot the way they laughed at mine."[191]

As the war continued, so did the need for men. On March 3, 1863, Lincoln signed the Enrollment Act, which required every male citizen and immigrants who had filed for citizenship between the ages twenty and forty-five to enroll for a federal draft. The Enrollment Act replaced the Militia Act of 1862. Quotas for each congressional district were determined and the drafts handled by federal authorities, not state ones as in 1862. Colonel James Barnet Fry was appointed provost marshal general on March 17, 1863.

Wisconsin did not experience the anti-draft violence that other states did, such as New York in 1863. The anti-draft violence of 1862 seemed to inoculate Wisconsin from any further violence, although opposition to the draft and the war continued.[192]

10

On Horseback and Water

The Cavalry and the Navy

The Cavalry

Wisconsin provided four regiments and a company of cavalry totaling 9,294 men.[193] Of these, more than 1,300 died in service. Cavalry regiments had a different organization than infantry regiments. They had three battalions. Each battalion was composed of two squadrons, each squadron of two troops. A troop was equivalent to a company in the infantry, with a nominal strength of 100. A cavalry regiment was commanded by a colonel, with a lieutenant colonel and three majors, one for each battalion. There were additional adjutants, quartermasters and commissary officers for each battalion.

The First Wisconsin Cavalry

The First Wisconsin Cavalry was mustered in between September 1, 1861, and March 8, 1862, under the command of Colonel Edward Daniels, of Ripon, at Camp Harvey in Kenosha. It left the state for St. Louis, Missouri, on March 17, 1862, and finished equipping at Benton Barracks. It was transported down the Mississippi to Camp Girardeau, Missouri, and operated in southeast Missouri and Arkansas scouting and "repeatedly encountering the enemy."

It suffered its worst loss on August 3, 1862, at L'Anguille Ferry, Arkansas. Its Second Battalion, under Major Eggleston, was escorting a train of supply wagons and ambulances when it was surprised by "an overpowering force of the enemy." At least sixty-seven men were killed, wounded or taken prisoner. Nearly one hundred African Americans who were following the wagons were captured and many of them shot and killed.

In the spring of 1864, the First Wisconsin Cavalry was assigned to the cavalry corps accompanying the army of General Sherman during his Atlanta campaign. On May 26, 1864, five companies of the First Wisconsin Cavalry with a portion of the Fourth Indiana Cavalry charged a brigade of Confederate cavalry and captured forty-seven prisoners.[194] Throughout May and June 1864, the regiment lost seventy-four men killed, wounded or missing. On July 28, 1864, near Campbellton, Georgia, the regimental commander Major Paine was killed. Ten others were killed, wounded or missing.

Major Levi Howland, Company A, First Wisconsin Cavalry. A native of Kenosha, Wisconsin, Howland was mentioned for gallantry at Anderson's Gap, Tennessee, on October 2, 1863, and promoted to major on January 6, 1865. He mustered out on July 19, 1865. *Library of Congress.*

Following the surrender of Atlanta, the First Wisconsin Cavalry took part in the pursuit of the Confederate army of General Hood. After the defeat of the Confederates at Nashville on December 15–16, 1864, the First pursued the retreating Confederates until the collapse of the Confederacy in April 1865.[195]

After the fall of Richmond on April 2, 1865, Confederate president Jefferson Davis and his family with some aides fled toward Texas. Federal commanders sent several cavalry regiments after him, including the First Wisconsin Cavalry. On May 10, 1865, two regiments caught up with Davis, the Fourth Michigan Cavalry—which would get the credit for capturing Davis—and the First Wisconsin Cavalry. Colonel Henry Harnden of the First Wisconsin described what happened moments after the Fourth Michigan captured Davis:

Col. Pritchard [of the Fourth Michigan] *and I rode together into the Davis camp, which was just across a little swale....The first person we saw there was John H. Reagan, the postmaster of the Confederacy, lately United States senator from Texas, who said to me, "Well, you have taken the old gentleman at last!" "Who do you mean?" "I mean President Davis." "Please point him out." "There he stands," said Reagan, pointing to a tall, elderly, and rather dignified looking gentleman, standing a short distance away. We rode up, dismounted, and saluted, and I asked if this was Mr. Davis? "Yes," he replied, "I am President Davis." At this the soldiers set up a shout that "Jeff" Davis was captured.*[196]

During its time in service, the regiment engaged in fifty-four battles, losing about four hundred men—seventy-two killed in action or died of wounds. Of those who died of disease, most died from unhealthy drinking water in southeastern Missouri in 1862. The regiment was mustered out July 16, 1865.[197]

The First Wisconsin Cavalry: A Closer Look

Historians owe a debt to Stanley E. Lathrop. A veteran of the First Wisconsin Cavalry, he compiled statistics from the original muster-out rolls that were made out by the company commanders at the time of the regimental muster-out at Edgefield, Tennessee, on July 19, 1865. Lathrop was a corporal in Company M. He enlisted from Westfield, Wisconsin, on December 20, 1861, and was taken prisoner at L'Anguille Ferry, Arkansas, on August 3, 1862. He was discharged for disability on January 10, 1863, but reenlisted on December 22, 1863. He was mustered out July 19, 1865.

The total enrollment of the First Wisconsin Cavalry was 2,541, larger than any other Wisconsin regiment. This was because recruits were continually sent to the regiment over the course of the war.[198]

Mid-nineteenth-century America was an immigrant society, and the First Wisconsin Cavalry reflected this. The men of the regiment were born in twenty-five states and thirteen foreign countries. The number of foreign-born was 513, one-fifth of its number. Most of these men came to Wisconsin as children with their parents—228 were born in Germany (including Austria and Hungary), 71 in England, 67 in Ireland, 65 in Canada, 18 in Scotland, 17 in Holland, 17 in Norway, 11 in France, 8 in Switzerland, 6 in Denmark and 1 each in Cuba, Mexico and Poland—2 were recorded as "born on the ocean."

Of those born in the United States, 984 were born in New York State and 210 came from New England. This illustrates the heavy migration from those states to Wisconsin in the 1840s and '50s. Also, 155 men were born in Ohio and an equal number, 158, from Pennsylvania, Indiana, Illinois and Michigan. Southerners accounted for 52. They hailed from Alabama, Maryland, Missouri, North and South Carolina, Tennessee, Kentucky, Virginia and Mississippi. Only 97 of the more than 2,500 members of the regiment were born in Wisconsin.

Most Wisconsin infantry regiments during the Civil War were raised in a particular county or counties. There were fifty-four infantry regiments and thirteen artillery batteries but only four cavalry regiments. Because of the relative rarity of Wisconsin cavalry regiments, they generally drew from all parts of the state, not localized areas.

The city of Ripon in east-central Wisconsin, the birthplace of the Republican Party, furnished 110 men, the most from any one town. The nearby town of Beaver Dam provided 80 men; Oshkosh, Waupun and Berlin 15 each. To the north and east, Appleton gave 30, Green Bay 20 and Menomonie 30. Along the lake, Sheboygan sent 40, Milwaukee 60 and Kenosha 80. Moving west from Milwaukee, Waukesha enlisted 65, Fort Atkinson 15 and Madison 35. Even western Wisconsin was represented with Prairie du Chien, on the Mississippi River, sending 20.

The occupations were also a reflection of mid-nineteenth-century America. The vast majority were farmers, 1,828. There were also 43 blacksmiths, 60 laborers and 48 carpenters. Interestingly there were 27 sailors, 7 doctors, 2 engineers, 5 architects, 1 actor and 6 preachers. One of the preachers was promoted to regimental chaplain, replacing Chaplain G.W. Dunmore, who was killed in battle. Two of the other preachers were southern Union men who joined in Missouri in 1862.

The average age was twenty-three. The oldest was fifty and the youngest fifteen. One of the youngest was Bernard Schultheis of Company M, who was born in Port Washington. He transferred from the Ninth Wisconsin Infantry in May 1862, having already served six months. He was fifteen years old and four feet, nine inches high. He served for three years. From the enlisted ranks, 128 men were commissioned officers; 6 were given commissions in other regiments.

During its service, the regiment traveled 2,182 miles by train and 2,540 miles by steamer on the Mississippi, St. Francis, Ohio, Cumberland and Tennessee Rivers. The distance traveled on horseback is about 20,000 miles across Missouri, Arkansas, Kentucky, Tennessee, Alabama, Mississippi,

Georgia, North Carolina and Florida. If the daily scouting and foraging are added, the distance would more than double.

The First Wisconsin Cavalry was in fifty-four battles and innumerable skirmishes. In its three and a quarter years of service, between 226 and 245 men were taken prisoner. Of these, 33 died in Andersonville, 10 others at Little Rock, Florence, Millen, Richmond and other Southern prisons. Others were paroled or exchanged. Many of these men were discharged for disability and died at home. A soldier's chance of being taken prisoner was almost one in ten. Somewhere between 389 and 401 men in the regiment died, most by disease or accident. At least 72 were killed in action or died of wounds. The chance of a cavalryman in the First Wisconsin Cavalry dying in service was one in six.

It is unknown if the makeup of the First Wisconsin Cavalry is representative of Wisconsin's other cavalry regiments or artillery batteries. One suspects that based on its size and because it was the first cavalry regiment organized it may have been more cosmopolitan than the others.[199]

The Second Wisconsin Cavalry

The Second Wisconsin Cavalry regiment was organized at Camp Washburn, Milwaukee, between December 1861 and March 1862 under Colonel Cadwallader C. Washburn of La Crosse. It left the state on March 24, 1862, for St. Louis and was sent to Missouri and Arkansas. The First Battalion remained in Missouri, the Second and Third Battalions joined Major General Samuel Curtis's army in Arkansas, occupying White River ports in late spring and taking Helena, Arkansas, in July 1862. During the campaign, the Second Wisconsin traveled four hundred miles without losing a man and captured 150 prisoners. During the Battle of Prairie Grove, Arkansas, on December 7, 1862, the regiment deployed as skirmishers, suffering no casualties. In January 1863, the Second and Third Battalions were moved to Memphis, Tennessee, and the following June, they were sent to Vicksburg, Mississippi. The day after the surrender of Vicksburg, the two battalions took part in Sherman's Jackson campaign and then returned to Vicksburg doing occupation and patrol duties.[200]

The following year, on July 4, 1864, the Second and Third Battalions were surprised by the First Louisiana Cavalry. On that morning, the captain of Company I, Captain George W. Ring of Milwaukee, rushed into camp with about seventy-five men, followed, "to the surprise of

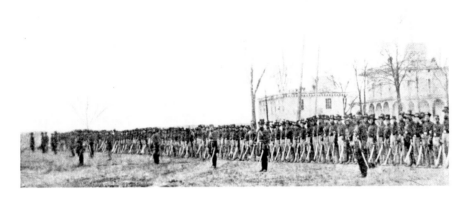

Second Wisconsin Cavalry. The Hardee hats typical of Wisconsin soldiers are visible. *From Miller's* Photographic History of the Civil War.

all," by six hundred men of the First Louisiana Cavalry. The Badgers saddled their horses and formed a line of battle "under the enemy's fire. Companies C, M and F, forming quickly, held the Confederates in their front at bay. A few Second Wisconsin companies that were on the enemy's flank fired several volleys, forcing the Confederates to fall back. Then the entire Second Wisconsin Cavalry charged, breaking the line of the Confederates. The Fifth Illinois Cavalry, on the left of the Second, was also mounted and pursued the Confederates. On July Fifth, Lieutenant Hamilton, in command of Companies M, F, I and C, wrote that "our gallant men moved on in the shower of bullets as though it was a hail storm. Our boys fought rapidly and long enough to empty their cartridge boxes."[201]

In September, the First Battalion rejoined the regiment, which remained in the Vicksburg area until November 1864. Then, for several months, the regiment was sent on expeditions from Vicksburg to Memphis and Ripley, Mississippi, and Gaines Landing, Arkansas. In August 1865, it was ordered to Texas, where companies were stationed at different points assigned to patrol and garrison duty. On October 30, 1865, the regiment was mustered out of the service at Austin and returned to Madison, Wisconsin, where it was disbanded on December 14, 1865. In total, 2,449 men served in the Second Wisconsin Cavalry. It lost more than 304 men, 18 of whom were killed in battle or died of wounds.[202]

The Third Wisconsin Cavalry

The Third Wisconsin Cavalry regiment was recruited and organized by Colonel William A. Barstow at Camp Barstow in Janesville between November 3, 1861, and January 31, 1862. The regiment left the state on March 26, 1862, for St. Louis. Near Chicago, four train cars were thrown from the track when an axle broke, killing or drowning twelve and injuring twenty-eight more. The second car was thrown into a water-filled ditch, and seven in the car drowned. A half dozen wounded were sent to the Camp Douglas hospital.

The regiment was sent to Fort Leavenworth, Kansas, in May 1862 and attached to the Army of the Frontier, serving in Missouri, Arkansas and the Indian Territory. Colonel Barstow was appointed provost marshal general of Kansas, and the regiment was engaged in provost duty throughout the state. The Second Battalion was sent to Fort Scott, the farthest outpost of Union forces, under the command of Major Henning. Company I, under Captain Conkeym, occupied Carthage, Missouri, ordered to disperse Confederate guerrillas and keep a watch on Arkansas.

The First Battalion went to Elwood, Shawneetown, Leavenworth, Aubrey and Cold Water Grove, Kansas. The Third Battalion was sent to Atchison, the city of Leavenworth and Fort Leavenworth. The companies at Leavenworth, in addition to provost duty, were engaged in scouting the border counties of Missouri, in which Quantrill's guerrillas operated. On July 17, 1863, elements of the regiment took part in the Battle of Honey Springs in which Confederate generals Cooper and Stand Waite were defeated.

On September 6, 1863, Brigadier General James G. Blunt, accompanied by forty men of Company I of the Third Wisconsin, forty-three men of Company A, Fourteenth Kansas Cavalry and the brigade band, which was composed of Wisconsin men, was attacked near Baxter Springs in the Cherokee Nation by Quantrill's guerrillas. Forming a battle line of only sixty-five men, the Federals were charged by three to five hundred. The men of Company A, Fourteenth Kansas Cavalry, broke. The men of Company I, Third Wisconsin Cavalry, fired their revolvers until the raiders were within twenty feet of them, then turned to escape. The Confederates shot down the fleeing men and killed the wounded. Of the forty men in Company I, twenty-two were killed and four wounded and left on the field for dead. During the attack, the wagon carrying the band attempted to escape, but one of the wheels came off. The Confederates rushed it and "commenced an indiscriminate slaughter of the whole band. Many of them were shot

while in the wagon." Eleven band members were killed. Their bodies were thrown in the wagon and set on fire. It was a different type of war in the Plains, often ruthless and without mercy.

As this massacre was going on, another group of Quantrill's men attacked a nearby contingent of Company C, Third Wisconsin Cavalry, led by First Lieutenant James Pond. Pond and his men "made a gallant defense" and "received great praise for the manner in which he defended his position." Lieutenant Pond would be awarded the Medal of Honor for his actions. In this "Massacre of Blunt's command," the Third Wisconsin Cavalry lost three dozen killed and wounded, mostly killed.[203]

Three-fourths of the regiment reenlisted in early 1864. Seven companies of the Third Cavalry engaged in picketing, guard duty and scouting between the Arkansas and White Rivers, frequently engaging Confederate raiders. The other five companies were stationed in Kansas and Missouri. They were also engaged in scouting, picket, forage and escort duty. The regiment was mustered out in September 1865. During its service, the regiment lost 63 killed or died of wounds and another 163 from disease for a total of 226.[204]

The Fourth Wisconsin Cavalry

The Fourth Wisconsin Cavalry regiment was unique among Wisconsin regiments in that was both an infantry and a cavalry regiment. The regiment was organized as the Fourth Wisconsin Infantry at Camp Utley in Racine and mustered in between July 2 and July 19, 1861, under thirty-five-year-old Colonel Halbert E. Paine. Paine was an Ohio-born lawyer who moved to Milwaukee in 1857 to practice law and formed a partnership with Carl Schurz.[205]

The regiment left the state on July 15, 1861, for Baltimore and took part in Major General John Adams Dix's expedition to the Eastern Shore of Virginia in November 1861. It was then assigned to General Butler's expedition to New Orleans, Louisiana.[206]

After the capture of Forts St. Philip and Jackson, Colonel Paine and six companies of the Fourth went up the river to New Orleans with other troops and took possession of the city. On May 12, 1862, it occupied Baton Rouge. A week later, the regiment took part in an expedition against Vicksburg, losing two men wounded, and returned to Baton Rouge.[207]

Soon after the return of the first expedition from Vicksburg, Colonel Paine was placed under arrest for refusing to obey an order to return

fugitive slaves to their masters. The *Kenosha Telegraph* reported that two slaves came into Federal lines near Vicksburg and "gave much valuable information." Their owners arrived and demanded their "property." The slaves were "driven out" of the Federal lines and recaptured by their masters, who "administered 150 lashes to their bare backs" and put heavy iron collars on their necks with two prongs or spikes on each side of the head sticking up above the ears. Five days later, these same men, with their "hideous collars" still on, came in to the camp of the Fourth Wisconsin Infantry. Colonel Paine ordered the collars filed off. The masters returned and again demanded "their property." Colonel Paine refused to give them up. The

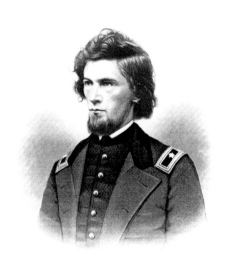

Colonel Halbert Paine. Put under arrest for refusing to return escaped slaves, he would later lose a leg leading an assault. Paine later became a three-term U.S. congressman for Wisconsin. *National Archives.*

masters appealed to the commanding officer, Brigadier General Thomas Williams, who ordered Colonel Paine to give up the slaves. Colonel Paine refused and was "deprived of his command" and put under arrest. When the Fourth Wisconsin Infantry marched out of Baton Rouge for Vicksburg, Colonel Paine "marched in the rear, without arms." He was subsequently given his command back.[208] On June 17, 1862, Colonel Paine and his regiment captured the town of Grand Gulf, Mississippi, and burned it by order of Major General Butler. On September 29, 1862, Paine was placed in command of the First Brigade of General Sherman's division. Lieutenant Colonel Bean was appointed colonel of the Fourth Wisconsin Infantry.[209]

On May 27, 1863, eight companies of the 4th Wisconsin Infantry took part in the first assault on Port Hudson, Louisiana. The regiment charged over logs, fallen trees and ravines, driving the Confederates into their fortifications, capturing many prisoners. They reached a ridge within two hundred yards of the Confederates and held the position. On June 14, the 4th Wisconsin Infantry led another assault on Port Hudson. Placed in the advance as skirmishers with the 8th New Hampshire Infantry, the men charged "on the double quick," with the Confederates "pouring in a terrible

fire." Men fell "at every step." Some reached the breastworks and went over but were either killed or taken prisoner. Most "fell under the works, killed or wounded." The survivors took cover behind stumps and in swells of ground. While urging his men on, Brigadier General Paine was hit by a bullet in the leg and fell "among a large number of dead and wounded" about eighty yards from the Confederates' works. Some of his men tried to rescue him, but Confederate fire prevented it. A private from 133rd New York Infantry, named Patrick Cohen, tossed him a canteen of water taken from a dead soldier. Paine thought it saved his life. At night, he was removed by his men and sent to the Hotel Dieu in New Orleans, where his leg was amputated. After the failed assault, the 4th Wisconsin Infantry remained in front of Port Hudson. The fall of Vicksburg on July 4, 1863, forced Port Hudson's surrender four days later.[210]

On September 1, 1863, the War Department ordered the Fourth Wisconsin to be changed to a cavalry regiment. After its organization as cavalry, the Fourth Wisconsin Cavalry was used in scouting, picketing and foraging in the vicinity of Baton Rouge. On November 27, 1864, the Fourth, with eight other cavalry regiments, left Baton Rouge in support of Major General Sherman's March to the Sea. It headed for Mobile, Alabama, hitting the Gulf of Mexico at West Pascagoula, Mississippi. It returned to Baton Rouge on January 6, 1865, by way of New Orleans. It had traveled three hundred miles and didn't lose a man.

On June 26, 1865, the regiment left Vicksburg for Texas, where it was mustered out on May 28, 1866, returning to Madison in June 1866—almost a year after the war had ended. During its service, it lost 397 men, more than a quarter of them killed in battle of dead of wounds, most when it was an infantry regiment.[211]

Lieutenant Colonel Joseph Bailey

Born in Ohio, Joseph Bailey moved to Columbia County, Wisconsin, in 1848 and began a successful real estate, lumbering and public works contracting business. When the Civil War broke out, he raised a company of lumbermen and was commissioned a captain in the Fourth Infantry. Rising to the rank of lieutenant colonel, he was detached to serve as chief engineer on Major General William B. Franklin's staff on March 8, 1864. Franklin commanded the Nineteenth Corps. Bailey accompanied that corps on Major General Nathaniel P. Banks's Red River Expedition. The corps used sixty transports

Lieutenant Colonel Bailey, the savior of a Union fleet. *From Miller's Photographic History of the Civil War.*

accompanied by ironclad gunboats. The Confederates defeated the Federals, who retreated to their ships. The water level of the Red River had fallen, preventing the fleet from passing. It seemed as if the troops would have to go overland after destroying the ships. Lieutenant Colonel Bailey suggested building a dam to raise the water level. On April 30, 1864, lumberjacks from the Twenty-Third and Twenty-Fourth Wisconsin Infantries, using their skills learned in Wisconsin's lumber camps, began building an earth and timber dam.[212]

Directing three thousand men, many working waist-deep in the water, Bailey constructed a 640-foot-long dam in eleven days. It raised the water level nearly six feet. After the first gunboat went through and the dam partially collapsed, Bailey's men built a series of wing dams upriver, which were used to channel the current. The water rose again, and the remaining ships escaped downriver. "Words are inadequate," said Admiral Porter in his report, "to express the admiration I feel for the ability of Lieutenant Colonel Bailey. This is without doubt the best engineering feat ever performed." For this achievement, Bailey was promoted to colonel, brevetted brigadier general, voted the thanks of Congress and presented with a sword and a purse of $3,000 by the officers of Porter's fleet. He settled in Missouri after the war and was elected a county sheriff. He was killed by former Bushwhackers on March 21, 1867.[213]

The Milwaukee Cavalry

Little is known about the actions of this company during its service. In the summer of 1861, Captain Gustavus Von Deutsch of Milwaukee was authorized to recruit a company of cavalry as an "Independent acceptance." The company, numbering ninety-three men, was ordered to St. Louis, where it was mustered in during September 1861. The company

briefly served under Major General John C. Frémont in Missouri and then was attached to the Department of Missouri. It took part in Brigadier General Samuel Curtis's campaign in Missouri and Arkansas and one against Confederate major general Sterling Price culminating in the Battle of Pea Ridge, Arkansas, on March 6–8, 1862. On November 15, 1862, the company was consolidated with the Fourth Missouri Cavalry and served in southeast Missouri, west Tennessee, west Mississippi and in the Department of Texas until November 1865.[214]

WISCONSIN ON THE WATER

Impossibilities are for the timid.
—Lieutenant Commander William B. Cushing, USN,
born in Delafield, Wisconsin

During the Civil War, Wisconsin was represented by both ships and men on America's inland rivers and Atlantic coast. In his annual report for 1865, Adjutant General Gaylord noted that a total of 743 men from Wisconsin became "naval recruits" during the war or were enlisted from "Rebel" states and mustered with Wisconsin regiments. It is unknown how many of these joined the navy from Wisconsin. There were undoubtedly hundreds.

Perhaps the most celebrated Wisconsin native to gain naval renown during the war was Lieutenant Commander William B. Cushing, brother of Captain Alonzo H. Cushing, who was killed at Gettysburg and awarded the Medal of Honor. Cushing had entered the Naval Academy in 1857, at the age of fourteen. He was described by contemporaries as having "a talent for buffoonery" and as "perfectly fearless." He also had a talent for amassing demerits and making an enemy of Commandant of Midshipmen Lieutenant Commander C.R.P. Rodgers. Halfway through his last semester, he was forced to resign.

In the opinion of Gideon Welles, Lincoln's secretary of the navy, Cushing failed at the academy because "with his exuberant spirit he had too little to do; his restless, active mind was filled with zeal to accomplish something." After the war began, one of Welles's earliest appointments was to make Cushing an acting master's mate on the USS *Minnesota*. By February 1864, twenty-one-year-old Cushing had become the youngest lieutenant in the history of the navy, assigned to the North Atlantic Blockading Squadron off

the coast of North Carolina. He led two daring raids against Confederates during the spring and summer. That fall, he gained a national reputation and praise from President Lincoln when he sank the Confederate ironclad ram *Albemarle* with a torpedo launched from a small open steamboat.

On the "dark and slightly rainy" night of October 27, 1864, Cushing led fourteen officers and men, armed with revolvers, cutlasses and hand grenades, up the Roanoke River to sink the *Albemarle*. They used a thirty-foot "low-pressure" steamer that carried a twelve-pound howitzer and a torpedo. The "torpedo" is not what we think of today. It was essentially a bomb fixed to the end of a boom that could be detonated by pulling a cord. The boom was fourteen feet long and had a "goose-neck" hinge that allowed it to be moved from stern to bow, lowered and raised.

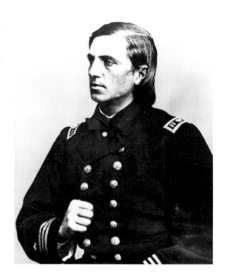

Lieutenant William B. Cushing, USN, circa 1864. *Naval History and Heritage Command.*

Cushing and his party quietly steamed up the river, slipping past Confederate sentries until about 3:00 a.m. on November 28, when they were discovered near the ironclad. The Confederate crew "rang the bell and commenced firing…seeming much confused," Cushing later wrote. There was a fire ashore that illuminated the scene, showing Cushing that the ironclad was tied to a wharf with a "pen of logs around her" thirty feet from its side. He noticed that the logs had been in the water long enough to have become slimy. He guessed that his boat, under full power, could slip over them and into the pen. Ordering full steam ahead, Cushing "went at the dark mountain of iron in front" of him. A "heavy" rifle fire came from the ship and from men stationed on the shore. He went at the ironclad "bows on." As he turned away from the bow to move toward the center of his launch, "the whole back of my coat was torn out by buckshot, and the sole of my shoe was carried away. The fire was very severe." He ordered the howitzer to fire canister. This "served to moderate their zeal and disturb their aim."

Cushing's launch hit the logs, "just abreast the quarter port," the bow resting on them. Cushing lowered the torpedo boom, positioned the torpedo under the overhang of the ironclad and exploded it. The detonation blew

a hole in the ironclad "big enough to drive a wagon in." The dense mass of water thrown out by the torpedo came down with a "choking weight." Water filled the launch and disabled it. At the same time, a cannon on the *Albemarle* fired "100 pounds of grape [shot] at 10 feet range," which "crashed among" the sailors.

From fifteen feet away, the Confederates shot at Cushing and his men, demanding their surrender. Cushing refused twice then ordered his men "to save themselves." Cushing threw away his sword and revolver, took off his coat and shoes and jumped into the river. Soon, the Confederates were in boats, picking up his men. Only Cushing and one other man, Edward Houghton, escaped. Two were killed; the rest were captured. Held in Libby Prison, the ten men who accompanied Cushing and survived were awarded the Congressional Medal of Honor. Cushing, as a naval officer, was not eligible for it.

The *Albemarle* sank, leaving the armored upper works mostly dry. It was eventually captured and raised by the Federals and sold after the war. The Confederate commander of the *Albemarle*, Captain A.F. Warley, later wrote that "a more gallant thing was not done during the war."

President Lincoln personally recommended that Cushing be promoted and "receive a vote of thanks from Congress for his important, gallant, and perilous achievement in destroying the rebel ironclad steamer, *Albemarle*." Cushing was promoted to lieutenant commander and survived the war. He was promoted to the rank of commander in 1872, the youngest to achieve that rank up to that time. He died in 1874. Five U.S. Navy ships have been named after him.[215]

The USS *Winnebago*

During the war, two Federal ironclad warships were named in association with Wisconsin. One was the USS *Winnebago*, a double-turreted river monitor built by the Union Iron Works at Carondelet, Missouri. It was named after the tribe of Native Americans who lived on the banks of the Wisconsin River south of Green Bay. It was launched on July 4, 1863, and commissioned on April 27, 1864, with a crew of 120 officers and men under the command of Commander Thomas H. Stevens Jr. It carried four eleven-inch Dahlgren smoothbore cannons.

Assigned to the Mississippi Squadron, the *Winnebago* operated on the Mississippi River and connected waterways. On June 15, 1864, the

Winnebago, with two other ships, dueled with Confederate artillery at Ratliffs Landing, Louisiana. Afterward, it was sent to Admiral Farragut's West Gulf Blockading Squadron off Mobile. On August 5, 1864, the *Winnebago* was one of four ironclad monitors and fourteen wooden steamships that took part in the Battle of Mobile Bay.

The *Winnebago* was third in the column of ironclads, behind the *Tecumseh* and *Manhattan* and ahead of the *Chickasaw*. The *Winnebago* and the other monitors placed themselves between Fort Morgan and the wooden ships in order to draw the fire of the Confederate guns away from the wooden ships. Shortly after 7:00 a.m., the *Winnebago* began firing loads of grape and canister at Fort Morgan. As the *Winnebago* steamed past Fort Morgan, it took on board ten survivors from the *Tecumseh*, which had hit an underwater mine and sank. The *Winnebago* continued up the bay and anchored at 10:45 a.m. It had been hit nineteen times; three cannonballs penetrated the deck near the aft turret. Fortunately, there were no casualties.

After the battle, the *Winnebago* remained in Mobile Bay intermittently shelling Fort Morgan. On the night of August 8, the *Winnebago* sent fourteen men under the command of Acting Ensign Michael Murphy on a mission to cut the telegraph cable between the city of Mobile and Fort Morgan. Commander Stevens later reported that the mission was "one of danger and difficulty" and was "neatly performed." Fort Morgan surrendered on August 24, 1864.

On March 27, 1865, the Federals began operations to capture the city of Mobile. The Confederates tried to prevent waterborne advances by sowing mines (called torpedoes) in the river. Clearing operations by the Union navy removed 150 "torpedoes" but did not completely clear the river. The *Winnebago* emerged from the attack undamaged, but its sister ship, the *Milwaukee*, was sunk. Union forces, with the help of the *Winnebago*, eventually cleared the Blakely River.

Afterward, the *Winnebago* served on convoy duty after the fall of Selma, Alabama, in April 1865, protecting a convoy of thirteen troops under Major General Steele. Joined by the gunboats *Sebago* and *Octorara*, the *Winnebago* blockaded the Confederate ironclad CSS *Nashville* and the gunboat CSS *Morgan* in the Tombigbee River until the end of the war.

At the end of the war, the *Winnebago* was "laid up" in New Orleans and remained there until it was sold at auction on September 12, 1874.[216]

USS *Milwaukee*

The USS *Milwaukee* was the lead ship of a class of double-turreted monitors. It was named for the Milwaukee River, not the city. Commissioned at Mound City, Illinois, on August 27, 1864, it had 120 crew members and four eleven-inch Dahlgren smoothbore cannons. The *Milwaukee* served with Rear Admiral David G. Farragut in the West Gulf Blockading Squadron. After being delayed between Cairo, Illinois, and Memphis, Tennessee, by low water and "derangement of machinery," it reached New Orleans on October 27, 1864. On November 22, 1864, Lieutenant Commander James H. Gillis, an 1854 graduate of the U.S. Naval Academy, became the commanding officer.

Rear Admiral Farragut's victory at Mobile Bay on August 5, 1864, had closed that port to the Confederacy, but it still held the city of Mobile. To defend it, the Confederates mined the waters leading to the city, built obstructions and erected batteries. In early 1865, the *Milwaukee* swept mines, bombarded Confederate fortifications, removed obstructions and transported army soldiers.

The USS *Milwaukee*, a double-turreted Milwaukee-class river monitor. The ship supported Union forces during the Mobile campaign in early 1865. It hit a mine in March and sank without loss. *Library of Congress.*

As part of the Union's attack on Mobile, the army besieged Spanish Fort on the east bank of the Blakely River. On March 27, 1865, the *Milwaukee*, with the side-wheel gunboat *Octorara* and the ironclads *Osage*, *Winnebago*, *Chickasaw* and *Kickapoo*, crossed the Dog River Bar into deep water in order to cut communications between the fort and Mobile.

The next day, March 28, 1865, the *Milwaukee* and the *Winnebago* went up the Blakely River to shell a Confederate ship thought to be carrying supplies to Spanish Fort. They forced the ship to retreat. The *Milwaukee* dropped down with the current to its former position. Lieutenant Commander Gillis kept the ship's bow upstream and had his ship's small boats sweep ahead for torpedoes. Within two hundred yards of the anchored *Kickapoo*, the *Milwaukee* exploded a torpedo on its port side, behind its aft turret, "about 40 feet from the stern." The USS *Winnebago* had passed through the same waters "not ten minutes before." The ship was doomed. "My first object after realizing the impossibility of saving the vessel," Gillis later wrote, "was to save the crew." Although confusion reigned after the explosion, "a single command served to restore order," the captain reported, "and all of the crew came on deck in a quiet, orderly manner." *Milwaukee*'s stern sank in approximately three minutes, but the forward part of the ship remained afloat "for nearly an hour," allowing the entire crew to not only survive but also save "most of their effects." Lieutenant Commander Gillis supervised the abandoning of the ship and transferred his men to the *Kickapoo*. The *Milwaukee*'s hulk was raised in 1868 and towed to St. Louis, where its material was used in the construction of the James B. Eads Bridge across the Mississippi, the first all-steel bridge built in the world.[217]

11

WISCONSIN WOMEN

Women played an important role in supporting the war effort in Wisconsin. Women not only provided for themselves and their families but also supported the soldiers. They organized aid societies throughout the state, linking with national ones. They sent inspectors to army hospitals to improve conditions as well as nurses and supplies to the front lines and hospitals. They also distributed food to soldiers. Women became important members of the U.S. Sanitary Commission, the largest volunteer organization in national history up to that time, which had an important impact on the health of soldiers.

The Civil War took the lives of approximately 750,000 Americans—more than half of them Union soldiers. An additional 300,000 were wounded and survived. Many of these men suffered permanent disability, with about 30,000 undergoing amputations. It was a human and medical catastrophe unparalleled in U.S. history. In Wisconsin, about 81,000 men, more than half of the male population of military age, fought in the war. More than 11,000 died, two-thirds from disease. Another 15,000 were discharged for disability because of disease or wounds.

One in three Wisconsin soldiers became a casualty, and one in seven did not survive.[218]

WISCONSIN SOLDIERS' AID SOCIETIES

At the second war meeting held in Milwaukee in the early summer of 1861, the Milwaukee Ladies' Soldiers' Aid Society was formed by Margaret A. Jackson, Louisa M. Delafield and others. Its purpose was to raise and disburse money for the relief of soldiers' families and "the sanitary wants of the soldiers." In a single day, members of the chamber of commerce raised more than $11,000 for the society. Another $12,000 was raised the same day at a meeting of the city's merchants.[219] Eventually, it became a branch of the U.S. Sanitary Commission, and the name was changed to the Wisconsin Soldiers' Aid Society. There were 229 auxiliaries in the state, and each usually had a weekly meeting.

Milwaukee was "made the depot and channel" for the distribution of sanitary supplies from across the state. Four different bureaus were set up: one to help soldiers' families get payments from the state, one to find employment for soldiers' wives and mothers, one to secure employment for the partly disabled soldiers and one to provide for widows and orphans. The Wisconsin Soldiers' Aid Society itself sent almost six thousand packages valued at $200,000 to soldiers in the army.[220]

A U.S. Christian Commission poster announcing a "Union meeting" for the benefit of sick and wounded at a church in Fulton, Wisconsin. *Wisconsin Historical Society.*

Eliza Salomon, the wife of Governor Salomon, supported the society and often accompanied her husband on visits to hospitals in Indiana, Illinois, St. Louis and Missouri and along the Mississippi as far south as Vicksburg. At the first Sanitary Fair, held in Chicago in 1863, Eliza Salomon organized a German Department, selling needle and handiwork contributed by German women in Wisconsin and Chicago that brought in $6,000. In January 1864, when Governor Salomon returned to private life, she continued her efforts for relief until the end of the war.[221]

The Central Freedmen's Aid Society was also established in Milwaukee during the war and had many branches throughout the state. Its services were valuable in "benefiting the race the

rebellion sought to hold in bondage" and by encouraging enlistments among the freedmen. The society also contributed to the Great North-Western Fair for the benefit of the North-Western Freedmen's Aid Commission, also held in Chicago from December 20–24, 1864.

The Wisconsin Christian Commission was the name of the Wisconsin branch of the United States Christian Commission (USCC). The USCC was organized on November 14, 1861. Walter S. Carter of Milwaukee represented Wisconsin and organized a state branch on October 8, 1864. During its existence, from October 1864 to July 1865, it donated 1,048 packages valued at $54,915. "Total receipts of the branch" during its existence were $63,883.87. It provided more than any other branch to soldiers except Pittsburgh and Cincinnati. An example of its work was the sending to the eleven Wisconsin regiments at Mobile 450 barrels of supplies, including 40 barrels of pickles and more than three tons of dried apples.

The Wisconsin Christian Commission commissioned forty-five delegates, more than any other branch except Boston, Cincinnati, Brooklyn and Chicago. Nearly half were still in service at the end of the war. Two delegates were present at the surrender of General Lee at Appomattox Court House.[222]

AID TO FAMILIES

The families soldiers left behind often faced hardship. Generally, the men who were the income earners were now gone. The army allowed them to send money back to their families, but it was often delayed or insufficient.

Beginning in May 1861, the Wisconsin state legislature passed a series of acts that provided $5 per month financial support for families of "any soldier mustered into the service of this state or the United States." The wife or "person having charge of the family" was to be certified by a justice of the peace of the town in which the soldier resided. An amendment authorized the levying of a state tax of $275,000 for the "War Fund" to be used as payment for state aid to families of volunteers.

Apparently, there were problems with the initial act because over the next three years, other acts disqualified some families, such as of those soldiers "who shall desert or be dishonorably dismissed from the service." They further defined the term "families" or "family" to mean "the wife living with, and actually dependent upon the volunteer for support at the time of his enlistment; or, having no wife as above, then his children under

fourteen years of age; having no wife or children, then infirm and indigent parent or parents actually dependent upon the labor of said volunteer for support, at the time of his enlistment." The acts further noted that anyone making a false statement used in obtaining the aid "shall forfeit double the amount received from the state treasurer." Additionally, families "of any person who at the time of enlistment was not an actual resident of the state" were also disqualified.[223]

Chapter 371 approved on June 17, 1862, authorized the governor to take care of sick and wounded Wisconsin soldiers and appropriated $20,000. The state treasurer, S.D. Hastings, reported during the fiscal year ending September 30, 1862, that $17,526 was provided. In 1863, it was $482,005—in 1864, $367,374.[224]

By April 1, 1866, the state had paid $2,531,983 in aid to soldiers' families. Towns and counties paid $7,752,505 in bounties or to "sustain families of volunteer." This totaled $10,284,488 in aid. Additionally, the state paid $1,370,443 for "other war expenses."[225]

CORDELIA HARVEY

The most prominent and influential Wisconsin woman during the Civil War was Cordelia Harvey. Called "The Nightingale of Wisconsin" and "The Wisconsin Angel," she was the widow of Governor Louis Harvey, who drowned while visiting wounded Wisconsin soldiers after the Battle of Shiloh in April 1862.

Cordelia Adelaide Perrine was born in December 1824 in Barre, New York. Her family moved to Southport (now Kenosha), Wisconsin, in 1843. Cordelia's mother died in November 1844, and for the next four years, she took over her mother's responsibilities on the farm her father had bought near Clinton, Wisconsin. She also taught in a rural school. Cordelia met Louis Harvey, who had moved to Wisconsin in 1841 and ran a private school. Harvey was interested in politics and edited Southport's Whig Party newspaper, the *Southport American*, for several years. Cordelia and Louis married in 1847. They moved to Rock County, where Louis had purchased a small general store, remaining there until 1859, when Louis was elected secretary of state. In 1861 he was elected governor of Wisconsin.[226]

After her husband's death, Cordelia Harvey found herself a thirty-eight-year-old grief-stricken, childless widow in the midst of the country's

Cordelia Harvey in her mourning cloak. *Wisconsin Historical Society*.

greatest crisis. What was she to do? She was aware of the U.S. Sanitary Commission, a federally sanctioned organization that distributed food, clothing and medical supplies and ran hospitals. It also maintained facilities that fed and lodged soldiers, provided for dependent families, worked for higher standards of hygiene in army hospitals and organized transportation services for wounded Union soldiers. All this activity was dependent on donations. It raised money by means of Sanitary Fairs but was largely dependent on volunteers to act as hospital attendants and nurses and agents, who coordinated the movement of supplies and patients and inspected hospitals.[227]

Cordelia Harvey asked Governor Edward Salomon to appoint her the sanitary agent for Wisconsin, and he did. In September 1862, Cordelia made her way to St. Louis, where she visited the army's medical director and toured the military hospital, then went to Cape Girardeau:

> *In the fall of 1862 I found myself in Cape Girardeau, where hospitals were being improvised for the immediate use of the sick and dying then being brought in from the swamps by the returning regiments and up the rivers in closely crowded hospital boats. These hospitals were mere sheds filled with cots as thick as they could stand, with scarcely room for one person to pass between them. Pneumonia, typhoid, and camp fevers, and that fearful scourge of the southern swamps and rivers, chronic diarrhea, occupied every bed.... At Helena...I found over two thousand graves of Northerners. Two-thirds of these men might have been saved, had [they] been sent north.*

A letter that Cordelia wrote on December 6, 1862, was published in the *Wisconsin Daily State Journal* on December 30, 1862:

> *The heroism of our people is not confined to camp or battlefield, as every daily visitor upon our hospitals can testify. To lie extended upon a narrow cot day after day slowly perishing by disease, surrounded by the dead and dying, far from friends and home, with no hope of seeing either again on earth, with every sensibility tortured by sight and sound, requires more courage, greater power of endurance and firmness of purpose to meet and bear uncomplainingly, than to meet the armed foe in the heat and excitement of battle.*

Cordelia Harvey worked ceaselessly to improve the medical conditions of Wisconsin's soldiers until the spring of 1863, when she came down with

The *Nashville* was a side-wheeler launched in 1849. At the outbreak of Civil War, the boat was converted into a hospital ship. Its two decks accommodated one thousand causalities. It could not move on its own and required steam tugs or other vessels to move it. *Library of Congress.*

malaria. She returned north and spent the summer in Wisconsin. By the fall, she had recovered her health. This experience convinced her that Wisconsin's soldiers would not recover in the army's hospitals in the South, where they suffered from heat and humidity and diseases like malaria and yellow fever, which were endemic along the Mississippi River. If the men could be treated in Wisconsin, as she had been, Harvey thought they would recover more quickly.[228]

"By the advice of friends and with an intense feeling that something must be done," she went to Washington, D.C., to persuade President Lincoln to establish hospitals in the North. "I entered the White House," she later wrote, "not with fear and trembling, but strong and self-possessed, fully conscious of the righteousness of my mission. I was received without delay." She had never met Lincoln before. When she entered his "medium sized office-like room" he was alone. There was "no elegance about him, no elegance in him." He was dressed in a plain suit of black that "illy fitted him. No fault

of his tailor, however; such a figure could not be fitted. He was tall and lean, and as he sat in a folded up sort of way in a deep armchair, one would almost have thought him deformed."[229]

She met with Lincoln repeatedly, sometimes having heated discussions with him. "I have visited the regimental and general hospitals on the Mississippi River from Quincy to Vicksburg, and I come to you from the cots of men who have died," she told Lincoln, "who might have lived had you permitted. This is hard to say, but it is none the less true." The president and the army feared that the men would desert if they were sent north to recover. Harvey countered, "They have been faithful to the government; they have been faithful to you; they will still be loyal to the government do what you will with them; but if you will grant my petition you will be glad as long as you live."[230]

In the end, she convinced Lincoln. On September 27, 1863, Secretary of War Edwin M. Stanton wrote to Cordelia Harvey, ordering the

Civil War amputees, including Edward A. Whaley of Prairie du Chien, who served in Company C, Sixth Wisconsin Infantry. His right femur was struck by a musket ball during the Battle of Five Forks, and his leg was amputated. *Wisconsin Veteran's Museum.*

establishment of a hospital for three hundred patients at the Farwell House in Madison, "to be called the Harvey Hospital in memory of your late lamented husband, the patriotic governor of Wisconsin." The Farwell House, built by former governor Leonard J. Farwell in 1854, had been sitting empty since he went bankrupt in the Panic of 1857.[231]

HOSPITALS

Before the end of the war, three army general hospitals were established in Wisconsin: the Harvey General Hospital at Madison in October 1863, Swift

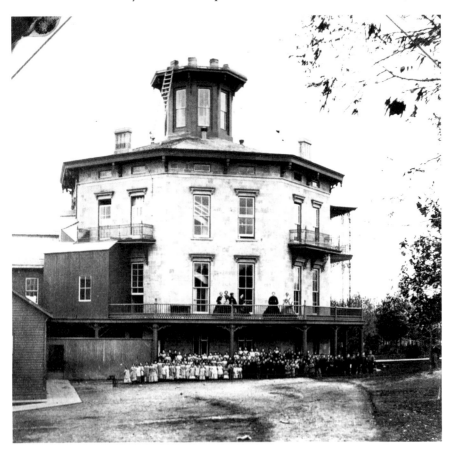

The first army hospital established in Wisconsin during the war. After the war, it became the Soldiers' Orphans Home. *Wisconsin Historical Society.*

General Hospital in Prairie du Chien in November 1864 and an "officer's hospital" in Milwaukee in 1864.

At the Harvey General Hospital in Madison, and in a branch established at Camp Randall, by 1864 there were 630 patients. The original hospital was enlarged by the building of three wings. This was the largest of the three. On December 31, 1864, H. Culbertson, the surgeon in charge of the Harvey Hospital, recorded the numbers of soldiers admitted and what happened to them. From October 27, 1863, to December 31, 1864, 2,337 sick and wounded were admitted, only 48 died. By any measure, the hospital was a success, and Cordelia Harvey was responsible for saving many lives.[232]

In November 1864, the Swift United States Army General Hospital opened in Prairie du Chien. It was designed to hold 400 soldiers. In the year of its existence, 1,468 men from Wisconsin, Minnesota and Iowa regiments received care there. The hospital was in two locations because of the need for space. The main hospital was located south of Fort Crawford in a three-story hotel. Men from Wisconsin regiments were cared for in this building. Men from Minnesota and Iowa regiments were housed in the Fort Crawford Hospital and one of the fort barracks. Major General U.S. Grant toured the Swift Hospital buildings in August 1865. Shortly after his visit, the remaining men were discharged or moved to a hospital in Madison. The hospital in Milwaukee was designed mainly as an officers' hospital and had a capacity for up to 200.[233]

When the last of the patients were discharged from the hospital in Madison, it was converted into an asylum and school for orphaned children of soldiers who had died during the war. The home was opened in January 1866, and the state took charge six months later, with eighty-four children in residence. The state housed, fed, clothed and educated them. The age limits were four to fourteen, and preference was given to those who had lost both parents.

Cordelia Harvey was the first superintendent of the Orphans' Home and ensured that it got off to a successful start. Cordelia resigned as superintendent on May 1, 1867. Over the next nine years, the Soldiers' Orphans' Home of Wisconsin served seven hundred children, three hundred housed at one time. When the home closed in 1875, a small monthly allowance was made to relatives or private orphan asylums for the care of orphans under fourteen years old.

For Cordelia Harvey, the "uncomfortable notoriety" and hard work of the past five years had a negative effect on her health. She eventually remarried

and led a quiet life as the wife of a respected educator in Buffalo, New York. When her husband, Albert Chester, died in 1892, Cordelia returned to Wisconsin to live with her sister Ellen Benson in Clinton Junction. She died at the Benson home on February 27, 1895, at the age of seventy-two.[234]

JANET JENNINGS: VOLUNTEER NURSE

For every Cordelia Harvey there were a thousand Janet Jennings. This is not meant to diminish Jennings's contribution but to acknowledge that thousands of women served and sacrificed to support the health of the men who served in uniform. Approximately 6,000 women, of whom 181 were African American, acted as nurses in convalescent and government hospitals during the Civil War.[235]

Often women without any training became nurses when a family member was wounded. Janet Jennings of Monroe, Wisconsin, is an example of this. Her younger brother, Corporal Guilford Dudley Jennings of Company C, Third Wisconsin Infantry, suffered a "severe" hip wound at the Battle of Chancellorsville on May 3, 1863. At twenty-four, she was too young to be officially be accepted as a nurse, but with her parents' consent, she left her teaching position in Monroe and traveled alone to Washington, D.C. Prevented from regular nursing duty by her inexperience and youth, she cared for her brother and many other wounded men in the tent hospitals near the White House. She was so well liked by the soldiers and staff at the hospital that when her brother was sent home she was allowed to stay, writing letters for the soldiers and offering comfort and encouragement.

Guilford survived his wound and was mustered out at the expiration of his service on July 1, 1864. Eight years later, Janet was at Guilford's deathbed in Omaha, Nebraska. One wonders if his early death was a result of the lingering

Janet Jennings, volunteer nurse. *Wisconsin Historical Society.*

Catharine Eaton, the wife of Samuel Eaton, the chaplain of the Seventh Wisconsin Infantry. *Grant County Historical Society.*

wound he received at Chancellorsville. During her time in Washington, Jennings met Clara Barton, who later formed the American Red Cross. In 1898, Jennings would join Barton's hospital unit sent to Cuba during the Spanish-American War.[236]

CATHARINE EATON: THE HOMEFRONT

Most women left behind did not have the opportunity or ability to serve as nurses. Their job was to maintain the family at home and support the husbands and brothers who had left. Catharine Eaton of Lancaster, Wisconsin, is a representative example.

On July 22, 1862, Samuel Eaton, a Congregational minister, left the train depot at Boscobel, Wisconsin, to become the chaplain of the Seventh Wisconsin Infantry. He left behind his wife, Catharine, and four young sons in nearby Lancaster, Wisconsin. Raising four boys on the $1,200 per year income that her husband's chaplain's salary brought in was difficult. Wartime inflation took a toll. "Everything in the line of provisions is enormous," she explained to Samuel. "I only buy what we must have." On December 30, 1862, about twenty friends came to Catharine's house and threw her a "donation party," giving her sugar, nutmeg, soap, candles and a turkey.

Grant County, of which Lancaster was the county seat, sent four companies to regiments in the Iron Brigade. In the summer of 1863, the war had reached a crisis, and a battle was expected between Lee's Army of Northern Virginia and the Army of the Potomac. On July 11, Catharine received a letter from Samuel that the Iron Brigade had "lost one half our number." Lancaster and nearby villages lost sixteen killed, sixty-one wounded and five taken prisoner. Catharine learned that Major John Callis, a close family friend, had been shot in the chest on the first day at Gettysburg. With "sad feelings," she went to see his wife, Martha Callis, and told her as "carefully" as she could about her husband. Martha "decided to go at once to her husband," Catharine later wrote. Callis survived his wound.

The following spring, Major General Ulysses S. Grant led the Army of the Potomac into Virginia. In May, as casualty reports came in, Catharine wrote, "I watch with trembling our country's destiny. I see among the thousands marching on, only one man; one precious, brave one who is all the world to me." In Lancaster, the tension was high. The first notice of casualties arrived on the evening of May 16, when Catharine received a casualty list from Samuel. Upon receiving it, she wrote, "I flew to town… to relieve the hearts of anxious parents."

It was around this time that Catharine began to take part in charitable organizations, such as the U.S. Sanitary Commission and the Lancaster chapter of the Soldiers' Aid Society, a statewide organization providing food, clothing and bandages for the "comfort of sick and wounded soldiers." She attended a few meetings in 1863 but became much more involved in 1864.

The effect was that Catharine grew in independence. For the first time, she was making the decisions that affected her family and church, not her husband. When she entered the law office of Joel Allen Barber, she "was received with many bows." Catharine had become an influential member of the community, and she knew it. Like thousands of other women across the state and country, she provided leadership on the homefront and made an indispensable contribution to the war effort.[237]

Women in the Economy

When Wisconsin's men went off to war, they left behind wives and families who faced tremendous hardship when the traditional income-earners left. The majority of women and their children lived in rural communities. Without the adult men, women found themselves responsible for planting and harvesting crops as well as the household finances. Male relatives and young children could help, but in most cases, it was the woman who assumed the responsibility of the day-to-day welfare of the family.

Until 1863, the loss of thirty-five thousand Wisconsin men as soldiers was largely compensated for by agricultural machinery. During the final years of the war, however, when more troops were required, wages for farm hands rose in harvest season to $2.00 and $2.50 per day, and women and children were required to do more work on the farm.

On June 9, 1864, the editor of the *Green Bay Advocate* wrote, "The sturdy, muscular German and Belgian women plough and sow and reap with

all the skill and activity of men, and we believe are fully their equals in strength. If need be they will even go into the pineries and do the logging." On June 1, 1864, the *Milwaukee Daily News* noted, "A grown man at work in the field is a rare sight. The farm labor is mostly being done by women and children." On the opposite side of the state, the *La Crosse Democrat* observed in July 1864, "It is not an uncommon thing to find half a dozen farms adjoining where there is not a man or boy to harvest the grain crop."[238]

Women also entered fields previously not open to them. The printing trade was particularly hard hit by a scarcity of labor. In 1865, it was estimated that the printing offices of the state had furnished at least a regiment of men. In 1864, Milwaukee Typographical Union No. 23 was forced to disband because so many of its members had enlisted. Soon after the war began, more women gained employment as compositors because they could become as skillful as men and would work for little more than half the wages. Needless to say, organized labor and the printers of the state were not happy about this.

During the war, women also gained employment as clerks in dry goods and "fancy" stores. The *Chicago Republican* wrote that "every young man who sold dry goods, boots, or shoes, hats and caps, etc., behind a counter ought to be ashamed of himself." In woodenware, shingles and match factories across the state, particularly those in the Fox River Valley, women found increasing employment opportunities.

The wages of women were inadequate, however, varying during the years from three to five dollars per week. Early in 1864, a notice signed by "Many Milwaukee Tailoresses" appeared in the *Milwaukee Sentinel*, in which they put their grievances before the public. In Madison, seamstresses found it necessary in the spring of 1864 to organize in order to secure living wages. In 1867, the *Milwaukee Sentinel* estimated that four thousand girls and young women were employed in the various shops and manufacturing establishments of the city, and their wages ranged "from three to twelve dollars a week—the average being probably five dollars. How do they live on such a pittance? Board alone can hardly be had for less than five dollars a week."[239]

Like in so many other areas of Wisconsin during the Civil War, the socioeconomic realities changed. Between 1860 and 1870, the number of women involved in commerce and industry grew by over 500 percent.[240]

WOMEN WITH THE ARMY

Daughters of the Regiment: Miss Eliza Wilson

Eliza Wilson, the daughter of Colonel Wilson, a "wealthy lumberman and former state senator" from Menomonie, Wisconsin, served as the "daughter" of the Fifth Wisconsin Infantry. She had her own tent and servant and paid all her expenses. Eliza was "useful as well as ornamental." Her duties were to lead the regiment when on parade and to "assuage the thirst of the wounded and dying on the battlefield." Several of Wilson's relatives and a number of men lately in the employ of her father were in the regiment, so she was well chaperoned. A newspaper gave a description of her:

> *Eliza is decidedly smart and intelligent, of medium size, amiable, twenty, and pretty. She dresses in clothes of such pattern as the military…board have ordered for nurses in the army.…The color is bright brown; dress reaches half way between the knee and ankle; upper sleeve loose, gathered at the wrist; pantalettes same color, wide but gathered tight around the ankle; black hat with plumes or feathers of same color; feet dressed in morocco boots. No hindrance to rapid movements.*

One soldier wrote, "Were it not for her, when a woman would appear, we would be running after her, as children do after an organ and a monkey."[241]

Another daughter of the regiment was Hannah Ewbank, a schoolteacher who joined the Seventh Wisconsin Infantry "Her uniform is very neat, consisting of a Zouave jacket of blue merino, trimmed with military buttons and gold lace; a skirt of scarlet…trimmed with blue and gold lace; pants and vest of white…balmoral boots; hat of blue velvet trimmed with white and gold lace, with yellow plumes, and white kid gloves. A more jaunty or bewitching little Daughter of the Regiment never handled the canteen."[242]

Female Soldiers

Although females were prohibited from joining the military at the time, over four hundred women served as soldiers in the Civil War. It was relatively easy for them to pass through the recruiter's station, since few

questions were asked—as long as one looked the part. Women bound their breasts when necessary, padded the waists of their trousers, cut their hair short and adopted masculine names.[243]

How is possible that women passed the required entrance medical examination? The reality is that the medical exams were often cursory. In addition, the prevailing standards of modesty facilitated women disguised as men avoiding discovery. Soldiers rarely bathed, and everyone slept with their clothes on. In addition, ill-fitting uniforms helped hide things. When armies were in the field, it would have been easy for women to take care of bodily functions out of sight. In addition, after months of marching, poor nutrition and stress, many menstrual cycles were most likely interrupted. Finally, because there were so many teenage boys in the army, a woman's beardless face would not seem usual.[244]

Eight women are known to have fought in the Battle of Antietam, for example. Seven were Federal, and one was Confederate. Five became casualties. In terms of Wisconsin, perhaps the most famous was Rebecca Peterman of the Seventh Wisconsin Infantry.[245]

Rebecca Peterman

Known as Georgianna in the press, Rebecca Peterman, a country girl from Ellenboro, Wisconsin, served in the Seventh Wisconsin Infantry. She is known to have fought at South Mountain and at Antietam in 1862. She enlisted in the fall of 1862 at the age of sixteen or seventeen and served the first year as a drummer boy; the second year she "did good service with a musket." During her service, Peterman was wounded above the temple. It left her with a bad scar but did not cause her masquerade to be discovered.

After her discharge from the Seventh Wisconsin Infantry, she was questioned about her motives for soldiering. It was reported that "she gives no reason for entering the service other than a desire to see what war was, and to be near her brother and cousin who were in the same regiment. Her cousin induced her to take the step." Apparently, for two weeks her stepbrother did not know Peterman was in the regiment.

As mentioned above, wanting to be near her family members was not Peterman's only motive. She was known as an adventurous person. Peterman's former schoolteacher said that "plain country life was not enough for her ambition."[246]

A newspaper reported that Peterman was "rather slenderly formed, but with somewhat masculine features, though with a very small and delicate hand. In walk and carriage she has every appearance of a boy." Another reported that "in her soldier's clothes [she] has the appearance of a rather good looking boy of sixteen. She is of medium height, with dark eyes and hair….She is very quiet." Another article agreed that "all who have seen this military specimen…agree that she is unusually good looking." Peterman's former schoolteacher remembered seeing her in her uniform and said "she was a fine looking soldier in fact looked better as a soldier than as a girl." Peterman apparently looked so convincing that no one in her regiment, other than her cousin and stepbrother, ever suspected her gender. Interestingly, she said she knew of two other women from her same county who served in the Union army.[247]

After her discharge from the Seventh Wisconsin Infantry, Peterman was on her way home to Ellenboro, Wisconsin, when she arrived in Chicago in February 1865. Her overcoat, in which she kept her discharge papers and money, was stolen at the Soldier's Rest. Without money Peterman wandered the streets looking for a warm place to spend the night. She went to a police station and asked to sleep there. A policeman on duty "detected something wrong in the appearance" of the soldier. Peterman confessed to being a woman. The *Chicago Evening Journal* reported the incident, and the story was reprinted in other papers. After praising Peterman for her "good service," the Chicago reporter appeared surprised that "she [seemed] to regard her past course as something not to be regretted."[248]

Rebecca, renamed Georgianna by newspapers in Minnesota, Illinois and Wisconsin, was not pleased by her notoriety. When she reached Ellenboro, the local paper announced her arrival. An article in the *Platteville Witness* noted, "She lives in Ellenbro…is about twenty years old, wears soldier clothes, and is quiet and reserved."[249] She left home two weeks later, after her older sister died in an accident. A newspaper reporter attributed Peterman leaving home due to her mother pressuring her to wear a dress. For more than a month, the travels of Rebecca "Georgianna" Peterman were printed in Wisconsin newspapers.

Peterman first went to Prairie du Chien, wearing her uniform, and checked into a soldiers' hostel. A few soldiers she knew recognized her and she was forced to leave. She then went to Boscobel and tried to reenlist. Unsuccessful, she traveled to Portage and tried again. Because Wisconsin newspapers were chronicling her moves, Portage officials recognized her "as the celebrated girl soldier from Ellenboro" and put her in jail.

Reporters from the *Grant County Witness* interviewed her stepfather, who said that Peterman's "wild, erratic course" was a source of grief to her "staid, respectable" family. He further claimed, "The girl is perfectly uncontrollable." Peterman left Portage and disappeared from the newspapers. One hopes she found whatever she was looking for.[250]

WISCONSIN'S NATIVE AMERICANS

Unrecognized Allies

In 1860, it was estimated that more than 300,000 Native Americans lived in the United States; 5,098 enlisted in the Union army during the Civil War. It is unclear how many Native Americans lived in Wisconsin. The 1860 census listed 2,833. Another 4,300 Chippewa lived in the seven Lake Superior reservations; however, only four of those were in Wisconsin. It seems 4,000 to 6,000 is a reasonable estimate. Of these, more than 500 served in the Union army in Wisconsin regiments during the Civil War. The exact number is impossible to know because many of Wisconsin's Native Americans were not identified as such when they enlisted.[251]

The numbers in government reports do not include all of those who enlisted. The Oneida, Stockbridge-Munsee and Menominee Nations, often called the "Green Bay tribes," officially provided 279 men. Their rate of enlistment was high. Of 164 males enumerated among the Stockbridge and Munsee, 43, or 26 percent, enlisted. Of 518 Oneida males, between 111 and 142 enlisted. This is between 21.5 percent and 27.4 percent. At least 46 of them died or were reported missing during the war. Some tribal historians estimate as many as 65 Oneida died during the war. Among the 886 Menominee males, 125 or 14 percent enlisted. One-third of the Menominee died, either in battle or of disease. In total, about 8.5 percent of the Green Bay tribal population served in the Union army. This was not far below the 10.2 percent participation rate for Wisconsin overall. In addition, 190 Ojibwe and Chippewa men enlisted. These numbers, added to the 279 for the Green Bay tribes, gives a total of 469, and it is undoubtedly low.[252]

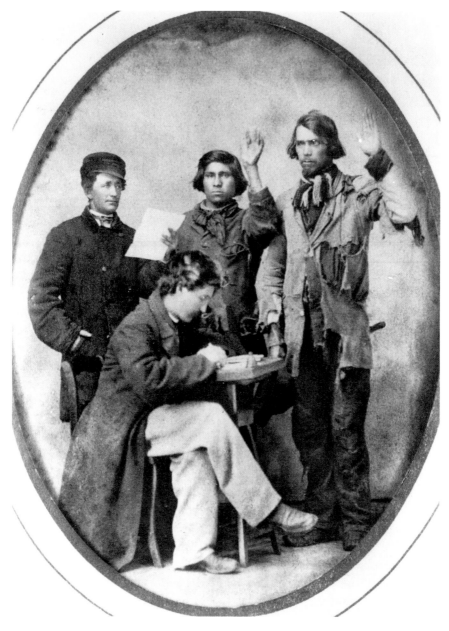

Thomas Bigford (*in cap, on left*) and another official swearing in two Native American Civil War recruits. According to Bigford, the recruit on the right may be Adam Scherf of Stockbridge. *Wisconsin Historical Society*.

Why did these men enlist? There were a number of reasons. The depressed economic circumstances of many Native Americans in Wisconsin provided one incentive. Money paid in the form of bonuses to new enlistees or to draft substitutes was also a strong motivation.

By October 1863, the Federal government offered a $302 bounty for three-year recruits. The following year, local communities in Wisconsin added their own bounties to spur enlistment.[253] The Oneida are representative of Wisconsin's Native Americans. Despite some of the Oneida chiefs advising against it, many Oneida enlisted. On May 31, 1864, M.M. Davis, the agent for the Green Bay Agency, wrote:

The Oneidas who have enlisted in the military service have done so of their own free will. They have received government and local bounties and I have no doubt they are much better provided for in the service than they have ever been heretofore. The families of these enlisted men are also much better off than heretofore. They already received large bounties and they receive $5 per month from the state.[254]

Another reason for enlistment was a sense of tribal loyalty to the United States. Because the tribal reservations were established by federal treaty, some tribe members felt fighting on the side of the Union was an obligation to the U.S. government. In addition, because of their tradition of fighting with the Americans during the Revolution and afterward, most Oneida thought of themselves as allies of the United States rather than enemies.[255]

There was also a desire to keep their land. Whether it was the Menominee living in their traditional lands or the Oneida and Stockbridge-Munsee who arrived from the East, all the tribes wanted to avoid further removal to the West. Tribal members hoped that loyalty to the U.S. government would prevent this.[256]

Finally, the "warrior culture" of the Native American tribes undoubtedly provided an impetus. For years, the government had tried to get the Native Americans to abandon their traditional ways and adopt "civilized" ones. This especially applied to warfare. Enlisting in the Union army represented a chance to literally become a warrior and enact those personal and tribal traditions (in the same way young men do from every culture).[257]

WISCONSIN'S NATIVE AMERICANS
OFFER THEIR SERVICES

Less than a month after the firing on Fort Sumter, a "mixed blood" Menominee trader living near Oshkosh, Wisconsin, named Robert Grignon offered Governor Randall the services of two hundred Menominee warriors "well armed with rifles, sure at forty rods and anxious to serve under the stars and stripes." The letter was ignored. The reason, according to Augustus Gaylord, the adjutant general of Wisconsin, was that there was was "some doubt" as to the "propriety" of using Native Americans "in the present contest with our brothers" as long as there are volunteers from "civilization."[258]

Despite the state government's rejection of the organized enlistment of Native Americans, in the first year of the war, dozens of Brothertown, Menominee, Oneida and Stockbridge-Munsee men enlisted. They went unnoticed because they enlisted as individuals or in small groups. For example, seven Oneida men enlisted in the Eleventh Wisconsin Infantry in October 1862 but were put in three different companies. There was also an arbitrariness to Native American enlistment. Some were accepted into Wisconsin's "white" regiments, while others served in the U.S. Colored Troops once "colored" units were authorized.[259]

One of the first to join was William Stanton, who enlisted on June 4, 1861, from Brothertown into Company I, Fifth Wisconsin Infantry; he may have been of Stockbridge lineage. He was the son of Moses Stanton, the founder of Chilton, Wisconsin, and was of mixed African American and Native American ancestry. His family was marked *M* for mulatto in the 1860 census. In total, 140 Brothertown men enlisted during the war and served in all four cavalry regiments and fourteen different infantry regiments. Like the other Wisconsin Native Americans, they were often clustered in particular units. The largest single group appears to be 16 who served in the Twenty-First Wisconsin Infantry, all but 3 in Company E; at least 13 served in Company C of the Thirty-Eighth Wisconsin Infantry. Many also served in the cavalry. In Company A of the Second Wisconsin Cavalry there were 13 and 12 in Company K of the Fourth Wisconsin Cavalry. At least 28 Brothertown men died in service, 11 were discharged for disability or disease, 13 were wounded and recovered and 4 were taken prisoner, 1 of whom died at Andersonville.[260]

Other early enlisters were five Stockbridge-Munsee sworn into Company A, Third Wisconsin Infantry, at Fond du Lac on June 15, 1861. As part

of the Third Wisconsin, these men fought at Antietam, Chancellorsville and Gettysburg and took part in Sherman's March to the Sea. One of them, Jefferson Fiddler, was discharged after being wounded but rejoined the regiment. He died on campaign in Georgia in May 1864. Another, Henry Davids, was wounded in three battles: Antietam, Chancellorsville and Resaca.[261]

By 1863, volunteers from "civilization" were harder to acquire, and a draft was instituted. Native Americans were exempt, but they could enlist or serve as "substitutes" for white men who were drafted and earn large bonuses. Many of them took advantage of the opportunity.[262]

Although Wisconsin's Native Americans served in many regiments, they were concentrated in a few. About twenty Menominee men served in Company K of the Seventeenth Wisconsin Infantry. Six of them enlisted in early 1862. The regiment participated in the Battle of Corinth and the Siege of Vicksburg. One Menominee soldier, John Kitson, was wounded in an assault on Vicksburg; two others died of disease.[263]

The largest single group of Native American soldiers in a Wisconsin regiment were the Oneida of the Fourteenth Wisconsin Infantry. No fewer than forty-seven of them served. Thirty-nine served in Company F and at least eight more in Company G. In the words of Elisha Stockwell Jr., a member of the regiment, "Company F was a big part Indian, and good skirmishers."[264]

Many of the Oneida who enlisted in the Fourteenth Wisconsin Infantry enlisted in December 1863 and January 1864 and did so in groups of five or six, indicating they enlisted with friends or relatives. Five of the Company G Oneida enlisted on New Year's Eve 1863 in Green Bay. Twelve who enlisted in Company F did so on March 4, 1864, at Fond du Lac.

Most of the Oneida enlistments were credited to white communities near the reservation, such as DePere, Fort Howard, Green Bay and Lomira. Some were credited to Oshkosh and Sheboygan for draft quota reasons, although the men enlisted in Green Bay or Fond du Lac.

The Oneida joined a veteran regiment that had been organized at Fond du Lac and already served for two years. As part of the Fourteenth Wisconsin Infantry, the Oneida took part in the Atlanta and Nashville campaigns and saw action in Arkansas and Alabama before being mustered out in 1865. Ten of the Oneida died in service: two in action, eight of disease. This is a death rate of nearly 20 percent.[265]

Like the Oneida of the Fourteenth, the Menominee who enlisted in Company K, Thirty-Seventh Wisconsin Infantry, did so in groups. Between

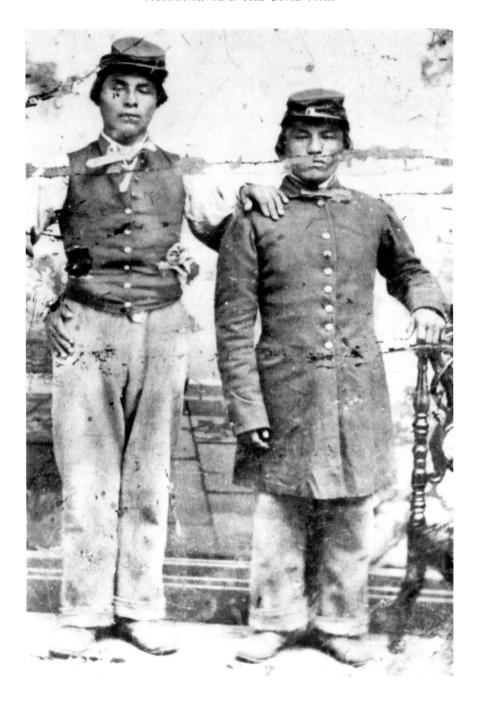

Two Native American soldiers in uniform. The man on the right is wearing a frock coat, indicating that he is in the infantry. *Neville Public Museum.*

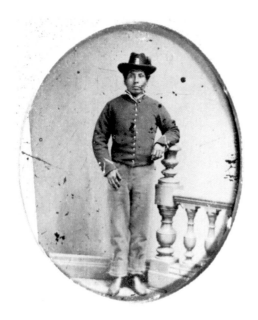

Left: A Native American soldier in a cavalry uniform. *Neville Public Museum.*

May and June 1864, at least forty Menominee enlisted into the regiment. Twenty of them enlisted between May 14 and 20, 1864.[266]

Like the Twenty-Ninth U.S. Colored Infantry, the Thirty-Seventh Wisconsin Infantry joined the Army of the Potomac during the Siege of Petersburg. A week after its arrival, the regiment took part in the Battle of the Crater. The Thirty-Seventh suffered heavily; only 95 of the 250 men who went into action answered the roll call that evening. Company K suffered 17 killed, wounded or taken prisoner. At least 7 of the killed were Menominee. Their names were Corporal Semour Hah-pah-ton-won-i-quette and Privates Amable Nah-she-kah-appah, Joseph Jsah-wahquah, Meshell Shah-boi-shak-kah, Felix Wah-to-nut, Paul Weier-is-kasit and Joseph Wah sha-we-quon.[267]

The regiment served until the end of the war and took part in the Grand Review in Washington, D.C., in May 1865. The Menominee in Company K, Thirty-Seventh Wisconsin Infantry, formed the largest concentration of Native American soldiers in any of Wisconsin's regiments at the company level. In 1864, William Dole, the commissioner of Indian affairs, wrote that the Menominee enlistments in the army attested to "the life-long loyalty of the tribe," noting that the Menominee made "brave and enduring soldiers, coming easily under discipline."[268]

One particular case of irony was that of Baptise St. Martin, a Chippewa who enlisted in the Thirtieth Wisconsin Infantry. As a child, he most likely

marched to Sandy Lake, Minnesota, in a forced removal from northwestern Wisconsin. He later returned to Wisconsin. As part of the Thirtieth Wisconsin Infantry, he was sent west instead of south, to fight the Sioux. Historically, the Chippewa and Sioux were not friendly. But one wonders what he thought having gone from a person seen as an enemy of the government to someone enforcing that same government's military policy against other Native Americans.[269]

In the end, the Native Americans in Wisconsin gained little from their sacrifices during the Civil War. The Oneida epitomize this. In the opinion of one historian, the Civil War years were "tragedy of immense proportions" for the Wisconsin Oneida. Aside from the Oneida killed during the war, a smallpox epidemic ravaged the reservation from November 1864 through March 1865. Fifteen tribe members died. Overall, the tribe suffered a population decline of 4 to 5 percent during the war. The Native American sacrifice for the Union, while contributing to a legacy of courage and sacrifice, did little to improve their condition.[270]

NATIVE AMERICANS IN THE IRON BRIGADE

Several Ojibwe (Chippewa) and men described as "half-breeds" served in Company G, Seventh Wisconsin Infantry. They were from Burnett and Polk Counties and enlisted in the spring of 1864.[271] On May 9, 1864, they helped the Sixth Wisconsin Infantry drive back Confederate skirmishers at Spotsylvania, Virginia. Colonel Rufus Dawes of the Sixth wrote:

The skirmishers of each army occupied the tangled brush and woods between the lines, and they kept up, day and night, a ceaseless and deadly fire....On the morning of May 9th a determined effort was made to drive back the enemy's skirmishers, and thirty men were ordered from the Sixth for this service....The Indians of the 7th Wisconsin regiment took an active part in this skirmishing. They covered their bodies very ingeniously with pine boughs to conceal themselves in the woods. When skirmishers advanced from our lines, they would run across the open field at the top of their speed, and numbers of them were shot while doing so. Upon this run the Indians would give a shout or war whoop.[272]

THE GREAT INDIAN SCARE OF 1862

On November 27, 1861, Clark W. Tompson, the superintendent of Indian affairs of the Northern Agency, wrote, "A bad feeling is growing up between the Indians and settlers, which threatens serious consequences, unless soon arranged." Nothing was arranged.[273]

After years of hunger and grievance caused by corrupt traders and government agents, the Dakota Sioux went to war, attacking settlers and army posts in southwestern Minnesota during August and September 1862. Thousands of refugees fled to eastern Minnesota. Panic swept the state. About forty thousand refugees crossed into Wisconsin telling stories of massacre.[274]

Western Wisconsin soon succumbed to the panic, and it spread eastward. Superior, Wisconsin, stands out as an example. When news of the massacres in Minnesota reached Superior about August 25, 1862, the citizens formed a committee of public safety. On August 31, it issued Public Order No. 1, creating "a regularly organized guard" that patrolled the town from 9:00 p.m. until 5:00 a.m. "Every male person" living in the city limits between the ages of eighteen and sixty was required to take their turn standing guard or "furnish a substitute." In addition, all families were required to sleep in a designated part of the city. Finally, the committee suggested that the people of the neighboring towns come to Superior until "all danger has passed." The "panic" reached the shores of Lake Michigan north of Milwaukee, more than two weeks after it began, with refugees fleeing to Port Washington, Waukesha and Milwaukee.[275] Many years later, a resident of Sheboygan Country, Viola Sisson Stout, remembered the scare:

Trains arriving from the north and west brought frightened passengers who had left their homes at a moment's notice....In vehicles and on foot, fearful fugitives crowded all approaches from the country. Invalids had been dragged from their beds and hurried into lumber wagons or clumsy farm carts in which they were jolted to town at the highest attainable speed.

When inhabitants of isolated farms witnessed...unfrequented highways near their dwellings cluttered with vehicles of all descriptions carrying fugitives and household goods and were trembling assured that four thousand rampagaeous, blood-thirsty Indians were not far behind, they gave way impulsively to unreasoning panic and joined the rush for safety.[276]

Menominee Indians in Council.

A Glimpse at the Cause of the Troubles in Minnesota!

Other Tribes Implicated with Sioux!

The South Instigates the Movement!

THE MENOMONEES LOYAL!

No Danger Here--No Cause for Fear.

SPEECHES OF MENOMONEE CHIEFS.

From the Shawano Journal of Sept. 25th.

Proceedings of a War Council held by the Menomonee Indians at Keshena, Aug. 28th, 1862, for the purpose of expressing their loyalty to the government of the United States, and their willingness to assist their Great Father in keeping peace upon the northern frontier. The following Chiefs were present: Ah-co-ne-may, Head Chief of Nation, Ke-she-na Second Chief, Shoo-na-nee, head War Chief, Carrow, Ka-man-e-kin, La-mote, Shoe-wai-tuk, Wau-ke-chon, Wau-she-sha, Nau-wa-to-pe-neeh, Ash-ke-na-wieh, Mah-pe-ta-powess, Way-kah, Chiefs of Bands.

An announcement of a meeting of Menominee in Keshena to pledge their loyalty to the United States in the *Green Bay Advocate. Public domain.*

The reality was that Wisconsin residents were in no danger from the violence in Minnesota, and they had nothing to fear from the Native Americans in Wisconsin. This was because, as their government agent Moses Davis wrote, the Menominee had "the rights of home in this State [and] are thoroughly loyal." The Menominee even held a special council at Keshena on August 28, 1862, to express their loyalty to the U.S. government and their willingness "to assist their Great Father in keeping peace upon the northern frontier."[277]

In response to the attacks in Minnesota, three Wisconsin regiments preparing to move south, the Twenty-Fifth, the Thirtieth and later the Fiftieth Wisconsin Infantry, were sent into Minnesota and the Dakota Territory to help pacify the area. Even a company of paroled prisoners from the Battle of Shiloh, Company B of the Eighteenth Wisconsin Infantry, was used. They were sent to Superior, Wisconsin.[278]

A Milwaukee newspaper editor wrote, "It is a wonder how such an unfounded panic could get started. The human family is at times ridiculous or frightened or desperate or foolish or cowardly, but never until the Indian scare of 1862 were the dwellers of Milwaukee and Wisconsin possessed of all five of these attributes at once."[279]

GETTING OLD ABE

In the spring of 1861, after "the big snow had gone," Ahgamahwegezhig, also known as Chief Sky, a chief of the Flambeau Band of the Ojibwe Indians, noticed an eagle's nest on top of a tall pine tree near the Flambeau River in northern Wisconsin. Chief Sky saw birds circle the nest. This told him there were young ones in it. He tried to climb the tree several times, but the parent eagles "stubbornly" attacked him and he could not reach

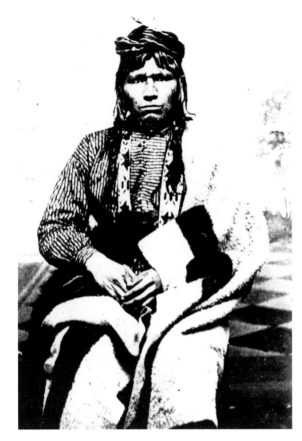

Left: Ahgamahwegezhig (Chief Sky), the man who secured the bald eagle "Old Abe," which became the mascot of the Eighth Wisconsin Infantry. *Wisconsin Historical Society*.

Below: Old Abe and the Eighth Wisconsin. *Wisconsin Historical Society*.

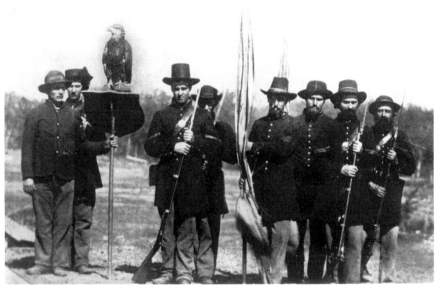

Old Abe, the live war eagle. *Library of Congress.*

the nest. So, he cut the tree down with an axe. There were two young eagles in the nest, but one was killed by the fall. He took the other to his tepee where it was fed by "squaws and papooses with bits of meats and scraps from the camp kettle."

Chief Sky kept the eaglet for three or four weeks. When "the full moon came and the weather grew warm" his father, Thunder-of-Bees, led his men down the Flambeau River to trade maple sugar, furs and moccasins with the "white men." Chief Sky took the eaglet with him. At Eagle Point, in Chippewa County, he met a man named Daniel McCann who offered him a bushel of corn for the bird. Chief Sky took the offer.[280]

In August 1861, a militia company, the Eau Claire Badgers, was organizing. McCann sold the bird to the Eau Claire company, which brought the eagle to Madison with it, where it became Company C of the Eighth Wisconsin Infantry, afterward called the "Eagle Regiment." The company commander, Captain John E. Perkins, named the eagle "Old Abe" after President Lincoln. The eagle was carried throughout the war on a custom-made perch. A member of the regiment described the how the eagle was handled:[281]

> *The eagle was carried the same way that the flag was. The bearer wore a belt with a socket attached to receive the end of the staff, which was about five feet long. Holding the staff firmly in hand, the bearer could raise the eagle about three feet above his head, which made him quite conspicuous. The bird had a leather ring around one leg to which was attached a strong cord about twenty feet long. When marching or engaged with the enemy, the bearer wound the cord up on the shield, giving the eagle about three feet of slack.[282]*

It was noted that Old Abe became "greatly excited" during battle and quiet afterward. He would also announce the approach of Confederate soldiers with "a note of alarm." It was at the Battle of Corinth on October

3, 1862, that Old Abe gained recognition from the enemy. General Sterling Price reportedly said, "That bird must be captured or killed at all hazards. I would rather get that eagle than capture a whole brigade or a dozen battle flags." Price and the Confederates never did. Old Abe survived the war, living in the basement of the Wisconsin state capitol, earning thousands of dollars for charities in fundraising events. He lived until 1881.[283]

Wisconsin's African Americans

In 1860, 1,171 "free colored" people lived in Wisconsin, mostly in Milwaukee and Racine Counties, although freed slaves from Virginia, Tennessee, Missouri and Arkansas started an African American farming community five miles west of Lancaster in Grant County. Called Pleasant Ridge, the community grew to about one hundred residents and built one of the first integrated schools in the country in 1873, employing both black and white teachers. The residents also created an integrated church in 1884 and an integrated community hall in 1898.[284]

Despite the small number of African Americans living in Wisconsin, the state is officially credited with providing 353 soldiers. In reality, the number is more than 420. Many of these enlistees were not residents of Wisconsin. They came from other states, primarily Illinois and Missouri. But at least 110 were residents.[285]

At the beginning of the war, African Americans were not allowed to serve as soldiers. Heavy Federal casualties and the Emancipation Proclamation changed that. In early 1863, recruitment of African Americans began. On May 22, 1863, the War Department established a Bureau of Colored Troops to coordinate recruitment and organization at the Federal level.

During the Civil War, African American regiments organized by the Federal government were known as the United States Colored Troops (USCT). They consisted of infantry, artillery and cavalry. White officers led the regiments. Wisconsin provided ten officers for the USCT during the war. They served in both infantry and heavy artillery units. All of them had previously served in Wisconsin's "white" regiments.[286]

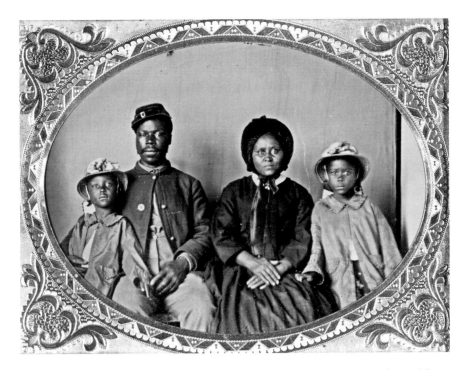

An African American soldier with his wife and daughters. Many African American soldiers, like their white counterparts, had families. *Library of Congress.*

In October 1863, the War Department authorized Wisconsin to raise a unit of colored troops. Adjutant General Augustus Gaylord wrote in 1864, "Whatever prejudice may have existed in the minds of the people against the employment of colored troops…has fast given way if it be not now everywhere extinct." But the "sparseness" of the African American population in Wisconsin offered "little encouragement to any white officer to undertake the raising of even a company," Gaylord noted. No effort was made until 1864. In that year, Chicagoan John A. Bross, a former captain in the Eighty-Eighth Illinois Infantry, was appointed to command the Twenty-Ninth USCI. He opened two recruiting stations in Wisconsin. As a result, most of the African American soldiers credited to Wisconsin served in the same unit, Company F of the Twenty-Ninth U.S. Colored Infantry (USCI).[287]

African American soldiers who were Wisconsin residents served in other regiments as well. The Eighteenth USCI had more than sixty men credited to Wisconsin. The Third U.S. Colored Heavy Artillery had twenty-seven men, twelve of whom lived in Wisconsin before or after the war, and at least ten served in each of the Seventeenth, Forty-Ninth, Sixty-Seventh

and Sixty-Eighth USCI. Small numbers also served in the Twenty-First, Twenty-Third, Forty-Second, Forty-Seventh, Fiftieth and Ninety-Second USCI and the Thirteenth USCHA. No fewer than nine Wisconsin men joined the Fifty-Fifth Massachusetts. Two of the men from the Fifty-Fifth were among the soldiers who signed a petition to the Wisconsin legislature in 1865 asking for a referendum on African American suffrage.

At least forty-two men in the Forty-Ninth USCI were credited to Wisconsin; fourteen or more lived in Wisconsin before or after the war. Twenty-one were in Companies F and K. The Forty-ninth USCI was organized in March 1864 and drew largely from the Eleventh Louisiana Infantry (African Descent) operating in the Vicksburg, Mississippi Military District and then at various points in the Department of Mississippi.[288]

In addition, some African American men who lived in Wisconsin went to Chicago and enlisted. Some served in the Twenty-Ninth, credited to Chicago. At least 3 members of Company F did this. African Americans also served as cooks, servants and wagoners. At least 182 served in these capacities in Wisconsin units.[289]

TWENTY-NINTH USCI

When the Twenty-Ninth USCI was recruited, the draft was in effect. Under the Civil War draft system, each state had a quota of soldiers it was to provide. States were allowed to enlist men from other states and have them count toward their quota. Company F of the Twenty-Ninth USCI was made up primarily of African Americans from Illinois and Missouri who took the place of Wisconsin residents and so were credited to Wisconsin. An example of this was thirty-year-old private James Taylor, a runaway slave from Missouri who enlisted in Company F in December 1863. He was counted toward the Milwaukee quota, although he had never been there. Ninety of its enlistees gave Wisconsin as their residence; twelve gave Illinois residences. At least twenty-two of the men who served in Company F lived in Wisconsin when they enlisted, with the same number serving in the other companies of the Twenty-Ninth USCI. The African Americans from Wisconsin came primarily from Milwaukee and Janesville, where the largest numbers of African Americans resided, and from Grant and Vernon Counties, where former slaves had formed communities.[290]

Two sergeants in Company F—Alfred Weaver and Peter Stark—were from Wisconsin. Weaver was born a slave in North Carolina. He was living in Vernon County by 1858 working as a carpenter and laborer. In March 1864, he traveled to Madison and enlisted in Company F.[291]

The Twenty-Ninth USCI was organized in Quincy, Illinois, in the spring of 1864 with John A. Bross commissioned as lieutenant colonel. The first five companies, A through E, were raised in Illinois, many from the Chicago area, and sworn-in in April 1864. The regiment numbered only 450 men, with most of its dozen officers still waiting for their commissions. Company F only had 14 men, too few for the company to officially muster. Because Illinois was having difficulty recruiting the number of soldiers needed to form six companies, the number needed to make the regiment official, it accepted recruits credited to Wisconsin to form Company F.

Company F recruiting continued through June. Most of the new recruits were enlisted by agents acting for Wisconsin who would forward them to the company. Only twenty-two soldiers were in Company F when the regiment left Quincy, Illinois, in May 1864 to join the Army of the Potomac. Company F was not at full strength until the beginning of July. The other four companies of the regiment were recruited later.[292]

The commander of Company F was thirty-nine-year-old captain Willard E. Daggett. Born in Massachusetts, he was living in Milwaukee as a boot and shoe dealer when he enlisted as a private in the Twenty-Fourth Wisconsin Infantry on August 21, 1862. Presumably he was with the regiment, known as the "Milwaukee Regiment," at the Battles of Perryville, Stone's River and Chickamauga and the storming of Missionary Ridge. Interestingly, the muster roll for the Twenty-Fourth Wisconsin Infantry lists him as having deserted on April 3, 1864. The muster roll for the Twenty-Ninth USCI lists him as appointed captain on April 22, 1864, from "Civil Life." It is unclear if he actually deserted or if it was a "paperwork" issue. He is known to have recruited for the Twenty-Ninth USCI in the spring of 1864. He apparently wasn't worried about being arrested for desertion, as he was mustered in on June 10, 1864, at Quincy, Illinois. He joined the regiment on July 19, 1864.[293]

John A. Bross, the commander of the Twenty-Ninth USCI, was a lawyer and assistant U.S. marshal before the war. He had a good combat record, fighting with the Eighty-Eighth Illinois Infantry at the Battles of Perrysville and Murfreesboro. Bross was a Douglas Democrat and not an abolitionist. His willingness to command a colored regiment demonstrated the commitment among War Democrats to victory despite political differences with Republicans

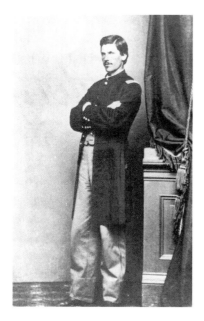

Robert K. Beecham, a veteran of the Second Wisconsin Infantry, became an officer in the Twenty-Third U.S. Colored Infantry. He was taken prisoner and escaped after eight months. *Public domain.*

and social antipathies toward African Americans. He also knew the dangers of commanding a regiment of black troops. During a speech prior to his regiment's departure, he was quoted as saying, "When I lead these men into battle, we shall remember Fort Pillow, and shall not ask for quarter....I ask no nobler epitaph, than that I fell for my country, at the head of this black and blue regiment."[294]

The regiment was ordered east in May 1864, and by July, it had joined the Army of the Potomac in the trenches outside of Petersburg, Virginia. The fact that the regiment was untrained and understrength when it was sent to war did not matter. The fighting between the Army of the Potomac and Lee's Army of Northern Virginia had been bloody. The Union army needed men.[295]

Near the end of July 1864, Sergeant William McCoslin wrote in a letter to a hometown newspaper that the regiment had "built two forts and about three miles of breastworks," which showed that they were "learning to make fortifications, whether we learn to fight or not." They had worked that way for eight or ten days "without stopping." Their construction work was about to end.[296]

THE BATTLE OF THE CRATER

On July 30, 1864, the regiment took part in the Battle of the Crater. In an attempt to break the stalemate with Lee's Army of Northern Virginia at Petersburg, the Army of the Potomac dug a five-hundred-foot tunnel to the Confederate line, filled two parallel galleries with eight thousand pounds of black powder and blew it up.

Major General Ambrose Burnside's Ninth Corps was chosen to lead the assault (Burnside having developed the plan). Initially, Brigadier General

Edward Ferrero's division, which consisted of nine USCI regiments, was to lead the assault, but Major General Meade, the commander of the Army of the Potomac, convinced Major General Grant, the overall commander, to have the white divisions lead the assault instead. Meade did not think the African American troops could make the assault successfully and convinced Grant that if the black troops were slaughtered it would be said they were sacrificed "because we did not care anything about them." He felt that could not be said if they "put white troops in front."[297]

On the morning of the attack, the regiment was awakened at 3:00 a.m., ate their ration of raw salt pork and coffee and waited. After delays, the mine was detonated at 4:44 a.m. The explosion propelled tons of earth, wood beams, boulders and several hundred soldiers from the Eighteenth and Twenty-Second South Carolina Infantry skyward "in an enormous mass… without form or shape," which then crashed back to earth. The resulting crater in the Confederate lines was two hundred feet long, sixty feet wide and thirty feet deep.[298]

The three white divisions of the Ninth Corps, without effective leadership and opposed by Confederate counterattacks, floundered in their assault—barely able to get beyond the crater itself. Finally, several hours after the explosion, with the assault already a debacle, Ferrero's division was ordered to advance. The Twenty-Ninth USCI was in Ferrero's Second Brigade. Lieutenant Colonel Bross led his men forward, under fire for the first time.[299]

An eyewitness recorded the Second Brigade "going in fine shape" past the troops of Ledlie's First Division, through the Confederate entrenchments and "out into the open field" beyond. This is when Confederate artillery fired on them, and as the brigade commander Colonel Henry Thomas reported, they were met with "a murderous cross-fire of musketry."[300]

The USCI regiments suffered heavily. The brigade commander, Colonel Henry Thomas, wrote that "hundreds of heroes, 'carved in ebony' fell." The Twenty-Ninth USCI also suffered its first casualties. Captain Flint, commanding Company E, was killed, and Captain Aiken of Company B was wounded, dying two days later. Five of the regiment's flag bearers were killed or wounded. The severe "cross and enfilading fire" forced the soldiers to take cover in abandoned Confederate fortifications about eight hundred feet beyond the crater. A Confederate lieutenant, John S. Wise, no fan of African American troops, observed, "To the credit of the blacks be it said that they advanced in better order and pushed forward farther than the whites."[301]

After "a short time," Colonel Thomas ordered his brigade to charge again, across open ground, seeking to reach a crest that was the objective of the attack. Thomas's men were "mowed down like grass." He ordered them to retreat, closer to the crater. Brigadier General Ferrero ordered his two brigades to make another assault. Colonel Thomas organized his shattered regiments and ordered a charge. Lieutenant Colonel Bross again led his men forward, this time carrying the flag. Thomas reported that Bross was "the first man to leap from the works into the valley of death below." Confederates reported seeing "a gallant Union officer, seizing a stand of colors, [who] leaped upon their breastworks and called upon his men to charge." Bross was hit by a bullet in the head and fell dead, "enwrapped in the flag." Thomas noted that the men of the Twenty-Ninth USCI "followed into the jaws of death," advancing until stopped by a Confederate counterattack. The regiment then retreated through "a perfect storm of shot and shell."[302]

Company F lost 10 killed or died of wounds and 1 missing. The understrength Twenty-Ninth USCI lost 38 killed or died of wounds and 32 prisoners, 18 of whom died in captivity. Because of poor records, the regiment's wounded can only be estimated. One historian estimates 75 based on Brigadier General Ferrero's casualty report of July 31, 1864. Three different sources give a total number of killed, wounded and missing (including captured) as between 124 and "more than" 140. These numbers were about 25 percent of the regiment's strength. The entire Ninth Corps lost 3,828 men, 1,327 of these (almost 35 percent) from Ferrero's division, a disproportionately high number. One of the wounded was Captain Daggett. Records indicate he had a "contusion of left side." Daggett was on sick leave from August 4, 1864, to November 10, 1864. He was sent to the U.S.A. General Hospital at Bedloe's Island in New York Harbor and then the Officers U.S.A. Hospital, Annapolis, Maryland.[303]

One of the regiment's enlisted men wrote after the battle that everyone in the regiment had the "utmost confidence" in Lieutenant Colonel Bross and that he "was loved by everyone because he was a friend to everyone." The soldier wrote that he would not weep for someone "who was one of God's chosen ones, who tried to deliver his people out of Egypt."[304]

Three of the company's most seriously wounded were later discharged. Private Charles South, forty-six years old, enlisted with his younger brother Collins in Missouri. They had both been slaves in Pike County, Missouri. Both were counted as Wisconsin men. Charles's right arm and left knee were severely injured during the battle. In October, he was sent to the

hospital in Quincy, Illinois, and was discharged as totally disabled in early January 1865.

The other two discharged wounded were actually Wisconsin residents when they enlisted. Private Henry Sink, born in a slave in Batesville, Arkansas, in 1837, was living in Green Bay, Wisconsin, when he enlisted. He was wounded in the left arm and discharged in March 1865. In 1890, he was found to be one-quarter disabled and given a five-dollar monthly pension. He died at Fond du Lac, Wisconsin, in 1905. The other was Sergeant Daniel B. Underhill, who also enlisted in Wisconsin. He was discharged in June 1865.[305]

AFTER THE CRATER

After the battle, the Twenty-Ninth USCI was not given a rest. It stayed on the Bermuda Hundred front and before Richmond until the end of the war. Daggett rejoined his company in November 1864. After Appomattox, the Twenty-Ninth USCI served in Virginia until May 1865, when it was transferred to Texas and duty on the Rio Grande. Daggett was with the regiment until June 28, 1865, when he was put under arrest at Ringgold Barracks, Texas, and court-martialed—twice. The first time was for ordering the public beating of Private Joseph Burbo, who required hospitalization, and for disobedience of orders in Virginia. The second court-martial was for fraternization with enlisted men, the purchase of whiskey and the disobedience of orders in Texas. One wonders if Daggett was too harsh in his discipline during the war and, once it was over, went too far in trying to ingratiate himself with his men. Apparently, the army thought so, as Daggett was found guilty and a sentence "promulgated in G.C.M. Orders No. 3" on October 18, 1865. It "was never carried into effect," however. This is possibly because the Twenty-Ninth USCI had already been ordered to muster out, which it did on November 6, 1865. Daggett moved back to Massachusetts, settling in Brookline. In its brief history, the Twenty-Ninth USCI lost 234 men, 46 of them killed or mortally wounded in battle.[306]

For his part, the adjutant general of Wisconsin, Augustus Gaylord, did what he could for the African Americans who served for Wisconsin. He recommended that the war fund for families of soldiers from the state be amended to include the volunteers "in this [Twenty-Ninth USCI]

and other colored regiments." He noted that they were in the service of the United States and not the state and were "deprived of the benefits" accruing from the fund. "Their position differs from white volunteers in the regular service from this state," he stated, "in the fact that there are no colored state organizations. It therefore appears to me but a simple act of justice to extend to them such benefits as may accrue to their families through the war fund." In 1866, African American soldiers credited to Wisconsin were included in the 1864 "relief of families" of Wisconsin soldiers' law.[307]

WISCONSIN SOLDIERS AND FREED SLAVES

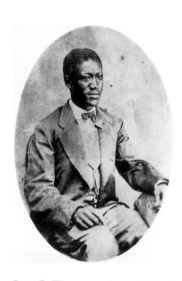

Peter D. Thomas, a slave who lived in Wisconsin after he was liberated, later served in the USCT. *Wisconsin Historical Society.*

Given the small population of African Americans in Wisconsin at the time of the Civil War, the way most Wisconsin soldiers interacted with African Americans was on campaign in the South. Undoubtedly the first African American most Wisconsin soldiers encountered was as an escaped slave or "contraband" coming into Federal lines. A good example of this is the story of Peter D. Thomas, a fourteen-year-old slave in western Tennessee liberated when Wisconsin troops occupied his plantation in 1862. Thomas later recalled that "the Yankees came on our plantation and told us we were all as free as they were and could go where we pleased. It seemed to good to be true, but as our owners said nothing, we knew it must be true."

Thomas became the servant of Captain Charles Nelson of Company G, Fifteenth Wisconsin Infantry. He was with him for the next year and a half and present at the Battles of Chickamauga, Missionary Ridge, Resaca and others. Captain Nelson was wounded at the Battle of New Hope Church, Georgia, on May 28, 1864. Thomas helped Nelson return to his home in Beloit, Wisconsin, to recover and worked on his farm. Several months later, Thomas traveled to Madison, Wisconsin, and enlisted in the Eighteenth

USCI. He served in the St. Louis area until November 1864, when his regiment was ordered to Nashville, where it took part in the Battle of Nashville and the pursuit of General Hood to the Tennessee River. Afterward, the regiment served at Bridgeport, Alabama, and Chattanooga, Tennessee, mustering out February 21, 1866. After the war, Thomas returned to Beloit to gain an education. When he enlisted in 1864 he had to sign his name with an "X." He eventually became a teacher in Chicago, ultimately settling in Racine, Wisconsin, where he was elected county coroner.[308]

14

PRISONERS

Approximately 212,000 Union soldiers were captured during the Civil War. Of these, 16,000 were "paroled on the field," meaning that they were released on the promise they would not fight again until officially "exchanged" for Confederates. Other Federals were imprisoned until exchanged, and some were never exchanged. Approximately 30,000 Union soldiers died in Confederate prisons.[309]

An estimated 462,000 Confederates were captured; about 247,000 of these were "paroled on the field." The remaining 215,000 were imprisoned and 26,000 died in captivity.[310]

The exact number of Wisconsin soldiers taken prisoner during the Civil War is not known. Incomplete records and the fact that captured soldiers might escape without ever being listed as captured prevents this. The best number, based on official records, is 3,508.[311]

THE EXPERIENCE OF BEING CAPTURED

After capture, Confederate soldiers often took the Union soldiers' blankets, overcoats and shoes, not to mention any valuables like rings or money. As Henry B. Furness, a sergeant in Company B of the Twenty-Fourth Wisconsin Infantry, noted, "Thus destitute, the luckless prisoner was forced to march, barefoot, hatless, unprotected from the weather, whether in summer or winter, for many miles, to some distant station."

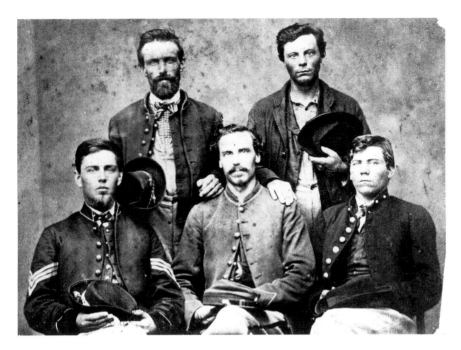

Five members of Company C, First Wisconsin Infantry. They enlisted in 1861, were captured at the Battle of Chickamauga and escaped together from a Confederate prison. *Standing*: Joseph Leach (*left*) and Lemuel McDonald; *sitting*: Chauncey S. Chapman (*left*), Thomas Anderson (*center*) and John R. Schofield. *Wisconsin Historical Society*.

During these "rapid and exhausting marches," prisoners were sometimes without food for four days, lacked water and were compelled to sleep without cover on the bare ground without fires. When food was issued, it was sometimes raw. Fire was allowed to cook it, but not having cooking utensils, the soldiers baked their food on boards or in the ashes of the fire.

The guards were usually cavalry. Those who couldn't keep up because of weakness were sometimes tied to a saddle. Furness noted that a disabled prisoner was often left behind with a guard, "who afterward rejoined the escort, without him."

Unless a soldier was captured near the prison that was to hold him, his march usually ended at a railway station, where he was transported to the prison. Here, he was crowded into boxcars with sixty to seventy others and shut in. Again, the men might be without food or water for twenty-four to thirty-six hours and without "the means to relieve natural necessities." Furness described what it was like in the boxcars:

Packed so closely, he had no opportunity of sitting, without danger of being trodden upon by his comrades—most of whom were compelled to stand.... Not infrequently, the cars had been used upon the up-trip for transporting cattle. It was not deemed necessary to cleanse them for the reception of Yankee prisoners. The end of the journey reached, the luckless captive, besmirched with filth, was presented at the prison gate.[312]

THE NUMBERS

The four Wisconsin cavalry regiments lost 360 men as prisoners. Almost two-thirds of them (226) were from the First Wisconsin Cavalry. The high loss was because the regiment took part in some of the heaviest fighting in the West, including the Battle of Chickamauga and the Atlanta campaign.

The thirteen artillery batteries lost approximately 146 men as prisoners. The Seventh Wisconsin Battery lost the most—55. About half these men were captured during Forrest's raid on Grant's supply lines in December 1862.[313]

The Tenth Wisconsin Light Artillery had sixteen men captured. It is a good example of how artillery batteries would lose men on campaign. Taking part in Sherman's March, most of the men were captured on March 9, 1865, when the battery was encamped near Monroe's Cross Roads, North Carolina, and surprised by Confederate cavalry. The battery lost ten prisoners, thirty horses killed and captured and one gun disabled. All but one of the other Wisconsin batteries lost ten or fewer men in the course of the war.[314]

The First Wisconsin Heavy Artillery Regiment lost ten prisoners. In reality, the prisoners were all from the Second Wisconsin Infantry and captured at the First Battle of Bull Run. They are credited to the First Wisconsin Heavy Artillery because the company they came from, in the Second Wisconsin Infantry, was transferred to the First Wisconsin Heavy Artillery.

Of course, most of Wisconsin's prisoners were from the infantry—3,003. The regiment to lose the single largest number of prisoners was the Eighteenth Wisconsin Infantry—272. Most of these (about 174) were captured at the Battle of Shiloh as part of Prentiss's division, after holding off repeated Confederate attacks at what became known as the "Hornet's Nest."[315]

The Second Wisconsin Infantry, the regiment that suffered the highest percentage of battle deaths in the Union army, not surprisingly lost many

men as prisoners—250. This regiment also illustrates the early war practice of prisoner exchanges. John M Ambruster was wounded and taken prisoner at Gainesville in 1862 but shows up again as wounded at Gettysburg in 1863. He apparently was exchanged in the interim. Corporal Luke Avery was wounded and taken prisoner at Gainesville in 1862 then apparently exchanged, because he was killed in action on July 1, 1863, at the Battle of Gettysburg. George Batcheldor was taken prisoner on August 6, 1862, but is listed as wounded at Gettysburg. He survived his wounds only to die of disease on October 2, 1863.

The Twenty-First Wisconsin Infantry, which fought at the Battles of Perryville and Chickamauga and took part in Sherman's Atlanta campaign and the March to the Sea, lost 212 men.[316]

Regiments organized later in the war did not necessarily escape the large loss of prisoners. Like regiments formed earlier, it depended on how much action they saw and if they were in particularly brutal battles. The Thirty-Sixth Wisconsin Infantry was organized in the spring of 1864 but took part in the June 3 assault at Cold Harbor, the Battle of the Crater and the battles at Deep Bottom, Weldon Railroad, Reams' Station and Hatcher's Run in Virginia. It lost 196 men as prisoners.[317]

Because most of Wisconsin's soldiers fought in the West, many of its prisoners were sent to Andersonville Prison in Georgia. More than forty-five thousand Union soldiers were held there during the course of the war. The 26.5-acre stockade lacked basic sanitation and was essentially an outdoor latrine, which fostered disease. The conditions killed more than thirteen thousand men by the end of the war.[318]

Approximately 968 Wisconsin soldiers were held at Andersonville, and at least 253 of them died. The regiments that had more than 50 men at Andersonville are, in order of death toll: the Tenth Infantry (39), the First Cavalry (35), the Fifteenth Infantry (32), the Twenty-First Infantry (25), the First Infantry (most captured at Chickamauga, 19), the Seventh Infantry (many captured at Gettysburg, 17), the Thirty-Sixth Infantry (13) and the Twenty-Sixth Infantry (9). Not surprisingly, there is a correlation between the duration of the stay at Andersonville and the death toll.

The last recorded death at Andersonville was that of Knud Hansen, Company F, First Wisconsin Cavalry, who died on April 28, 1865, eleven days after the Confederates abandoned the prison. Hansen and thirty-two other sick soldiers were left behind by the Confederates.[319]

ESCAPE

Wisconsin soldiers, like many others, tried to escape when they could. One of the more celebrated escapes was via the "Great Yankee Tunnel" from Libby Prison on February 9, 1864, when 109 Union prisoners escaped after digging a sixty-foot tunnel by hand. Many were later recaptured.[320]

At least five, and possibly six, Wisconsin officers took part in the escape. They were Lieutenant Colonel Harrison C. Hobart of the Twenty-First Wisconsin Infantry; Lieutenant C.H. Morgan, also of the Twenty-First Wisconsin Infantry; First Lieutenant Albert Wallber (Walber) of the Twenty-Sixth Wisconsin Infantry; and Lieutenant Colonel Theodore S. West of the Twenty-Fourth Wisconsin Infantry. These prisoners made good their escape. Lieutenant William L. Watson of the Twenty-First Wisconsin Infantry was captured after the escape, but he survived the war.

The questionable Wisconsin participant was either a Captain S.C. Bose or S.C. Rose of the Fourth Wisconsin Cavalry. Multiple sources give both spellings. Unfortunately, neither name is in the *Roster of Wisconsin Volunteers*. Another source indicates that it was a S.C. Bose of the Fourth Missouri Cavalry.[321]

Christian M. Prutsman, a first lieutenant in Company I of the Seventh Wisconsin Infantry, was captured in October 1863. He was sent to Libby Prison first; then a prison near Macon, Georgia; then a jail yard in Charleston, South Carolina; and finally a prison in Columbia, South Carolina. In the spring of 1865, he was being transported by train from Columbia when he and three others sawed through the floor of their boxcar and escaped. Coming upon cabins occupied by slaves, he approached them. "I began to question them in regard to my safety and as to the danger of betrayal, at which they gave me the assurance that I never would be betrayed by a negro or colored person; and further, they would both feed and secrete me as far as laid in their power."

Prutsman and his companions were sheltered by the slaves while Confederate soldiers camped nearby. After several days, Sherman's army arrived (after burning Columbia). The first unit encountered by Prutsman and his companions, by coincidence, was the Thirty-Second Wisconsin Infantry.

Prutsman made his way to Wilmington, North Carolina, where, before boarding a transport to the North, he was informed there were seven hundred ex-prisoners nearby. Hoping to find men he was captured with, he visited them. Upon entering a large warehouse where some of the men were kept, he was horrified:

I beheld, stretched out on blankets laid over a little of hay, a number of emaciated forms, looking more like skeletons than living beings, their eyes sunk in their sockets, many with no hair on their heads,—all arranged in a circle around the room with their heads toward the wall....I searched for faces...they looked at me in utter blankness....I found but two who could tell me their names....I could not talk to them; and they could no more answer my questions, than if they had been six months' old babies. Some of them could and did laugh; but...it reminded one more of the babbling of an idiot than that of a sentient, human being. They would roll up their eyes at me and stare, then turn them in their sockets until the white appeared, causing indescribable shudders to creep over my frame.[322]

Prior to his escape, Prutsman had been "very secretly informed of an 'underground railway'" that would help him get to Union lines if he were to escape. John Azor Kellogg, the captain of Company I, Sixth Wisconsin Infantry, actually used that "Underground Railway." Kellogg was captured at the Battle of the Wilderness on May 5, 1864. Five months later, on October 8, 1864, he and a few others escaped by jumping from a moving train while being transported. "It is difficult to describe one's sensation in jumping from a rapidly-moving to a stationary object," he wrote, "You do not fall, but the earth comes up and hits you." Behind Confederate lines in South Carolina, Kellogg and his fellow escapees eventually came upon slave cabins:

These faithful fellows were not only ready to feed and shelter us, but they willingly risked their lives for us. We also obtained from them accurate knowledge of the movements of Sherman's troops...a hundred and fifty miles from the scene of action. How they obtained it they would not tell; but it was plain they had means of conveying intelligence in some way, probably from one plantation to another, by means of runners.

Kellogg and his compatriots repeatedly relied on the help and guidance of slaves "faithful to every trust imposed upon them by us, even to the imperiling of their lives" and came to a startling conclusion: "In my opinion they were, as a class, better informed of passing events and had a better idea of questions involved in the struggle between North and South, than the majority of that class known as the 'poor whites' of the South." Kellogg and his comrades arrived at Union lines on October 26, 1864, near Calhoun, Georgia.

Kellogg led the Iron Brigade in the final campaigns of 1865 and was brevetted to brigadier general on April 9, 1865. He was mustered out on July 14, 1865, and elected to the Wisconsin State Senate in 1879.[323]

CONFEDERATE PRISONERS AT CAMP RANDALL

From the end of April through May 1862, more than 1,200 Confederate enlisted prisoners were held at Camp Randall. They were captured with the surrender of Island No. 10 on the Mississippi River on April 8, 1862. The prisoners sent to Camp Randall were from a number of regiments, but most were from the First Alabama Infantry. On the evening of April 20, 1862, 881 of them arrived by train. The people of Madison had forewarning of their arrival, and a large crowd of people had gathered to see the "secech prisoners" or, as a newspaper put it, "get a glimpse at Sir Butternut."[324]

The Madisonians on the station platform and the prisoners inside the cars engaged in "considerable conversation" when the train arrived, asking "civil questions" and answering in a "respectful manner." Jokes also passed freely between the people and the prisoners, who "expressed themselves well satisfied with the treatment they had received since they were captured… much better than they had expected."

One witness observed of the Fifty-Fifth Tennessee Infantry that "some of the boys looked barely 16 years old, and they appeared woebegone in a beggarly dress that ill-protected them from the keen wind….Considering the cold wind and the light clothing of many of the prisoners, we shall not be surprised at the proportion of sick being large."

The prisoners disembarked from the cars and marched between two ranks of the Nineteenth Wisconsin Infantry into a makeshift stockade at Camp Randall. The men of the Nineteenth Wisconsin Infantry made "a fine appearance," the *Wisconsin State Journal* noted. "The men march well and appear to be of the right sort of stuff."[325]

A second group of prisoners, numbering 275, arrived on April 24. Some of these were the sick left at Island No. 10. They were suffering from chronic diarrhea, pneumonia and other respiratory diseases. A number had died en route. The sickest were carried from the train on stretchers. Because many of the Confederates were suffering from exposure due to a lack of clothing, the quartermaster general of the camp issued each prisoner an extra shirt. They were also given full army rations.[326]

The day after the first prisoners arrived, the *Wisconsin State Journal* printed the name of six who had died, four from the First Alabama Infantry and two from the Fifty-Fifth Tennessee Infantry. They were buried in Forest Hill Cemetery, a local civil cemetery, where a "beautiful spot" was "set apart for the purpose." The graves were marked by a painted headboard giving the name, company, regiment, state and date of death. Union soldiers who died in the military hospital and Madison's general hospital were also interred in Forest Hill Cemetery in a Soldiers' Lot.[327]

An inspection on May 1, 1862, revealed that the soldiers guarding the prisoners, not surprisingly, were woefully inexperienced. Civilians were allowed to enter the camp, and as a result, two or three prisoners escaped because of "the difficulty of discriminating between proper persons and others passing the guard." The officer in charge of the prisoners ordered that no more civilians be allowed in the camp. An inspection also showed that the camp hospital was unable to handle the sick Confederate soldiers.[328]

During the first month, the death rate among the prisoners was shocking; as many as ten died a day. The cause was not ill-treatment or neglect on the part of the Federals but was due to the poor health caused by exposure suffered at Island No. 10.

One of the physicians attending the Confederate prisoners was Dr. Benjamin Franklin White. Born in New York, he moved with his family to Green Bay when he was nine years old. After receiving a medical degree from Rush Medical College in Chicago, he opened a practice in Prairie du Chien. When Wisconsin's first volunteer infantry regiment was organized, White was appointed the regimental surgeon. He served with the First Wisconsin Infantry at the Battle of Falling Waters on July 2, 1861, and was mustered out with the regiment on August 21, 1861. He resumed his medical practice in Wisconsin. When the Confederate prisoners arrived, White was contracted to help treat them. He

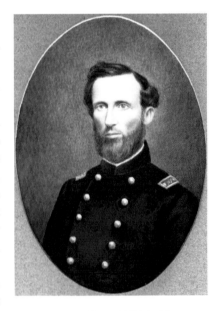

Dr. Benjamin White. *Civil War Museum, Kenosha, Wisconsin.*

suffered the fate of many of them when he contracted an illness and died in May 1862. He was thirty-five.[329]

At the end of May, the prisoners were sent to Camp Douglas in Chicago and eventually exchanged. During the time the prisoners were at Camp Randall, 140 of them died. One was shot by a guard; the remaining 139 died from disease or wounds suffered at Island No. 10. The First Alabama Infantry suffered the worst; 110 of them died. The Confederate dead were buried in a section of Forest Hill Cemetery known as Confederate Rest, the northernmost Confederate cemetery. The U.S. Army ultimately interred 240 of its own soldiers at Forest Hill. Near them lie the graves of eight children orphaned during the Civil War.[330]

DESERTERS

An estimated 200,000 Union and 100,000 Confederate soldiers deserted during the Civil War. The exact number of Wisconsin soldiers who deserted is unclear. 3,034 Wisconsin soldiers are listed as having deserted in the *Roster of Wisconsin Volunteers* published in 1886, and 3,362 is the number given in the Adjutant General's Report of 1865. The *Roster* numbers are more likely to be closer to the truth. In his 1866 *Military History of Wisconsin*, E.B. Quiner comments that the deserters were "chiefly drafted men." This is supported by the dates of desertion as given in the *Roster*.[331]

Of the desertions listed in the *Roster*, 2,446 were from infantry regiments, 431 from cavalry regiments and 157 from the artillery. The regiments that had the most desertions were the Thirty-Fourth Infantry (275), the Seventeenth Infantry (167), the Third Cavalry (161) and the Fiftieth Infantry (112).[332]

The Thirty-Fourth Infantry was composed of drafted soldiers who served ninety days in early 1863. They were sent to Columbus, Kentucky, and served garrison duty. Apparently, their morale was not very good.

The Seventeenth Infantry, composed primarily of Irish enlistees, was a hard-fighting regiment, and seven-eighths of the regiment reenlisted in January 1864. But the regiment suffered from sickness early in the war, and this is when most of the desertions occurred.

Two members of the Third Cavalry won the Congressional Medal of Honor, and enough of the regiment reenlisted for it to become a veteran regiment. The high number of deserters may have simply been a function of hard service in thinly populated Arkansas, Kansas and Missouri.

The Fiftieth Infantry left Madison in late March and early April 1865 and served at Fort Leavenworth and Fort Rice, in the Dakota Territory. The reason for the high number of deserters is unclear. It may have been that the fighting had ended and many of the men saw no reason to stay in the army (and took advantage of the free transportation to the West).[333]

Epilogue

The total number of enlistments furnished to the Federal government by Wisconsin during the war was 91,379. If reenlistments are subtracted, the estimate of the actual number of individuals who served is about 80,000. This is more than half of the voting population. Of these, 10,863 were killed in battle or died of wounds or disease.[334]

At the end of the war, the War Department ordered those regiments whose term was to expire on or before October 1865 to be mustered out as soon as possible. In June and July 1865, thirty-three regiments or artillery batteries and eight companies of heavy artillery were mustered out. In August and September, seventeen were. Eight of the nine remaining organizations were mustered out by the end of November 1865; only the Fourth Cavalry remained in service into 1866.[335]

The Soldier's Home

By late 1863, the members of the West Side Soldier's Aid Society of Milwaukee saw the need to house furloughed and discharged soldiers. In the spring of 1864, it reorganized itself as the Soldier's Home at Milwaukee with the purpose of establishing a permanent home for disabled soldiers in Milwaukee. Led by Lydia Ely Hewitt and Fanny Burling Buttrick, the organization gained statewide attention, incorporating the various aid

Left: Lydia Ely Hewitt, president of the Westside Soldier's Home. *Milwaukee Country Historical Society.*

Right: Fanny Burling Buttrick, vice president of the Westside Soldier's Home. *Milwaukee Country Historical Society.*

societies, mostly run by women. They raised $50,000 for the home from donations and by holding dances and public events.

A Soldier's Home Fair held from June 28 to July 12, 1865, which was "virtually a state fair," raised $130,000 and allowed the society to purchase land at Twenty-Seventh Street and Wisconsin Avenue. It eventually turned the project over to the federal government. The first building, one of the first soldiers' homes in the nation, was built in 1867. Additional buildings were constructed later. The Milwaukee Soldier's Home stands today as one of three remaining original post–Civil War soldiers' homes in the country.[336]

In 1881, Rufus R. Dawes, the former commander of the Sixth Wisconsin Infantry, was elected to the U.S. House of Representatives from Ohio. On December 18 of that year, he visited Arlington Cemetery, where twenty-four of the men who died under his command were buried. He wrote to his wife, Mary, about the experience:

The Milwaukee Soldier's Home, built in 1867, was one of the first soldiers' homes in the nation and stands today as one of three remaining original post–Civil War soldiers' homes. *Milwaukee Country Historical Society.*

My Dear Wife: I have to-day worshipped at the shrine of the dead. I went over to the Arlington Cemetery. It was a beautiful morning. My friends and comrades, poor fellows, who followed my enthusiastic leadership in those days, and followed it to the death which I by a merciful Providence escaped, lie here, twenty-four of them, on the very spot where our winter camp of 1861–1862 was located. I found every grave and stood beside it with uncovered head. I looked over nearly the full 16,000 headboards to find the twenty-four. Poor little Fenton who put his head above the works at Cold Harbor and got a bullet through his temples, and lived three days with his brains out, came to me in memory as fresh as one of my own boys of to-day, and Levi Pearson, one of the three brothers of company "A," who died for their country in the sixth regiment, and Richard Gray, Paul Mulleter, Dennis Kelly, Christ Bundy, all young men, who fell at my side and under my command. For what they died, I fight a little longer. Over their graves I get inspiration to stand for all they won in establishing our government upon freedom, equality, justice, liberty and protection to the humblest.[337]

Rufus Dawes's "fight" continues to this day.

Appendix A

INFANTRY[338]

W isconsin sent fifty-three infantry regiments to the field. The fourth infantry regiment was converted to cavalry and not listed below. An infantry regiment consisted of ten companies of between 80 and 101 officers and men and a regimental staff, commanded by a colonel, with 15 officers and men. As a result, newly recruited regiments ranged in size from 845 to 1,025. In addition, Wisconsin allowed men to enlist in already formed regiments, with the result that the total enrollment of a regiment, by the end of the war, might be 2,000 or more. Later regiments, serving for shorter periods of time or not fully recruited, had fewer men than the official minimum.

Unit	Enrolled	Deaths	Mustered In	Where	Mustered Out
1st WI Inf. (3 mo.)	810	3	05/17/61	Camp Scott	08/21/61
1st WI Inf.	1,508	266	10/08–10/09/61	Camp Scott	10/21/64
2nd WI Inf.	1,266	275	06/11/61	Camp Randall	07/02/64
3rd WI Inf.	2,156	259	06/29/61	Camp Randall	07/18/65
5th WI Inf.	2,256	308	06/10–07/03/61	Camp Randall	06/20, 07/11/65

Unit	Enrolled	Deaths	Mustered In	Where	Mustered Out
6th WI Inf.	2,142	328	05/29–07/01/61	Camp Randall	07/14/65
7th WI Inf.	1,932	408	08/16–09/02/61	Camp Randall	07/03/65
8th WI Inf.	1,643	272	09/05–09/13/61	Camp Randall	09/05/65
9th WI Inf.	1,422	186	10/29–11/26/61	Camp Sigel	01/30/66
10th WI Inf.	1,034	247	10/05–10/14/61	Camp Holton	11/03/64
11th WI Inf.	1,965	381	09/27–10/18/61	Camp Randall	09/04/65
12th WI Inf.	2,186	310	10/28–11/05/61	Camp Randall	07/16/65
13th WI Inf.	1,931	201	10/17–11/13/61	Camp Tredway	11/24/65
14th WI Inf.	2,182	301	01/30/62	Camp Wood	10/09/65
15th WI Inf.	906	302	12/02/61–02/14/62	Camp Randall	02/13/65
16th WI Inf.	2,200	393	11/26/61–01/31/62	Camp Randall	07/12/65
17th WI Inf.	1,859	240	03/03–03/15/62	Camp Randall	07/14/65
18th WI Inf.	1,637	276	01/30–03/15/62	Camp Washburn	07/18/65
19th WI Inf.	1,484	156	03/04–04/30/62	Camp Utley	08/09/65
20th WI Inf.	1,129	229	07/31–08/30/62	Camp Randall	07/14/65
21st WI Inf.	1,171	295	09/05/62	Camp Bragg	07/08/65
22nd WI Inf.	1,505	231	08/12–09/05/62	Camp Utley	07/12/65

Unit	Enrolled	Deaths	Mustered In	Where	Mustered Out
23rd WI Inf.	1,117	294	08/30/62	Camp Randall	07/04/65
24th WI Inf.	1,077	175	08/15–08/22/62	Camp Sigel	06/10/65
25th WI Inf.	1,444	424	09/13–09/14/62	Camp Salomon	06/07/65
26th WI Inf.	1,089	252	09/17/62	Camp Sigel	06/13/65
27th WI Inf.	1,196	252	10/23/62–03/07/63	Camp Sigel	08/29/65
28th WI Inf.	1,137	236	10/13–10/14/62	Camp Washburn	08/23/65
29th WI Inf.	1,089	300	09/27/62	Camp Randall	06/22/65
30th WI Inf.	1,219	70	10/21/62	Camp Randall	09/20/65
31st WI Inf.	1,078	116	10/09–12/24/62	Camp Utley	06/20/65, 07/11/65
32nd WI Inf.	1,474	282	09/25/62	Camp Bragg	06/12/65
33rd WI Inf.	1,066	201	10/18/62	Camp Utley	08/09/65
34th WI Inf.	961	20	12/02–12/31/62	Madison/Milwaukee	09/08/63
35th WI Inf.	1,088	273	12/11/63–02/27/64	Camp Washburn	03/15/66
36th WI Inf.	1,014	296	03/01–03/23/64	Camp Randall	07/12/65
37th WI Inf.	1,144	223	04/12–08/24/64	Camp Randall	07/27/65
38th WI Inf.	1,032	108	04/15–09/17/64	Camp Randall	07/26/65
39th WI Inf.	780	35	06/03/64	Camp Washburn	09/15/64

Unit	Enrolled	Deaths	Mustered In	Where	Mustered Out
40th WI Inf.	776	18	06/07–06/09/64	Camp Randall	09/16/64
41st WI Inf.	578	13	06/08–06/15/64	Camp Washburn	09/17/64
42nd WI Inf.	1,008	57	08/15–09/09/64	Camp Randall	06/20/65
43rd WI Inf.	913	75	08/17–10/08/64	Camp Washburn	06/24/65
44th WI Inf.	1,114	60	09/27/64–02/15/65	Camp Randall	08/28/65
45th WI Inf.	1,001	32	09/26/64–02/23/65	Camp Randall	07/17/65
46th WI Inf.	947	15	01/31–03/01/65	Camp Randall	09/27/65
47th WI Inf.	985	37	01/27–02/20/65	Camp Randall	09/04/65
48th WI Inf.	832	16	02/02–03/30/65	Milwaukee	Unknown
49th WI Inf.	1,002	52	02/08-03/06/65	Camp Randall	11/08/65
50th WI Inf.	953	43	02/04–04/14/65	Camp Randall	11/08/65
51st WI Inf.	843	11	02/25–04/12/65	Milwaukee	08/19/65
52nd WI Inf.	511	8	02/28–04/12/65	Camp Randall	07/28/65
53rd WI Inf.	389	6	02/17–04/12/65	Camp Randall	Trans. to 51st

Appendix B

ARTILLERY

Wisconsin provided thirteen batteries of light artillery totaling 2,938 men and a regiment of heavy artillery consisting of twelve companies totaling 2,163—a total of 5,101 men. Of these, 362 died in service, the vast majority by disease. Like its infantry and cavalry regiments, most of Wisconsin's light artillery batteries served in the western theater.

The basic unit of artillery was the battery, which had four to six guns (usually six) and was commanded by a captain. There were 4 lieutenants, 12 sergeants or corporals and 120 privates. Batteries were divided into gun crews of about 20 men and into sections of two guns. So, there were two or three sections per battery. A lieutenant commanded a section and a sergeant an individual cannon.

WISCONSIN'S LIGHT ARTILLERY REGIMENTS

Unit	Men	Deaths	Mustered In	Where	Left State	Mustered Out
1st WI LA	269	30	10/10–10/21/61	Camp Utley	01/23/62	07/18/65
2nd WI LA	195	13	10/10–10/21/61	Camp Utley	01/21/82	07/10/65
3rd WI LA	236	25	10/10–10/21/61	Camp Utley	01/23/62	07/03/65

Unit	Men	Deaths	Mustered In	Where	Left State	Mustered Out
4th WI LA	251	24	10/10–10/21/61	Camp Utley	01/21/62	07/03/65
5th WI LA	230	24	10/01/61	Camp Utley	03/15/62	06/06/65
6th WI LA	242	28	10/01/61	Camp Utley	03/15/62	07/03/65
7th WI LA	252	30	10/04/61	Camp Utley	03/15/62	07/20/65
8th WI LA	263	28	01/06/62	Camp Utley	03/18/62	08/10/65
9th WI LA	218	6	01/27/62	Camp Utley	03/18/62	09/30/65
10th WI LA	188	28	02/10/62	Camp Utley	03/18/62	06/07/65
11th WI LA	95	3	Unknown	Camp Douglas	04/06/62	Unknown
12th WI LA	311	32	03/03–04/02/62	Camp Randall	04/??/62	06/07/65
13th WI LA	188	15	11/04/61–12/29/63	Camp Washburn	01/28/64	07/20/65

FIRST WISCONSIN HEAVY ARTILLERY REGIMENT

The creation of the First Wisconsin Heavy Artillery regiment took place over the course of three years. What would become Company A of the regiment was formed from Company K of the Second Wisconsin Infantry when it was detached from the regiment on July 25, 1861, three days after the Battle of Bull Run. It was ordered to serve as heavy artillery in the defenses of Washington, D.C., at Forts Corcoran, Marcy and Ethan Allen, south of the Potomac River. After briefly rejoining the Second Wisconsin, it was permanently detached on December 9, 1861, and organized as the First Battery Wisconsin Heavy Artillery and stationed at Fort Cass near Arlington, Virginia. Captain Andrew J. Langworthy of Milwaukee commanded the battery until February 12, 1863, when he resigned.

Afterward, Charles C. Meservey, also of Milwaukee, took command of the battery.

On August 28, 1862, forty men and three pieces of artillery were sent to Fort Buffalo, where they were attacked by Confederates. They returned to Fort Cass in September 1862 and were stent to Fort Ellsworth in November. In May 1863, the battery was transferred to Fort Worth. That same month, William Barry, the inspector of artillery for the army, wrote, "Captain Meservey is an excellent artillery officer, and has now one of the best companies of foot artillery I have ever seen." A few weeks later, on June 8, 1863, Captain Meservey was authorized by Secretary of War Stanton to recruit four batteries of heavy artillery, "using the First battery for that purpose." In October 1863, Battery A (now known as Company A) was moved to Battery Rodgers until the following May, when it was transferred to Fort Willard, where it supported the defense of Washington, D.C., during Jubal Early's July 11–12, 1864 raid on the city

Companies B, C and D were all organized at Camp Randall. Company B was organized under Captain Charles W. Hyde, of Milwaukee, and served at Fort Terrell, Murfreesboro, Tennessee, until January 1864, when it was sent to Fort Clay, Lexington, Kentucky. Company C was mustered into service under Captain John R. Davis, of Racine, and was assigned to Fort Wood, Chattanooga. In January 1864, it was sent to Fort Creighton and in May 1864 moved to Fort Sherman near Chattanooga. In the spring of 1865, it was transferred to several other locations in Tennessee. Company D was mustered in under Captain Henry W. Peck, of Monroe, and was attached to the defenses of New Orleans at Fort Jackson until July 23, 1864, when it moved to Fort Berwick near Brashear City until June 1865. Then it was ordered to Washington, D.C., and assigned to its defenses.

General Orders No. 21, issued September 14, 1864, called for the recruiting of eight additional companies to complete the regimental organization. Charles C. Meservey was promoted to colonel and Captain Wallace M. Spear, of La Crosse, given command of Company A. All of the companies raised were organized at Camp Randall and sent to garrison the forts around Washington, D.C. The regiment lost seventy-five men during service. Four enlisted men from Company A were killed in action at Bull Run on July 21, 1861. Six died from accidents. Sixty-five died from disease, thirty-six of them from Company D, which was stationed in Louisiana.

Unit	Mustered In	Left State	Stationed	Mustered Out	Deaths
Co. A	06/11/61	06/20/61	See above	08/18/65	12
Co. B	08/23–09/09/63	10/01/63	See above	08/03/65	7
Co. C	10/01/63	10/30/63	See above	09/21/65	8
Co. D	11/07/63	02/01/64	See above	08/08/65	39
Co. E	08/18–09/21/64	10/03/64	Fort O'Rourke	06/26/65	2
Co. F	09/01–09/13/64	10/03/64	Fort Ellsworth	06/26/65	1
Co. G	09/21–11/04/64	11/12/64	Forts Lyon, Ellsworth	06/26/65	1
Co. H	08/29–10/01/64	10/07/64	Fort Lyon	06/26/65	0
Co. I	09/26–11/08/64	11/12/64	Fort Ellsworth	06/26/65	21
Co. K	08/24–10/17/64	10/17/64	Fort Lyon	06/26/65	1
Co. L	08/13–09/17/64	09/30/64	Fort Willard	06/26/65	0
Co. M	08/30–09/29/64	09/30/64	Forts Lyon, Weed, Farnsworth	06/25/65	3

NOTES

Chapter 1

1. Jackson and McDonald, *Finding Freedom*, 40, 49.
2. "Helped Save Glover," *Milwaukee Sentinel*, June 10, 1900, https://www.wisconsinhistory.org/Records/Newspaper/BA188.
3. Jackson and McDonald, *Finding Freedom*, 48.
4. Ibid., 7; "Historical Essay: A Journey from Slavery to Freedom. A Brief Biography of Joshua Glover," Wisconsin Historical Society, https://www.wisconsinhistory.org/Records/Article/CS4368.
5. Transcribed letter of Caroline Quarlls, Archives, Civil War Museum, Kenosha, Wisconsin; "Caroline Quarlls—First Underground Railroad "Passenger" in Wisconsin," Burlington Historical Society, http://www.burlingtonhistory.org/caroline_quarlls_1842_journey_on.htm; "Historical Essay. Quarlls, Caroline (1824–1892). Fugitive Slave," Wisconsin Historical Society, https://www.wisconsinhistory.org/Records/Article/CS1729; Davidson, *Negro Slavery*; Lyman Goodnow, "Lyman Goodnow's Story," typed manuscript in the Milwaukee Area Research Center, http://digital.library.wisc.edu/1711.dl/WI.Goodnow2e; Pferdehirt, *Caroline Quarlls*; "Caroline Quarlls," Wisconsin Women Making History, http://womeninwisconsin.org/caroline-quarlls.
6. "The Underground Railroad in Wisconsin," Wisconsin Historical Society, https://www.wisconsinhistory.org/Records/Article/CS1730.
7. Diane S. Butler, "The Public Life and Private Affairs of Sherman M. Booth," *Wisconsin Magazine of History* 82, no. 2 (Spring 1999): 192; "The Underground Railroad in Wisconsin," Wisconsin Historical Society,

https://www.wisconsinhistory.org/Records/Article/CS566; "In Re: Booth. 3 Wis. 1 (1854)," Wisconsin Court System, https://www.wicourts. gov/courts/supreme/docs/famouscases01.pdf.

8. Johansson, *Stephen A. Douglas*, 405; "The Origins of the Republican Party," Independence Hall Association, http://www.ushistory.org/gop/origins. htm.

9. "Wisconsin and the Republican Party," Wisconsin Historical Society, http://www.wisconsinhistory.org/turningpoints/tp-022/?action=more_ essay; "1854: Republican Party Founded," Wisconsin Historical Society, http://www.history.com/this-day-in-history/republican-party-founded.

10. According to a newspaper clipping titled "Milwaukee Man One of Seventeen Who Christened Republican Party," from December 1, 1906, in the online collection of the Wisconsin Historical Society, https://www. wisconsinhistory.org/Records/Newspaper/BA2135.

11. Klement, *Wisconsin in the Civil War*, 5; "Durkee, Charles," Biographical Directory of the United States Congress, http://bioguide.congress. gov/scripts/biodisplay.pl?index=d000573; "History of the Birth of the Republican Party," The Little White Schoolhouse, http://www. littlewhiteschoolhouse.com/History/history.html; "The Origins of the Republican Party," Independence Hall Association, http://www. ushistory.org/gop/origins.htm.

Chapter 2

12. Kennedy, *Population of the United States*, 534, 538; "Milwaukee, Wisconsin History," Wisconsin Historical Society, https://www.wisconsinhistory. org/Records/Article/CS1607; "19th-Century Immigration," Wisconsin Historical Society, http://www.wisconsinhistory.org/turningpoints/tp-018/?action=more_essay.

13. Kennedy, *Population of the United States*, 544; "Milwaukee," Wisconsin Historical Society, https://www.wisconsinhistory.org/Records/Article/ CS1607l; see 1962 *Wisconsin Blue Book*, 74.

14. Kennedy, *Population of the United States*, 532, 544; Klement, *Wisconsin in the Civil War*, 3, 4.

15. Kennedy, *Population of the United States*, 532, 605; C.K. Drew, the agent for the Chippewa of Lake Superior, in the *Annual Report of the Commissioner of Indian Affairs, For the Year 1860*, recorded 4,300 for all seven reservations in the agency. Only four of those reservations were in Wisconsin. So, it is unclear how many of these were in Wisconsin. In *Wisconsin in the Civil War*, Klement gives a number of 10,000 Native Americans on page 4 and 9,000 on page 34. I don't know where he got these numbers.

16. Lurie, *Wisconsin Indians*, 11; U.S. Office of Indian Affairs, *Report of the Commissioner of Indian Affairs, For the Year of 1860* (Washington, D.C.: George W. Bowman, 1860), 51, 52 (hereafter *1860 Report*).

17. U.S. Office of Indian Affairs, *Report of the Commissioner of Indian Affairs, 1865* (Washington, D.C.: Government Printing Office), 51, 52 (hereafter *1865 Report*); *1860 Report*, 36; Lurie, *Wisconsin Indians*, 12.

18. *1860 Report*, 12, 39; *1865 Report*, 51, 52.

19. Lurie, *Wisconsin Indians*, 12; *1860 Report*, 35–36.

20. U.S. Office of Indian Affairs, *Report of the Commissioner of Indian Affairs, For the Year of 1861* (Washington, D.C.: Government Printing Office, 1861), 71 (hereafter *1861 Report*).

21. *1861 Report*, 74, 75; *1860 Report*, 51–53; *1865 Report*, 53; Lurie, *Wisconsin Indians*, 10–13.

22. "History of the Upper Mississippi Valley Zinc-Lead Mining District," Mining History Association, http://www.mininghistoryassociation.org/GalenaHistory.htm; Klement, *Wisconsin in the Civil War*, 4; Kennedy, *Population of the United States*, vi, 545.

23. Klement, *Wisconsin in the Civil War*, says fifty-seven on page 6. Door County was "created" in 1851 but "not fully organized" and "attached" to Brown "for judicial purposes" in 1855. It was "fully organized" on January 1, 1861. This may be why some historians count fifty-seven counties in 1860. The 1860 election map shows votes from there, however, so I am considering it the fifty-eighth county.

24. Klement, *Wisconsin in the Civil War*, 7.

25. Alexander W. Randall, ed., *Governor's Message and Accompanying Documents for the Year 1861* (Madison, WI, 1861). Pages 21–25 contain the governor's annual message, delivered on January 10, 1861. The digital text may be found in the State of Wisconsin Collection online at http://digicoll.library.wisc.edu.

26. Klement, *Wisconsin in the Civil War*, 9.

27. Ibid.; James A. Swain, "Annual Report of Adjutant General Swain for 1860," in *Governor's Message and Accompanying Documents for the Year 1861*, 3, 6, 27, 28.

28. Swain, "Annual Report," 27–28.

Chapter 3

29. *Janesville Daily Gazette*, March 13, 1861, 2; *Manitowoc Daily Telegraph*, March 13, 1861, 2; *Milwaukee Press & News*, March 13, 1861, 4; *Wisconsin State Journal*, March 13, 1861, 1; *Kenosha Weekly Telegraph*, April 8, 1861, 2. All newspapers were accessed via online databases.

30. Donald Edwin Rasmussen, "Wisconsin Editors and the Civil War. A Study of the Reaction of Wisconsin Editors to the Major Controversial Issues of the Civil War" (master's thesis, University of Wisconsin, 1952), 10; *Daily Milwaukee Press and News*, April 13, 1861, 2.

31. Wm. L. Utley, "Annual Report of the Adjutant General of the State of Wisconsin, For the Year 1861" (hereafter Utley, *Report, 1861*) from Charles E. Estabrook, ed., *Annual Reports Adjutant General of the State of Wisconsin for the Years 1860, 1861, 1862, 1863, 1864* (Madison, WI: Democrat Printing Company, 1912) (hereafter Gaylord, *Report, 1862*; Gaylord, *Report, 1863*; and Gaylord, *Report, 1864*); Quiner, *Military History*, 59.

32. Utley, *Report, 1861*, 26.

33. *Kenosha Telegraph*, April 18, 1861, 2.

34. Alexander W. Randall, *Special Message of the Governor of Wisconsin Delivered to the Legislature at the Extra Session*, 29, 34–35, the State of Wisconsin Collection, http://digital.library.wisc.edu/1711.dl/WI.V010.

35. Ibid., 30.

36. *Beloit Courier Journal*, May 21, 1861, 1a, from E.B. Quiner, *Scrapbooks: Correspondence of the Wisconsin Volunteers, 1861–1865*, vol. 1, State Historical Society of Wisconsin Archives.

37. An account of the flag presentation appeared in the May 2, 1861 edition of the *Kenosha Telegraph*. Kenosha was informally called Park City because it had numerous parks, especially along the lake.

38. Quiner, *Military History*, 53; Love, *Wisconsin War*, 213.

39. Utley, *Report, 1861*, 28.

40. Howard Michael Madaus, Appendix III from Herdegen and Beaudot, *In the Bloody Railroad Cut at Gettysburg* (Dayton, OH: Morningside, 1990), 304–5; Quiner, *Military History*, 54, 60.

41. Klement, *Wisconsin in the Civil War*, 14; Estabrook, *Losses*, 1.

42. Quiner, *Military History*, 54, 55; Estabrook, *Losses*, 121; Love, *Wisconsin War*, 15.

43. Love, *Wisconsin War*, 218–20.

44. Ibid., 221.

45. Ibid., 220, 223, 224; Estabrook, *Losses*, 1.

46. Estabrook, *Records*, 122, says August 21. Love, *Wisconsin War*, 226, says August 22.

47. Love, *Wisconsin War*, 228.

48. "Soldier John Cronk's Letter Describing Training Camp," Wisconsin Historical Society, http://www.wisconsinhistory.org/pdfs/lessons/EDU-LetterTranscript-JohnCronk-LettertoCharles.pdf.

49. Love, *Wisconsin War*, 228; Quiner, *Military History*, 438; Allan Gaff, *If This Is War* (Dayton, OH: Morningside, 1991), 71.

50. Love, *Wisconsin War*, 230; Klement, *Wisconsin in the Civil War,* 16.
51. Thomas S. Allen, "The Second Wisconsin at the First Battle of Bull Run," *War Papers: Read Before the Commandery of the State of Wisconsin of the Military Order of the Loyal Legion of the United States*, vol. 1 (Milwaukee: Burdick, Armitage & Allen, 1891), 374–93.
52. Quiner, *Military History*, 440.
53. Jennifer M. Murray, *The Civil War Begins: Opening Clashes, 1861* (Washington, D.C.: Center of Military History, 2012), 41; James B. Fry, "McDowell's Advance to Bull Run," *Battles and Leaders of the Civil War*, vol. 1 (New York: Century Company, 1887), 190.
54. Allen, "Second Wisconsin," 374–93.
55. Gaff, *War*, 216, 239.
56. Quiner, *Military History*, 441–42; Love, *Wisconsin War*, 240; Mark (no last name), "Union Soldiers in Gray Uniforms: The 2nd Wisconsin Infantry at the First Battle of Bull Run," Iron Brigader, http://ironbrigader.com/2011/06/14/union-soldiers-gray-uniforms-2nd-wisconsin-infantry-battle-bull-run.
57. Civil War Archive, http://www.civilwararchive.com/unionwi.htm.
58. Quiner, *Military History*, 200.

Chapter 4

59. Estabrook, *Records*, 124; Nels J. Monson, "The Hard-Fighting 3rd Wisconsin Infantry Lost Nearly 60 Percent of Its Members in Two Hours at Antietam," *America's Civil War* (September 1997): 8.
60. Estabrook, *Records*, 124–25; Monson, "Hard-Fighting," 10.
61. Estabrook, *Records*, 124–25; *The War of the Rebellion: A Compilation of the Official Records of the Union and Confederate Armies*, series I, vol. 19, part I, *Operations in Northern Virginia, West Virginia, Maryland, and Pennsylvania, September 3–November 14, 1862. South Mountain, Antietam* (Washington, D.C.: U.S. Government Printing Office, 1880–1901), 498, 503, 504 (hereafter *OR*); Monson, "Hard-Fighting," 10, 12.
62. Wolfgang Johannes Helbich and Walter D. Kamphoefner, eds., Susan Carter Vogel, trans., *Germans in the Civil War: The Letters They Wrote Home* (Chapel Hill: University of North Carolina Press. 2006), i; Quiner, *Military History*, 747.
63. Transcribed letter of Charles Wickesberg, May 21, 1863, Archives, Civil War Museum, Kenosha, Wisconsin.
64. Ibid.
65. Monson, "Hard-Fighting," 12; Quiner, *Military History*, 752–53.
66. Wickesberg Collection, letter of September 2, 1864.

67. Estabrook, *Records*, 124–25; Monson, "Hard-Fighting," 12, 16; Estabrook, *Losses*, 17.
68. Norman K Risjord, "James Anderson, Infantryman in Blue," *Wisconsin Magazine of History* 87, no. 4 (Summer 2004): 41; Estabrook, *Records*, 126–27; Quiner, *Military History*, 510–11.
69. Philip W. Parsons, *The Union Sixth Army Corps in the Chancellorsville Campaign* (Jefferson, NC: McFarland, 2010), 23.
70. Risjord, "James Anderson," 46–47; Quiner, *Military History*, 513–14; Henry W. Elson, *The Civil War Through the Camera Together with Elson's New History* (Springfield, MA: Patriot Publishing, 1912), 263.
71. Quiner, *Military History*, 519–24; Estabrook, *Losses*, 23; Risjord, "James Anderson," 48.
72. *OR*, series I, vol. 36, part II, *Operations in Southeastern Virginia and North Carolina, May 1–June 12, 1864, Drewry's Bluff, Bermuda Hundred, Petersburg,* 147–68.
73. *OR*, series I, vol. 42, part I, *Operations in Southeastern Virginia and North Carolina, August 1–December 31, 1864, Richmond Campaign, Fort Fisher, N.C. etc.,* 847–87; Estabrook, *Records*, 172, 181–83; Estabrook, *Losses*, 232.
74. Quiner, *Military History*, 961–62; Estabrook, *Losses*, 177, 239.
75. Quiner, *Military History*, 668–69.
76. Ibid., 668–73; Estabrook, *Losses*, 97–100.
77. John Gibbon, *Personal Recollections of the Civil War* (New York: G.P. Putnam's Sons, 1928), 158; Frank A. Haskell, *The Battle of Gettysburg* (Madison, WI: Democrat Printing Company, 1910), iii. It was originally printed for the Commandery of the State of Massachusetts of the Military Order of the Loyal Legion by the Mudge Press in Boston in 1908.
78. Estabrook, *Records*, 180; Quiner, *Military History*, 836.
79. Quiner, *Military History*, 825–27, 831, 836–40, 843–44, 847–48, 850–51; Estabrook, *Records*, 157–58. Quiner was used for the details of service for all three regiments
80. Estabrook, *Records*, 157–58, 182; Estabrook, *Losses*, 178, 182, 185; Quiner, *Military History*, 844, 853.
81. Quiner, *Military History*, 871–72; John Plaster, *History of Sniping and Sharpshooting* (Boulder, CO: Paladin Press, 2008), 135.
82. Quiner, *Military History*, 873–77, 880; Gaylord, *Report, 1862*, 148, 149; Estabrook, *Losses*, 203; Augustus Gaylord, *Adjutant General Report for 1865* (Madison: William J. Park & Co., 1866), 1,108–9 (hereafter Gaylord, *Report, 1865*).

Chapter 5

83. Lance J. Herdegen, *The Men Stood Like Iron: How the Iron Brigade Won Its Name* (Bloomington: Indiana University Press, 1997), 110.

84. Alan T. Nolan, *The Iron Brigade: A Military History* (New York: Macmillan, 1961), 53–54.

85. Quiner, *Scrapbooks*, vol. 2, 297; *Roster of Wisconsin Volunteers, War of the Rebellion, 1861–1865* (Madison, WI: Democrat Printing Company, 1886), 372 (hereafter *Roster*).

86. Quiner, *Military History*, 448; Nolan, *Iron Brigade*, 79, 95, 110; Fox, *Regimental Losses*, 117.

87. From a newspaper clipping entitled "The Iron Brigade," from the *National Tribune* of September 22, 1904, in the online collection of the Wisconsin Historical Society, http://content.wisconsinhistory.org/cdm/ref/collection/quiner/id/21288; Herdegen, *Men Stood*, 237.

88. Herdegen, *Men Stood*, 241–42, 247, 250, 280; Nolan, *Iron Brigade*, 129, 133.

89. Dawes, *Service*, 91.

90. Ibid., 92.

91. Herdegen, *Men Stood*, 278; Nolan, *Iron Brigade*, 142.

92. Fox, *Regimental Losses*, 117; Herdegen, *Men Stood*, 427; Nolan, *Iron Brigade*, 256.

93. Dawes, *Service*, 197.

94. Fox, *Regimental Losses*, 2, 8, 9.

95. Orson B. Curtis, *History of the Twenty-Fourth Michigan of the Iron Brigade* (Detroit, MI: Winn & Hammond, 1891), 464; Nolan, *Iron Brigade*, 365; Fox, *Regimental Losses*, 439; Herdegen, *Men Stood*, 427.

96. Nolan, *Iron Brigade*, 211; Curtis, *History*, 471, citing Fox, *Regimental Losses*.

97. Fox, *Regimental Losses*, 117; Nolan, *Iron Brigade*, 282.

98. Congressional Medal of Honor Society, http://www.cmohs.org/medal-history.php.

99. U.S. Army Center of Military History, http://www.history.army.mil/moh.

100. Jefferson Coates, Find a Grave, https://www.findagrave.com/cgi-bin/fg.cgi?page=gr&GRid=19733.

101. Citations taken from *Medal of Honor Recipients: 1863–1978* (Washington, D.C.: U.S. Government Printing Office, 1979). The information regarding the Medal of Honor recipients was taken from the Congressional Medal of Honor Society, www.cmohs.org/recipient-detail; the U.S. Army Center of Military History, http://www.history.army.mil/html/moh/civwaral.html; W.F. Beyer and O.F. Keydel, eds., *Deeds of Valor: How America's Heroes Won the Medal of Honor*, vol. 1 (Detroit, MI: Perrien-Keydel Company, 1907); *Roster*, vol. 1, 529.

Chapter 6

102. Frank Klement, "Copperheads and Copperheadism in Wisconsin: Democratic Opposition to the Lincoln Administration," *Wisconsin Magazine of History* 42, no. 3 (Spring 1959): 182–84.

103. Klement, "Copperheads," 185; *La Crosse Weekly Democrat*, August 19, 1861; October 11, 1861; April 18 and 23, 1862; May 7, 1862; June 16, 1862; and September 28, 1862.

104. Klement, "Copperheads," 182–84; Frank L. Klement, "Catholics as Copperheads during the Civil War," *Catholic Historical Review* 80, no. 1 (January 1994): 36, 39, 57.

105. "Edward George Ryan, 1810–1880," Wisconsin Historical Society, http://www.wisconsinhistory.org/Content.aspx?dsNav=N:4294963828-4294963805&dsRecordDetails=R:CS1674.

106. Edward Ryan, *Address to the People, by the Democracy of Wisconsin, Adopted in State Convention at Milwaukee, September 3, 1862* (Madison, WI: Patriot Office Print, n.d.), 17–19, 21.

107. "Marcus Mills 'Brick' Pomeroy," American Pomeroy Historic Genealogical Association, http://www.americanpomeroys.org/brickpomeroy.

108. *La Crosse Democrat*, August 19, 1861.

109. "Pomeroy, Marcus Mills ["Brick"] 1833–1896," Wisconsin Historical Society, https://www.wisconsinhistory.org/Records/Article/CS2488; "Wisconsin Copperhead Anti-War Movement and Marcus 'Brick' Pomeroy," Wisconsin Historical Society, https://www.wisconsinhistory.org/Records/Article/CS3066.

110. "Wisconsin Copperhead Anti-War Movement and Marcus Brick Pomeroy," Wisconsin Historical Society, http://www.wisconsinhistory.org/pdfs/lessons/EDU-NewspaperArticle-CopperheadsAndPomeroy-LaCrosseTimesDailyDemocrat-8-15-1864.pdf.

111. "Wisconsin Copperhead Anti-War Movement and Marcus 'Brick' Pomeroy," Wisconsin Historical Society, https://www.wisconsinhistory.org/Records/Article/CS3066.

112. A.J. Beitzinger, "The Father of Copperheadism in Wisconsin," *Wisconsin Magazine of History* 39, no. 1 (Autumn 1955): 22–25; Klement, "Copperheads," 188.

113. Scott Karel, "Prolonging the War for a Permanent Peace: Wisconsin Soldiers and the 1864 Election," *Oshkosh Scholar* 3 (April 2008): 48.

114. Frank Klement, "The Soldier Vote in Wisconsin During the Civil War," *Wisconsin Magazine of History* 28, no. 1 (September 1944): 37–39; Karel, "Prolonging the War," 52.

115. *Sheboygan Journal*, April 19, 1863.
116. Klement, "Soldier Vote," 40–42, 46.
117. Karel, "Prolonging the War," 47–49.
118. Ibid., 53.
119. Ibid., 52.
120. Ibid.
121. Ibid., 51–52.
122. Chris Murray, "The 1864 Wisconsin Vote: Where the Copperheads Were," http://electiondissection.blogspot.com/2010/08/1864-wisconsin-vote-where-copperheads.html; Klement, *Wisconsin in the Civil War*, 122, says fifty-eight.

Chapter 7

123. Klement, "Copperheads," 184.
124. Frederick Merk, *Economic History of Wisconsin during the Civil War Decade* (Madison: Historical Society of Wisconsin, 1916), 273–74, 18–19.
125. Klement, "Copperheads," 184; Merk, *Economic History*, 18, 199–200, 208; Beitzinger, "Father of Copperheadism," 18, 204, 208.
126. Merk, *Economic History*, 159, 187, 192–93, 205, 209.
127. Ibid., 56–57, 160–63.
128. Ibid., 16–17, 19, 58; Beitzinger, "Father of Copperheadism," 24.
129. Merk, *Economic History*, 52–54, 145–46; *Transactions of the Wisconsin State Agricultural Society, with an Abstract of the Returns of County Societies and Kindred Associations Together with Reports on the Industry of Counties, 1861–68* (Madison, WI: Smith and Cullation, State Printers, 1868), 38–39.
130. Maureen Ogle, *Ambitious Brew: The Story of American Beer* (Orlando, FL: Harcourt, 2006), 15–17, 44.
131. Ibid., 14; Merk, *Economic History*, 37, 152–54.
132. Merk, *Economic History*, 22–24.
133. Ibid., 150–51.
134. Ibid., 20–21, 155.

Chapter 8

135. Leo M. Kaiser, ed., "Civil War Letters of Charles W. Carr of the 21st Wisconsin Volunteers," *Wisconsin Magazine of History* 43, no. 4 (Summer 1960): 268–69.
136. *OR*, series I, vol. 10, part I, *Operations in: Kentucky, Tennessee, North Mississippi, North Alabama, and Southwest Virginia*, 285–86.

137. "State of Wisconsin. Proclamation," *Biographical Newspaper Clippings*, 1861–1930, vol. 1, April 19, 1862, 173–74, Wisconsin Historical Society, http://content.wisconsinhistory.org/cdm/ref/collection/quiner/id/27592.

138. Estabrook, *Records*, 137, 180; Quiner, *Military History*, 637; Zimm and Edmonds, *Wicked Rebellion*, 77–78.

139. Quiner, *Military History*, 600–601; Fox, *Regimental Losses*, 514.

140. Estabrook, *Records*, 134, 137, 140, 180; Quiner, *Military History*, 603, 637; *OR*, series I, vol. 17, part I, *Operations in West Tennessee and Northern Mississippi*, 356.

141. Estabrook, *Records*, 135; Quiner, *Military History*, 606.

142. Quiner, *Military History*, 638; Estabrook, *Records*, 140.

143. Quiner, *Military History*, 640, 642–43; Estabrook, *Losses*, 96, 135.

144. Fox, *Regimental Losses*, 514; Estabrook, *Records*, 129; Estabrook, *Losses*, 41.

145. *OR*, series I, vol. 38, part I, *Operations in: North Georgia, etc....Relating Especially to the Atlanta Campaign*, 836–38; Estabrook, *Losses*, 233

146. *OR*, series I, vol. 44, *Operations in: South Carolina, Georgia and Florida*, 406.

147. Jack R. Arndt, ed., "Sherman's March to the Sea: A Wisconsin Soldier's Account," *Wisconsin Academy Review* 12, no. 2 (Spring 1965): 26–29, http://digital.library.wisc.edu/1711.dl/WI.v12i2.

148. *OR*, series I, vol. 44, *Operations in: South Carolina, Georgia and Florida*, 14.

149. *OR*, series I, vol. 47, part I, *Operations in: North Carolina, South Carolina, Southern Georgia, and East Florida*, 906–98.

150. Estabrook, *Losses*, 238.

151. Quiner, *Military History*, 644, 646, 648, 651; Estabrook, *Records*, 139. Estabrook, *Losses*, 91.

152. Estabrook, *Records*, 173–74, 177–78, 181, 183; Fox, *Regimental Losses*, 513; Quiner, *Military History*, 945–47, 966.

153. Estabrook, *Losses*, 240.

154. Ibid.

155. Quiner, *Military History*, 427–28, 432, 686.

156. Ibid., 429–30; Fox, *Regimental Losses*, 392.

157. Zimm and Edwards, *Wicked Rebellion*, 82.

158. Fox, *Regimental Losses*, 392; Estabrook, *Losses*, 6, 110; Quiner, *Military History*, 426, 434.

159. Estabrook, *Losses*, 50; Estabrook, *Records*, 131; Fox, *Regimental Losses*, 513.

160. Estabrook, *Records*, 136; Quiner, *Military History*, 621–22.

161. Quiner, *Military History*, 625–29.

162. Ibid., 630; Estabrook, *Losses*, 79.

163. *OR*, series I, vol. 30, part I, *Operations in: Kentucky, Southwest Virginia, Tennessee, Mississippi, North Alabama, and North Georgia*, 852–53.

164. Quiner, *Military History*, 934–37; Estabrook, *Records*, 181–83; Estabrook, *Losses*, 231.

165. Fox, *Regimental Losses*, 513–15; Estabrook, *Losses*, 125.

166. Daniel Webster and Don Carlos Cameron, *History of the First Wisconsin Battery Light Artillery* (Bethesda, MD: University Publications of America, 1993), 119.

167. Quiner, *Military History*, 928–32; Estabrook, *Losses*, 230; Estabrook, *Records*, 181–83.

168. Estabrook, *Records*, 174; *Roster*, vol. 1, 227–31; Quiner, *Military History*, 951.

169. Quiner, *Military History*, 951–52; *Roster*, vol. 1, 227–31.

170. Estabrook, *Losses*, 236; Estabrook, *Records*, 181–83.

171. Quiner, *Military History*, 697, 698, 700, 702; Estabrook, *Losses*, 115.

172. *Roster*, vol. 2, 207; *Roster*, vol. 1, 602; Mary Beth Danielson, "Lost in Racine: Recalling Civil War Hero," *Racine Journal Times*, June 22, 2001, http://journaltimes.com/lost-in-racine-recalling-civil-war-hero/article_5807d7c7-b0d8-56a3-bf30-55f5aac4abed.html.

Chapter 9

173. *OR*, series II, vol. 4, *Prisoners of War, etc.*, 358–69; James Barnet Fry, *Final Report Made to the Secretary of War, by the Provost Marshal General* (Washington, D.C.: Government Printing Office, 1866), 10–11. This can be found in the House Executive Documents, 39 Congress, 1st session (hereafter Fry, *Report, 1866*).

174. Gaylord, *Report, 1863*, 888. The commonly accepted number is 42,557. This is incorrect. Adjutant General Gaylord's Report for 1863 states that that number was "approximated" by "adding to the number of men in service...the number then called for by the War Department." "Subsequent correspondence" with the War Department determined that the actual quota was 45,561.

175. Quiner, *Military History*, 139–40; Gaylord, *Report, 1862*, 1,786; John Oliver, "Draft Riots in Wisconsin during the Civil War," *Wisconsin Magazine of History* 2, no. 3 (March 1919): 334–37.

176. "Northern Draft of 1862," http://www.etymonline.com/cw/draft.htm.

177. *OR*, series III, vol. 2, *Union Correspondence, etc.*, 369, 450.

178. Quiner, *Military History*, 140–41; Fred A. Shannon, *The Organization and Administration of the Union Army, 1861–65* (Cleveland, OH: Arthur H. Clark Company, 1928), 283.

179. "Northern Draft of 1862."

180. Quiner, *Military History*, 144.

181. Peter Levine, "Draft Evasion in the North during the Civil War, 1863–1865," *Journal of American History* 67, no. 4 (March 1981): 822; Gaylord, *Report, 1862*, 1,785–6.

182. Don Silldorff, "History of Ozaukee County," Ozaukee County, http://www.co.ozaukee.wi.us/DocumentCenter/View/624.

183. *History of Washington and Ozaukee Counties, Wisconsin* (Chicago: Western Historical Company, 1881), 473–74, 489, 494–5; "The Civil War Home Front," Wisconsin Historical Society, http://www.wisconsinhistory.org/turningpoints/tp-024/?action=more_essay; Joseph C.G. Kennedy, *Population of the United States in 1860; Compiled from the Original Returns of the Eighth Census* (Washington, D.C.: Government Printing Office, 1864), 532, 539, 544 (hereafter *1860 Census*).

184. Reuben Gold Thwaites, ed., *Messages and Proclamations of Wisconsin War Governors* (Madison, WI: Democrat Printing Company, 1912), 185.

185. *Milwaukee Pilot*, November 12, 1862; "Resistance to the Draft in Wisconsin: The Ozaukee County Riot," unattributed newspaper article in the Wisconsin Historical Society Library. Online facsimile at http://www.wisconsinhistory.org/turningpoints/search.asp?id=148; "The Civil War Home Front"; Quiner, *Military History*, 145–46; Dan Benson, "These Places Are Hardly Run of the Mill," Ozaukee County, http://www.co.ozaukee.wi.us/DocumentCenter/View/628.

186. *History of Washington and Ozaukee Counties*, 473–74, 489, 494–95; Quiner, *Military History*, 145–47, 767; "Northern Draft of 1862."

187. *Milwaukee Pilot*, November 12, 1862; Quiner, *Military History*, 147.

188. Quiner, *Military History*, 145, 147–49; "John C. Starkweather," Wisconsin Historical Society, https://www.wisconsinhistory.org/Records/Image/IM2797, see "Additional Information."

189. Quiner, *Military History*, 147–49.

190. Gaylord, *Report, 1862*, 1,786; Gaylord, *Report, 1863*, 243, 245.

191. "Northern Draft of 1862."

192. Fry, *Report, 1866*, 163.

Chapter 10

193. Quiner's *Military History* and Estabrook's *Records* give a higher total number for all the regiments. This is because they included reenlistments in their totals. I subtracted these in order to arrive at the actual number of individuals who served; Quiner, *Military History*, 899, 908, 920, 927; Estabrook, *Records*, 181.

194. Estabrook, *Records*, 166–67; Quiner, *Military History*, 892–94.

195. Estabrook, *Records*, 166–67.

196. Henry Harnden, *The Capture of Jefferson Davis* (Madison, WI: Tracy, Gibbs & Company, 1898), 31–32.

197. Estabrook, *Losses*, 210; Fox, *Regimental Losses*, 512; Estabrook, *Sketches*, 181–82.

198. Quiner, *Military History*, 899, and Estabrook's *Records*, 181, give the number of 2,602 for the First Wisconsin Cavalry. See note 193.

199. Stanley E. Lathrop, "Vital Statistics of the First Wisconsin Cavalry in the Civil War," *Wisconsin Magazine of History* 5 (Winter 1921–22): 296–300. He gives a number of foreign born as 495, but if the numbers are added together it totals 513; Estabrook, *Losses*, 210.

200. Quiner, *Military History*, 900, 902–903; Estabrook, *Sketches*, 167–68; "Union Occupation of Arkansas," Encyclopedia of Arkansas History and Culture, http://www.encyclopediaofarkansas.net/encyclopedia/entry-detail.aspx?entryID=6390.

201. "1864 August 27: The 2nd Wisconsin Cavalry and General Slocum's Expedition to Jackson," The Civil War and Northwest Wisconsin, https://thecivilwarandnorthwestwisconsin.wordpress.com/2014/08/28/1864-august-27-the-2nd-wisconsin-cavalry-and-general-slocums-expedition-to-jackson.

202. Estabrook, *Records*, 167–68; Estabrook, *Losses*, 216; Fox, *Regimental Losses*, 512.

203. The Third Cavalry section is based on Fox, *Regimental Losses*, 512, and Quiner, *Military History*, 910–17.

204. Estabrook, *Losses*, 221; Fox, *Regimental Losses*, 512.

205. "Paine, Col. Halbert E. (1826–1905)," Wisconsin Historical Society, http://www.wisconsinhistory.org/Content.aspx?dsNav=N:42949638284294963805&dsRecordDetails =R:CS1618.

206. Estabrook, *Records*, 180–81.

207. Quiner, *Military History*, 988.

208. Quiner, *Scrapbooks*, vol. 3, 125–26, from the *Kenosha Telegraph*.

209. Quiner, *Military History*, 500–501, 989.

210. Ibid., 503–7.

211. Ibid., 921–27.

212. Ibid., 996; Elson, *Civil War*, 419.

213. Elson, *Civil War*, 419; Quiner, *Military History*, 998–99.

214. Quiner, *Military History*, 927; Estabrook, *Records*, 181.

215. Theron Wilber Haight, *Three Wisconsin Cushings* (Milwaukee: Wisconsin History Commission, 1910), xiii, xiv, 71–72; W.B. Cushing. "The Destruction of the 'Albemarle'," *Battles and Leaders of the Civil War*, vol. 4, *The Way to Appomattox* (New York: Castle Books, 1956), 635–36, 638; Jamie Malanowski, "William Cushing's Raids on the Cape Fear

River," *Civil War Times Magazine* (June 2015): 25, 31, 35, 40–41; Stempel, *CSS Albemarle*, 204; Jamie Malanowski, *Commander Will Cushing: Daredevil Hero of the Civil War* (New York: W.W. Norton & Company, 2014), 200–201; Eliza Mary Hatch Edwards, *Commander William Barker Cushing, of the United States Navy* (New York: F. Tennyson Neely, 1898), 246.

216. "Winnebago I (Mon)," Naval History and Heritage Command, https://www.history.navy.mil/research/histories/ship-histories/danfs/w/winnebago-i.html.

217. "Milwaukee I (Monitor) 1864–1865," Naval History and Heritage Command, https://www.history.navy.mil/research/histories/ship-histories/danfs/m/milwaukee-i.html; http://civilwarwiki.net/wiki/USS_Milwaukee.

Chapter 11

218. J. David Hacker, "Recounting the Dead," *New York Times*, September 20, 2011, https://opinionator.blogs.nytimes.com/2011/09/20/recounting-the-dead/; *Wisconsin Bluebook 2015–2016* (Madison: State of Wisconsin, 2015), 159; *1860 Census*, 532, 592–93.

219. Howard Louis Conard, ed., *History of Milwaukee from Its First Settlement to the Year 1895* (Chicago: American Biographical Publishing Company, 1896), 114.

220. Love, *Wisconsin War*, 1,051; Gaylord, *Report, 1864*, 145–46.

221. L.P. Brockett, *Woman's Work in the Civil War: A Record of Heroism, Patriotism and Patience* (Philadelphia: Zeigler, Mccurdy & Company, 1867), 613–14.

222. Love, *Wisconsin War* 1,052–53.

223. General Laws Passed by the Legislature of Wisconsin, Chapter 8, May 25, 1861; Chapter 112, March 21, 1862; Chapter 374, June 17, 1862; Chapter 4, September 23, 1862; Chapter 117, March 8, 1864; Quiner, *Military History*, 139.

224. Love, *Wisconsin War*, 1,033.

225. Quiner, *Military History*, 973.

226. Anne Beiser Allen, "Wisconsin's Reluctant Heroine: Cordelia Perrine Harvey," *Wisconsin Magazine of History* 95, no. 2 (Winter 2011–12): 4–12.

227. Paul H. Hass, ed., "A Volunteer Nurse in the Civil War: The Letters of Harriet Douglas Whetten," *Wisconsin Magazine of History* 48, no. 2 (Winter 1964–65): 132.

228. Allen, "Wisconsin's Reluctant Heroine," 4–12.

229. Cordelia A.P. Harvey, "Wisconsin Woman's Picture of President Lincoln," *Wisconsin Magazine of History* 1, no. 3 (March 1918): 241–42.

230. Ibid., 250–51.

231. Allen, "Wisconsin's Reluctant Heroine," 4–12.

232. Gaylord, *Report, 1864*, 144–45.

233. "History: Fort Crawford in the Civil War, Fort Crawford Museum, www.fortcrawfordmuseum.com/history/fort-crawford-in-the-civil-war.

234. *Wisconsin Bluebook 2015–2016*, 160; Allen, "Wisconsin's Reluctant Heroine," 4–12.

235. "The Civil War," U.S. Army, https://www.army.mil/women/history.

236. John Evangelist Walsh, "Forgotten Angel: The Story of Janet Jennings and the Seneca," *Wisconsin Magazine of History* 81, no. 4 (Summer 1998): 271. Local sources give the story of her trip to Washington in 1863 to care for her brother but offer no evidence. Her brother did serve in the Third Wisconsin Infantry from May 1861 to July 1864. In the division's "Report of Killed and Wounded" at Chancellorsville, May 1–4, 1863, Corporal Jennings is listed as having suffered a "severe" hip wound; *Monroe Sentinel*, November 15, 1871, and June 4, 1873.

237. James B. Hibbard, "'When Will This Horrid War End!' Lancaster's Catharine Eaton on the Civil War Home Front," *Wisconsin Magazine of History* 93, no. 3 (Spring 2010): 2–15.

238. Merk, *Economic History*, 55–56.

239. Ibid., 166–68.

240. "The Civil War Home Front," Wisconsin Historical Society, http://www.wisconsinhistory.org/turningpoints/tp-024/?action=more_essay.

241. Hurn, *Wisconsin Women*, 100–101; Quiner, *Scrapbooks*, vol. 1, 216–17.

242. Hurn, *Wisconsin Women*, 102.

243. U.S. Army, "Civil War."

244. Elizabeth D. Leonard, *All the Daring of the Soldier: Women of the Civil War Armies* (New York: W.W. Norton & Company, 1999), 201–5.

245. Blanton and Cook, *They Fought Like Demons*, 14.

246. Ibid., 71, 14, 33, 38.

247. Ibid., 51, 59, 97; Hurn, *Wisconsin Women*, 103.

248. Blanton and Cook, *They Fought Like Demons*, 152.

249. Leonard, *All the Daring*, 221–22.

250. Blanton and Cook, *They Fought Like Demons*, 153.

Chapter 12

251. James P. Collins, "Native Americans in the Census, 1860–1890," National Archives, http://www.archives.gov/publications/prologue/2006/summer/indian-census.html. There were 2,833 enumerated in the 1860 census. C.K. Drew, the agent for the Chippewa of Lake Superior, reported 4,300 for all seven reservations in the agency in his 1860 annual report to the commissioner of Indian affairs. Only four of those reservations were in Wisconsin. It is unclear how many of the 4,300 were in Wisconsin; *1865*

Report, 578 (see note 17); Russell Horton, "Unwanted in a White Man's War: The Civil War Service of the Green Bay Tribes," *Wisconsin Magazine of History* 88, no. 2 (Winter 2004–5): 18.

252. *1865 Report*, 438, 576 (see note 17); Hauptman, *Iroquois*, 67; Richard Current, *History of Wisconsin*, 335; Horton, "Unwanted," 18, 26.

253. Horton, "Unwanted," 26; Hauptman, *Iroquois*, 68, 72; Current, *History of Wisconsin*, 328–29.

254. Hauptman, *Iroquois*, 68.

255. Horton, "Unwanted," 20; Hauptman, 67–68.

256. Horton, "Unwanted," 18, 20, 27, citing Grignon interview of February 18, 1900.

257. Jim Burnett, "American Indians in the Civil War? Petersburg National Battlefield Is Part of the Story," National Parks Traveler, http://www.nationalparkstraveler.com/2010/12/american-indians-civil-war-petersburg-national-battlefield-part-story7361; Horton, "Unwanted," 18, 20.

258. Horton, "Unwanted," 21, citing Grignon's letter of May 8, 1861, to Governor Randall; M.M. Quaife, "The Panic of 1862 in Wisconsin," *Wisconsin Magazine of History* 4 (Winter 1920–21): 172; Augustus Gaylord's letter of May 16, 1861, to Governor Randall.

259. Horton, "Unwanted," 22; "We Are All Americans—Native Americans in the Civil War," City of Alexandria, VA, https://www.alexandriava.gov/historic/fortward/default.aspx?id=40164; Laurence M. Hauptman, *Between Two Fires: American Indians in the Civil War* (New York: Simon and Schuster, 1995), 145.

260. Andler and Brucker, *Letters Home*, 3–8, back cover.

261. Horton, "Unwanted," 22.

262. Ibid.; Current, *History of Wisconsin*, 324–27.

263. Horton, "Unwanted," 22; Patrick K. Ourada, *Menominee Indians: A History* (Norman: University of Oklahoma Press, 1979), 138–39.

264. Horton, "Unwanted," 25; Hauptman, *Iroquois*, 73, 75–78; Byron R. Abernethy, ed., *Private Elisha Stockwell, Jr. Sees the Civil War* (Norman: University of Oklahoma Press, 1958), 32.

265. Hauptman, *Iroquois*, 73, 75–78; "14th Regiment Infantry," Civil War Archive, http://www.civilwararchive.com/Unreghst/unwiinf2.htm.

266. Horton, "Unwanted," 25.

267. Ibid., 25; Quiner, *Military History*, 838–40; Hauptman, *Between Two Fires*, 152–55; R.C. Eden, *The Sword and the Gun: A History of the 37th WI Volunteer Infantry from Its First Organization to Its Final Muster Out* (Madison, WI: Atwood & Rublee, 1865), 29–32. See Appendix A for further information on Menominee casualties.

268. Horton, "Unwanted," 25; Eden, *Sword*, 64–65; *Commissioner of Indian Affairs 1864 Report* (Washington, D.C.: Government Printing Office, 1865), 43 (hereafter *1864 Report*).

269. Burnett, "American Indians."

270. Hauptman, *Iroquois*, 83.

271. "7th Wisconsin Infantry, Company G," The Civil War and Northwest Wisconsin, https://thecivilwarandnorthwestwisconsin.wordpress.com/the-soldiers/companies-comprised-mainly-of-soldiers-from-northwest-wisconsin/7th-wisconsin-infantry-company-g.

272. Dawes, *Service*, 265.

273. *1861 Report*, 72 (see note 20).

274. Dee Brown, *Bury My Heart at Wounded Knee: An Indian History of the American West* (New York: Bantam Books, 1972), 38–40; John A. Haymond, *The Infamous Dakota War Trials of 1862: Revenge, Military Law and the Judgment of History* (Jefferson, NC: McFarland, 2016), 227; Hauptman, *Iroquois*, 70; "The U.S–Dakota War of 1862. During the War," Minnesota Historical Society, http://www.usdakotawar.org/history/war/during-war.

275. Quaife, "Panic of 1862," 178–81, 194; Public Order No. 1, Wisconsin Historical Society.

276. *Sheboygan Daily Press*, July 1, 1932.

277. Horton, "Unwanted," 23, 25; *Green Bay Advocate*, September 11, 1862.

278. *Wisconsin Blue Book, 2015–2016*, 149, 150; "The Sioux War of 1862 at Superior," *Wisconsin Magazine of History* 3, no. 4 (June 1920): 474.

279. James McGee, *A Branch of a Tree: A McGee Family in History* (N.p.: Xlibris, 2007), 82.

280. "Chief Sky, Now Blind and Helpless, Tells Story of 'Old Abe'; War Eagle," *Newspaper Clippings, 1861–1930*, vol. 8, 107–8.

281. "'Old Abe' Confirmed as Male DNA Testing of Mascots Feathers Answers 150 Year Old Debate," Wisconsin Veteran's Museum, https://www.wisvetsmuseum.com/2016/famed-bald-eagle-mascot-old-abe-convfirmed-as-male-dna-testing-of-mascots-feathers-answers-150-year-old-debate.

282. David McClain, "The Story of Old Abe," *Wisconsin Magazine of History* 8, no. 4 (June 1925): 408.

283. "Chief Sky," 107–8.

Chapter 13

284. *1860 Census*, 532. 737 were classified as "mulattoes."

285. Jeff Kannel, e-mail to author, September 6–8, 2016. Jeff Kannel is an independent researcher who has done great work on Wisconsin's

African American soldiers. He has agreed to let me use some of it. He plans to publish a book based on his research next year; *Roster*, vol. 2, 954–58.

286. *Roster, 1861–1865*, vol. 2, 953.

287. Gaylord, *Report, 1864*, 507; *Roster*, vol. 2, 956–57. Eleven served in Companies A, B, C and D.

288. Kannel, e-mail, September 6 and 20, 2016; October 1 and 2, 2017.

289. Roster, vol. 2, 958–60; Kannel, e-mail, May 16 and October 1, 2017.

290. Kannel, e-mail, May 16, 2017; September 6–8, 2016; Miller, *Black Civil War Soldiers*, 32, 33; "Civil War: African American Troops," Wisconsin Historical Society, https://www.wisconsinhistory.org/Records/Article/CS6445; "Black History in Wisconsin," Wisconsin Historical Society, https://www.wisconsinhistory.org/Records/Article/CS502.

291. Miller, *Black Civil War Soldiers*, 33; *Roster*, vol. 2, 954–55; "The Roster of Wisconsin's Only Unit of Black Civil War Soldiers," Wisconsin Historical Society, http://www.wisconsinhistory.org/turningpoints/search.asp?id=995.

292. Miller, *Black Civil War Soldiers*, 21, 32, 34, 37; Arthur Swazey, *Memorial of Colonel John A. Bross* (Chicago: Tribune Book and Job Office, 1865), 10; *Roster*, vol. 2, 955–57. The enlistments date from November 1, 1863, to July 1864; "29th US Colored Infantry Regiment," Illinois in the Civil War, http://civilwar.illinoisgenweb.org/reg_html/029c_reg.html.

293. Jeff Kannel, e-mail, October 27, 2016.

294. Miller, *Black Civil War Soldiers*, 12, 13; Swazey, *Memorial*, 10–11.

295. "Battle Unit Details," National Park Service, https://www.nps.gov/civilwar/search-battle-units-detail.htm?battleUnitCode=UUS0029RI00C.

296. William A. Dobak, *Freedom by the Sword: The U.S. Colored Troops, 1862–1867* (Washington, D.C: Center of Military History, 2011), 358.

297. *Report of the Committee on the Conduct of the War on the Attack on Petersburg, 30th Day of July 1864* (Washington, D.C.: Government Printing Office, 1865), 4–5; Richard Slotkin, *No Quarter: The Battle of the Crater, 1864* (New York: Random House, 2009), 45–46; Dobak, *Freedom*, 356–57; Miller, *Black Civil War Soldiers*, 69–70.

298. "The Crater," Civil War Trust, https://www.civilwar.org/learn/civil-war/battles/crater?tab=facts; Slotkin, *No Quarter*, 186; Noah Andre Trudeau, *The Last Citadel: Petersburg, Virginia, June 1864–April 1865* (Baton Rouge: Louisiana State University Press, 1993), 110; "The Crater," National Park Service, https://www.nps.gov/pete/learn/historyculture/the-crater.htm.

299. Gaylord, *Report, 1864*, 507.

300. Henry Goddard Thomas, "The Colored Troops at Petersburg" from *Battles and Leaders of the Civil War*, vol. 4, *The Way to Appomattox* (New York: Century Company, 1887), 564.

301. Miller, *Black Civil War Soldiers*, 70, 71; Thomas, "Colored Troops," 564, 565; John S. Wise, *The End of an Era* (Boston: Houghton, Mifflin and Company, 1899), 366.

302. Thomas, "Colored Troops," 565; Swazey, *Memorial*, 17; Miller, *Black Civil War Soldiers*, 71; Gaylord, *Report, 1864*, 508.

303. Fox, *Regimental Losses*, 55; Adjutant-General's Office, *Official Army Register of the Volunteer Force*, vol. 8 (Washington, D.C.: Government Printing Office), 200; Miller, *Black Civil War Soldiers*, 99, citing Ferrero's casualty report of July 31, 1864; *The Negro in the Military Service of the United States 1639–1868* (Washington, D.C.: National Archives and Records Service, General Services Administration, 1973). This is a twenty-page finding aid for the Records of the Adjutant General's Office, 1780s–1917, Record Group 94; Kannel, e-mail, October 27, 2016.

304. Miller, *Black Civil War Soldiers*, 100.

305. Ibid., 96–98.

306. "Battle Unit Details."

307. Gaylord, *Report, 1864*, 508; General Laws of Wisconsin, Chapter 33, approved March 28, 1866.

308. *Racine Journal*, "Veteran of Civil War," February 22, 1922, http://www.wisconsinhistory.org/turningpoints/search.asp?id=998; Kannel, e-mail, October 27, 2016.

Chapter 14

309. "Civil War Facts," National Park Service, https://www.nps.gov/civilwar/facts.htm

310. James Ford Rhodes, *History of the United States from the Compromise of 1850 to the Final Restoration of Home Rule at the South in 1877*, vol. 5 (New York: Macmillan, 1919), 507–8.

311. "Search for Prisoners," National Park Service, https://www.nps.gov/civilwar/search-prisoners.htm?.

312. Henry B. Furness, "A General Account of Prison Life and Prisons in the South During the War of the Rebellion Including Statistical Information Pertaining to Prisoners of War Late Sergeant Co. 'B,' Twenty-Fourth Wisconsin Infantry, Sheridan's Division, Army of the Cumberland," in *Prisoners of War Military Prisons* (Cincinnati, OH: Lyman & Cushing, 1890), 409–10.

313. Quiner, *Military History*, 951–53.

314. "Civil War Database," Wisconsin Veteran's Museum, http://museum. dva.state.wi.us/CivilWar/Soldiers.aspx.

315. Quiner, *Military History*, 658.

316. Ibid., 686–87.

317. Ibid., 826.

318. "Search for Prisoners."

319. Ibid.; *Report of the Wisconsin Monument Commission Appointed to Erect a Monument at Andersonville, Georgia* (Madison, WI: Democrat Printing Company, State Printer, 1911), 184–90.

320. Yancey Hall, "U.S. Civil War Prison Camps Claimed Thousands," National Geographic, http://news.nationalgeographic.com/news/2003/07/0701_030701_civilwarprisons.html.

321. Thomas E. Rose, *Col. Rose's Story of the Famous Tunnel Escape from Libby Prison* (N.p., n.d.), 9; Frances H. Casstevens, *Tales from the North and the South: Twenty-Four Remarkable People and Events* (Jefferson, NC: McFarland & Company, 2006), 300–302.

322. C.M. Prutsman, *A Soldier's Experience in Southern Prisons. A Graphic Description of the Author's Experiences in Various Southern Prisons* (New York: Andrew H. Kellogg, 1901), 8, 50, 58, 60, 70, 76–77.

323. John Azor Kellogg, *Capture and Escape: A Narrative of Army and Prison Life* (Madison: Wisconsin History Commission, 1908), 97–98, 141, 146–48; "John Azor Kellogg," Antietam on the Web, http://antietam.aotw.org/officers.php?officer_id=13037.

324. Quiner, *Military History*, 127; William A. Titus, "A Wisconsin Burial Place of Confederate Prisoners of War," *Wisconsin Magazine of History* 36, no. 3 (Spring 1953): 192; *Wisconsin State Journal*, "Matters at Camp Randall," April 21, 1862; *Wisconsin Weekly Patriot*, "Camp Randall—Arrival of Prisoners," April 26, 1862.

325. "Matters at Camp Randall"; "Camp Randall—Arrival of Prisoners."

326. Titus, "Wisconsin Burial Place," 193; George Mebane Diary (Co. H, Fifty-Fifth Tennessee) from the collection of the Civil War Museum, Kenosha, Wisconsin.

327. "Forest Hill Cemetery Soldiers' Lot Madison, Wisconsin," National Park Service, https://www.nps.gov/nr/travel/national_cemeteries/wisconsin/forest_hill_cemetery_soldiers_lot.html.

328. "Confederate Prisoners at Camp Randall," Wisconsin Historical Society, https://www.wisconsinhistory.org/pdfs/lessons/EDU-NewspaperClipping-ConfederatePrisoners-WSJ4-21-1862.pdf; "Visits to Camp Randall Discontinued," Wisconsin Historical Society, https://www.wisconsinhistory.org/pdfs/lessons/EDU-NewspaperClipping-ConfederatePrisoners-WSJ4-29-1862.pdf.

329. Titus, "Wisconsin Burial Place," 193; "Confederate Prisoners at Camp Randall as Seen in Newspaper Articles," Wisconsin Historical Society, http://www.wisconsinhistory.org/Content.aspx?dsNav=N:4294963828-4294963805&dsRecordDetails=R:CS3408.

330. Titus, "Wisconsin Burial Place," 192–93; "Confederate Rest Cemetery...Forest Hill (Madison, WI.)," Find a Grave, https://www.findagrave.com/cgi-bin/fg.cgi?page=vcsr&GSvcid=126578; "Forest Hill Cemetery Soldiers' Lot"; Quiner, *Military History*, 127, 674.

331. Gaylord, *Report, 1865*, 705; Quiner, *Military History*, 973.

332. Wisconsin Veteran's Museum Civil War Database, http://museum.dva.state.wi.us/CivilWar/Soldiers.aspx.

333. Quiner, *Military History*, 644–55, 867–68, 820, 909–20.

Epilogue

334. Quiner, *Military History*, 973.

335. Gaylord, *Report, 1865*, 27. The dates of mustering out are listed for each individual regiment. This information is readily available from a number of sources that detail the regimental histories.

336. *Wisconsin Blue Book 2015–2016*, 161; Howard Louis Conard, ed., *History of Milwaukee from Its First Settlement to the Year 1895* (Chicago: American Biographical Publishing Company, 1895), 115.

337. *Wisconsin Blue Book 2015–2016*, 169.

Appendices

338. All taken from the *Annual Reports of the Adjutant Generals of the State of Wisconsin for the Years 1860, 1861, 1862, 1863, 1864, 1865*; Estabrook, *Records*; Estabrook, *Losses*; Quiner, *Military History*.

Selected Bibliography

Andler, Caroline, and Andrea R. Brucker. *Letters Home from the Brothertown Boys*. Bloomington, IN: Authorhouse, 2011.

Baker, H. Robert. *The Rescue of Joshua Glover: A Fugitive Slave, the Constitution, and the Coming of the Civil War*. Athens: Ohio University Press, 2007.

Barker, Brett. *Exploring Civil War Wisconsin: A Survival Guide for Researchers*. Madison: Wisconsin Historical Society Press, 2003.

Blanton, De Anne, and Lauren Cook. *They Fought Like Demons: Women Soldiers in the Civil War*. Baton Rouge: Louisiana State University Press, 2002.

Current, Richard. *The History of Wisconsin. The Civil War Era, 1848–1873*. Madison: State Historical Society of Wisconsin, 1976.

Davidson, J.N. *Negro Slavery in Wisconsin and the Underground Railroad*. Milwaukee, WI, 1897.

Dawes, Rufus R. *Service with the Sixth Wisconsin Volunteers*. Marietta, OH: E.R. Alderman & Sons, 1890.

Estabrook, Charles E., ed. *Annual Reports of the Adjutant Generals of the State of Wisconsin for the Years 1860, 1861, 1862, 1863, 1864*. Madison, WI: Democrat Printing Company, 1912.

———. *Records and Sketches of Military Organizations*. Madison, WI: Democrat Printing Company, 1914.

———. *Wisconsin Losses in the Civil War*. Madison: Democrat Printing Company, 1915.

Fox, William F. *Regimental Losses in the American Civil War 1861–1865*. Albany, NY: Albany Publishing Company, 1889.

Hauptman, Laurence M. *The Iroquois in the Civil War: From Battlefield to Reservation*. Syracuse, NY: Syracuse University Press, 1993.

Herdegen, Lance J. *The Iron Brigade in Civil War and Memory: The Black Hats from Bull Run to Appomattox and Thereafter.* El Dorado Hills, CA: Savas Beatie, 2012.

Hurn, Ethel. *Wisconsin Women in the War Between the States.* Madison: Wisconsin Historical Society Press, 2013.

Jackson, Ruby West, and Walter T. McDonald. *Finding Freedom: The Untold Story of Joshua Glover, Runaway Slave.* Madison: Wisconsin Historical Society Press, 2007.

Johansson, Robert W. *Stephen A. Douglas.* New York: Oxford University Press, 1973.

Kennedy, Joseph C.G. *Population of the United States in 1860, Compiled from the Original Returns of the Eighth Census.* Washington, D.C.: Government Printing Office, 1864.

Klement, Frank. *Wisconsin in the Civil War: The Home Front and the Battle Front, 1861–1865.* Madison: Wisconsin Historical Society, 1997.

Love, William De Loss. *Wisconsin War of the Rebellion: A History of Regiments and Batteries the State Has Sent to the Field.* Chicago: Church and Goodman, 1866.

Lurie, Nancy Ostreich. *Wisconsin Indians.* Madison: State Historical Society of Wisconsin, 1987.

Miller, Edward A. *The Black Civil War Soldiers of Illinois: The Story of the Twenty-Ninth U.S. Colored Infantry.* Columbia: University of South Carolina Press, 1998.

Pferdehirt, Julia. *Caroline Quarlls and the Underground Railroad.* Madison: Wisconsin Historical Society Press, 2008.

———. *Freedom Train North: Stories of the Underground Railroad in Wisconsin.* Madison: Wisconsin Historical Society Press, 1998.

Pula, James. *The Sigel Regiment: A History of the 26th Wisconsin Volunteer Infantry, 1862–1865.* New York: Savas Publishin, 1998.

Quiner, E.B. *The Military History of Wisconsin.* Chicago: Clarke and Company, 1866.

Roster of Wisconsin Volunteers, War of the Rebellion, 1861–1865. Madison, WI: Democrat Printing Company, State Printers, 1886. Lists all the soldiers known to have participated in Wisconsin's Civil War regiments. An alphabetical index was published in 1914.

Solem, Jane Walrath. *Wisconsin Angel: Cordelia Harvey, Civil War Heroine.* Lake Mills, WI: Hartington Press, 2009.

Stempel, Jim. *The CSS Albemarle and William Cushing: The Remarkable Confederate Ironclad and the Union Officer Who Sank It.* Jefferson, NC: McFarland, 2011.

Thwaites, Reuben Gold, ed. *Civil War Messages and Proclamations of Wisconsin War Governors.* N.p.: Wisconsin History Commission, 1912.

Zimm, John, and Michael Edmonds, eds. *This Wicked Rebellion: Wisconsin Civil War Soldiers Write Home.* Madison: Wisconsin Historical Society Press, 2012.

INDEX

About the Author

Ronald Paul Larson is a Kenosha, Wisconsin native. After high school he served for two years in the U.S. Army. Afterward, he received a BA from the University of Wisconsin–Madison with a double major in history and communication arts, with an emphasis in radio, television and film

In the early 1990s, he began working in documentary television. He became the head text researcher for a documentary on the Revolutionary War for the Learning Channel. The six-part documentary won the cable Ace Award for "Best Documentary Series" in 1996.

In 2005, he received an MA in history from California State University–Fullerton. He has gone to several conflict zones over the years, photographing and interviewing fighters and civilians about their experiences: Afghanistan in 1985 (during the Afghan-Soviet war); Iraq in 2003 (as an embedded print reporter with a U.S. Army unit); Libya in 2011; Aleppo, Syria, in 2013; and Turkey in 2015 (interviewing Syrian activists and refugees).